DAVID BOMBERG

RICHARD CORK

David Bomberg

THE TATE GALLERY

front cover
David Bomberg, 'The Red Hat' 1931
(cat.111)

back cover
David Bomberg, 'The Dancer' 1913–14
(cat.50)

frontispiece
Photograph of David Bomberg, *c.*1914
Henny Handler

ISBN 0 946590 87 7
Published by order of the Trustees 1988
for the exhibition of 17 February – 8 May 1988
Copyright © 1988 The Tate Gallery All rights reserved
Published by Tate Gallery Publications,
Millbank, London SW1P 4RG
Design: Caroline Johnston Production: Joanne Ennos
Printed in Great Britain by Westerham Press, Westerham, Kent

Contents

Foreword

David Bomberg's greatest success in his lifetime was with his pre-1914 paintings with their energy, great simplification and clear cut style. Unfortunately this early success was not to be repeated and his return to a more representational approach after the first World War never proved popular. Indeed he struggled endlessly but to no avail to get himself accepted as the important artist that he knew he was. It was not until after his death that he was given the recognition he deserved with a retrospective exhibition organised by the Arts Council in 1958. Other shows followed and Bomberg's importance both as artist and as a teacher is now widely accepted.

The current exhibition is the largest and most comprehensive to have been organised and it includes many works not previously exhibited in London. We owe our thanks to Richard Cork, critic and art historian for selecting the show and for writing the catalogue which complements and extends his *David Bomberg*, recently published by Yale University Press.

Our thanks also go to the artist's step-daughter Dinora and her husband Bernard Davies-Rees, for their unstinting help and generosity over loans to the exhibition. They have made many gifts to the Tate and have recently also donated Bomberg's archive to the Tate Gallery Archive. We are deeply grateful to them, and to their daughter, Juliet Lamont.

Finally I should like to thank all the lenders who have responded to our request for loans so enthusiastically. Without their generous support this exhibition would not have been possible.

We are planning to tour the exhibition first to Seville, Spain, near where Bomberg painted so many of his landscapes and finally to the Yale Center for British Art, New Haven, Connecticut.

Alan Bowness *Director*

Acknowledgements

The first person who deserves to be thanked for helping me with my researches did not, sadly, live to see this exhibition. Lilian Bomberg, the artist's widow, gave me invaluable help at a time when infirmity could easily have excused her from the task of dealing with all my questions. But she carried out her responsibilities to the full, with unstinting assistance from her daughter Dinora. Since Lilian's death, Dinora has continued to prove an inexhaustible and ever-thoughtful source of support. No words could suffice to convey the extent of her encouragement, and I was fortunate indeed to be treated with such generous understanding. Her husband Bernard and daughter Juliet must also be thanked for their willing and friendly co-operation. It has been a delight to work with them all.

Among the many others who aided my researches, the late John Bomberg and his late wife Olive shared their memories with me. So did Bomberg's sister Kitty and her husband James Newmark, and I was also glad to discuss Bomberg's early life with his Slade contemporary Clare Winsten and his lifelong friend, the late Joseph Leftwich. Bomberg's first wife Alice Mayes corresponded with me before her death, and her son Denis Richardson was also very helpful. Sonia Cohen Joslen remembered her friendship with the young Bomberg, and Sarah Roberts discussed the Slade and war years as well. Louis Behr was kind enough to assist my enquiries into Schevzik's Vapour Baths, the starting-point for 'The Mud Bath'.

Artists who studied under Bomberg at the Borough Polytechnic likewise proved enormously helpful. Leslie Marr has been consistently kind and informative, and Roy Oxlade let me read his fascinating MA thesis on the Borough years. Frank Auerbach, Dennis Creffield and Leon Kossoff were all illuminating about their student years, and so were Peter and Nora Richmond.

Owners of Bomberg's work have been a pleasure to visit, none more so than Colin St John Wilson whose enthusiasm and helpfulness were always readily available. I must also thank Sam and Carole Sylvester, David Sylvester, Pamela Sylvester, Eunice Kossoff, Lady Alexander Trevor-Roper, Alan Rowlands, Vik Advani, Edgar Astaire, Mr and Mrs Harry Barr, Lyndon Brook, Abram Games, Henry Lewis, Anne Gray, Henny Handler, Devora Barnett, David Kessler, Erich Sommer, Arnold van Praag, Douglas Woolf, Ralph Shovel, Joan Rodker, Josef Herman, Professor Boyland, Mr and Mrs Raymond Danowski, Cecily Bomberg, Matthew Marks, Maureen Harris, Vivien Wrach, Mr and Mrs Geoffrey Chin and Edward Nygren. Norman Rosenthal kindly assisted me over one important loan, and Ronald Vint and his son deserve my special thanks as well.

Many museum officials have been unfailingly ready to assist: the staff at the Tate Gallery; the Ben Uri Gallery's Agi Katz and her successor Yael Hirsch; Sarah Brown at the National Gallery; Jean Liddiard at the National Portrait Gallery; Timothy Stevens at the Walker Art Gallery, Liverpool; Louise West of the Ferens Art Gallery, Hull; Deirdre Heywood of Oldham Art Gallery; Caroline Krzesinska of the Cartwright Hall, Bradford; Angela Weight of the Imperial War Museum; Anne Goodchild and Mike Tooby of Sheffield City Art

Galleries; Jane Farrington of Birmingham City Art Gallery; Robert Hall of Huddersfield Art Gallery; G. G. Watson of Middlesborough Art Gallery, and the Textiles Department of the Victoria & Albert Museum. Stephanie Rachum of the Israel Museum deserves special thanks, and I am also grateful to Miriam Stewart of the Fogg Museum and Catherine Johnston of the National Gallery of Canada.

A number of dealers have been of enormous assistance. At Fischer Fine Art, Jutta Fischer, Anita Besson and Jeffrey Solomons were always very willing to help. Anthony d'Offay, Robin Vousden and Judy Adam have likewise proved invaluable and more than ready to aid me in every way they could. Ivor Braka, Gillian Jason, Cavan O'Brien, James Mayor and Joe Wolpe also gave their welcome assistance.

At the Arts Council I am especially grateful to Joanna Drew, whose own role was so important in the organizing of the 1967 Bomberg exhibition at the Tate. Help was also willingly given by Isobel Johnstone, Susan Ferleger Brades and Pamela Griffin, while Michael Harrison responded with alacrity to my request for 'Trendrine, Cornwall' even though he needed it for another show. Mrs Lightbown and D. Kasher both aided me at the Slade, and D. T. Elliot, Chief Librarian at Tower Hamlets Library dealt most helpfully with my enquiries. Thanks are also due to Patrick Baird at Birmingham City Reference Library, A. R. Neate at the Greater London Record Office, Robert Thorne of the Historic Buildings and Monuments Commission for England, the GLC Photograph Library, Janet Green of Sotheby's and Francis Farmar at Christie's. During my stay in Ronda, I enjoyed the warm hospitality of Mayor Julian de Zulueta and his wife Gillian.

I am very grateful to the Drown brothers for allowing me to examine and discuss works by Bomberg which they have restored so well in recent years. John Bull also let me look at the works in his care, and I am likewise thankful to Tim Green for showing me work-in-progress on the important canvases he cleaned for this exhibition.

I would never have been able to undertake all the research which lies behind this catalogue without taking Nicholas Serota's advice and applying to the Elephant Trust, who provided generous financial support. Nor would I have coped with the complex task of selecting this exhibition without the expertise, patience and friendly advice shown at all times by the immensely able team at the Tate's Exhibition department. I could not have wished for a more pleasant and professional collaboration.

Bomberg's Odyssey

Although Bomberg is by no means the only important artist to have suffered from unforgiveable neglect during the present century, the indifference he encountered was particularly cruel. At the time of his death in August 1957 he was virtually a forgotten man, venerated by a few perceptive supporters and yet ignored by everyone else. Most of the work he produced during a long and fertile career remained unsold, consigned to the obscurity of a storeroom. The majority of his finest later paintings, including the exuberant canvases carried out during a trip to Cyprus in 1948, had never been exhibited anywhere. As for the great early canvases like 'The Mud Bath' and 'In the Hold' (cats.42 & 36, pls.11 & 9), they stayed unseen for almost half a century after their completion.[1]

Nobody, outside his immediate family and a few friends, had any notion of the size or complexity of Bomberg's achievement. By 1953 his reputation was so low that when Edward Marsh left his collection to the nation, in a generous bequest to the Contemporary Art Society, his two Bomberg paintings were rejected and sent back to Marsh's family. The rest of his bequest was allocated to galleries throughout Britain and the Commonwealth, but Bomberg's pictures of Jerusalem and Ronda (cat.122) were deemed unworthy of any public collection.[2] He longed for a retrospective exhibition which would rescue him from this ignominy, but the only survey of his career staged during the artist's lifetime was a modest 1954 show at the Heffer Gallery in Cambridge.[3] Consisting of just thirty-seven paintings and drawings, it was, 'for those who were interested, a revelation'.[4] Apart from reviews in the local press, however, it failed to elicit any critical comment and never received a London showing.

Nor was Bomberg granted the place he deserved in the literature of the period. One of the books which should have helped to redress the balance in his favour, Herbert Read's 1951 survey of *Contemporary British Art,* omitted him altogether. Even though this influential assessment by the most powerful critic of the day made room for artists as minor as Bateson Mason and H.E.Du Plessis, Bomberg was beneath Read's interest. His humiliating verdict echoed the treatment Bomberg had received at the Tate Gallery. After acquiring two modest graphic works in 1923, it never purchased another picture during the subsequent thirty-four years of his life.[5] Lacking the support of a dealer who might have promoted his cause with vigour, he decided in 1937 to take the matter into his own hands. After selecting 'the four best works I had',[6] a group which included 'Storm over Peñarrubia' (cat.130, pl.39), Bomberg asked the Tate's trustees to consider them at a board meeting. Their wholesale dismissal of the paintings prompted him to write a letter to the gallery, but all it earned him was a curt rejoinder from the Director's assistant declaring that 'it is a matter in which personal feelings are apt to assume an importance which is not really justified by fact'.[7]

Nothing could have been more 'justified' than Bomberg's mounting realisation that he was becoming a *persona non grata* in the eyes of the British art establishment. He struggled hard not to let it affect his spirits, and maintained in 1953 that 'I do not wish to convey the impression of being an aggrieved person – on the contrary is the case. I am happy in my own

fulfilment'.[8] But the lack of interest was all the more galling when compared with the response elicited by his early work. It had provoked extreme reactions, ranging from intense admiration to bitter hostility; and yet such comments were infinitely preferable to his subsequent awareness that, so far as curators, dealers and critics were concerned, he had almost ceased to exist. In July 1914, long before most of his contemporaries secured one-man shows for themselves in London, the young Bomberg staged a large solo exhibition at the Chenil Gallery. It was an exceptional event, both for the quality of work on display and for the level of interest it aroused. While some critics reviled the show, others admired it warmly. Prominent among them was the poet and philosopher T.E. Hulme, who concluded in his review that Bomberg was 'an artist of remarkable ability' and made the prophetic judgement that 'he is probably by this kind of work acquiring an intimate knowledge of form, which he will utilise in a different way later'.[9] Hulme never lived to discover just how 'different' this precocious artist would become, but in 1914 he voiced the general view among allies of the pre-war avant-garde that Bomberg was already an outstanding member of the emergent generation.

To attain such a heady position at the age of twenty-three, only a year after leaving the Slade School of Art, was notable in itself. To emerge so dramatically from Bomberg's background, as the son of a Jewish leather-craftsman who had been forced by pogroms to leave his native Poland, was more extraordinary still. Growing up in the slums of Birmingham, and then in the equally overcrowded immigrant ghetto of the East End, he came from a context where the notion of becoming an artist was generally regarded with incredulity. The fifth child of a large family occupying cramped accommodation in a Whitechapel tenement, he had no hope of gaining financial help from his father during his studentship. Bomberg, however, was a tenacious young man, and he received crucial assistance from a sympathetic mother who provided him with materials and a makeshift studio. He was also stimulated by the company of other emigrants' sons like Isaac Rosenberg and Mark Gertler, both of whom eventually studied with him at the Slade. They all received vital subsidy during their student days from the Jewish Education Aid Society, a philanthropic body which loaned Bomberg the funds he needed to enter the School in April 1911.

It was a propitious moment for an alert young artist to embark on his training. The Slade's reputation had reached its height under the stern yet incisive tutelage of Henry Tonks. Bomberg benefited from the emphasis laid on the firm underlying structure of draughtsmanship by both Tonks and his fellow-professor Fred Brown. It pervades Bomberg's few surviving drawings of this period, with their sculptural severity and clearsighted concentration on the essentials of form alone. He was fortunate in his teachers, and in the presence of an impressive generation of Slade students who included Stanley Spencer, Paul Nash, Christopher Nevinson, William Roberts and Edward Wadsworth. But he was equally lucky to witness and learn from a whole spate of exceptional exhibitions which introduced London to the most important movements of the age. Many years later Bomberg remembered how Roger Fry's seminal survey of *Manet and the Post-Impressionists,* held at the Grafton Galleries in November 1910, helped to bring 'the revolution towards Mass . . . to fruition.'[10] Fry focused on the works of Cézanne, Van Gogh and Gauguin rather than younger painters like Picasso or Matisse, neither of whom was generously represented. Bomberg, however, 'had

Photograph of the Slade Picnic, *c*.1912.
Back row: 3rd from left, Bomberg; 4th
from left, Professor Fred Brown; 5th
from left, C. Koe Child, Slade Secretary.
Kneeling on left: Isaac Rosenberg. Front
row: left, Dora Carrington; 3rd from left,
Nevinson; 4th from left, Gertler; 5th from
left, Roberts; 6th from left, Allinson; 7th
from left, Stanley Spencer. *Tate Gallery
Archive.*

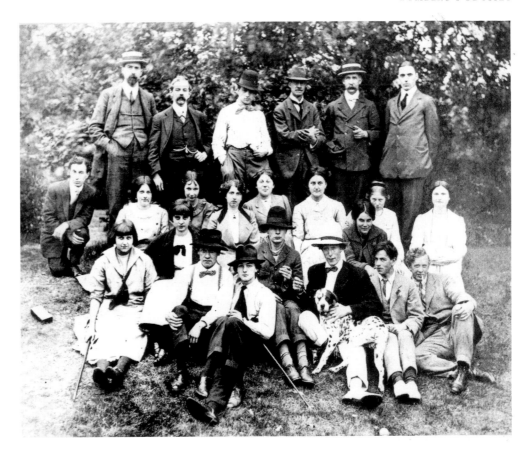

never hitherto seen a work by Cézanne',[11] and a 1910 drawing like 'Classical Composition'
(cat.3) suggests that he responded quickly to the Grafton catalogue's insistence that the artist
should 'try to unload, to simplify the drawing and painting by which natural objects are
evoked, in order to recover the lost expressiveness and life.' [12]

Fry's notorious exhibition, so explosive in its impact on British taste that his friend
Desmond MacCarthy nicknamed it 'The Art-Quake of 1910',[13] was viewed with intense
misgivings by Bomberg's teachers. But he was as enthusiastic about it as several of his Slade
contemporaries, and his previous experience of Sickert's evening classes at the Westminster
School had already made him predisposed to acknowledge contemporary French art's
vitality. An intriguing sheet of pencil studies (cat.7) reveals how he proceeded from the main
drawing of the life model to a sequence of drastically simplified figure compositions.
Bomberg here seems to share the views of Tonks's colleague John Fothergill who, relying on
the theories of Loewy and Wundt, argued that 'every complex form . . . must first be
broken up into its component parts before it can be fully apprehended or remembered.' [14]

To that extent, Bomberg's urge to experiment was aligned with the precepts of his
teachers, but they grew increasingly disturbed by the heretical exhibitions from the conti-
nent which invaded London in 1912. Futurism arrived at the Sackville Gallery in March,
and young British artists scarcely had time to digest its rhapsodic celebration of machine-age
dynamism before Fry astounded visitors to the Grafton Galleries with his *Second Post-
Impressionist Exhibition* in October. This time Cubism was represented as well as Matisse's

recent work, and the emergence of a radical generation of artists in Russia and Britain alike was acknowledged in special sections of the show. Paul Nash afterwards recalled that the exhibition seemed 'to bring about a national upheaval . . . every canon of art, as understood, was virtually shattered.' [15] Tonks had by now become horrified by the implications of these events, and told his friend George Moore that 'I cannot teach what I don't believe in. I shall resign if this talk about Cubism doesn't cease; it is killing me.' [16] His attempts to deter the more audacious students from visiting the Grafton Galleries proved futile, however, and no one responded more vigorously to the challenge of new continental developments than Bomberg.

His earliest surviving painting, 'Bedroom Picture' (cat.5) openly declared the affiliations with Sickert he had enjoyed before entering the Slade. In the centre of this Camden Town-like interior, however, with its glimpse of Bomberg's tenement studio through the door beyond the iron bedstead, stands a figure whose forms are handled in a different manner. Austere, angular and shorn of elaborate detail, her structure suggested to Hulme in 1914 that Bomberg 'has all the time, and apparently quite spontaneously, and without imitation, been more interested in form than anything else.' [17] 'Bedroom Picture' is far removed from abstraction, though, and the rigorously defined woman who gazes longingly out of the window also embodies Bomberg's growing desire to escape from the limitations of his family home.

His ideas developed rapidly during the course of 1912, impelling him to explore the ambiguity of a mirror-lined interior in a severe yet witty painting of 'Lyons Café' (cat.14). It was his first attempt to tackle a subject drawn from modern urban life, but he was also eager to deal with more 'primitive' sources of inspiration. The Slade's summer competition furnished him with an ideal opportunity, specifying as it did the open-ended theme of 'joy' (cat.9, pl.1). Bomberg produced a large, boisterous canvas that proceeds from the relative naturalism of the foreground figures towards the stripped, elemental forms struggling in the distance. More warlike than joyful, this fascinating picture shows a young artist striving to resolve the stylistic urges which conflict with each other as robustly as the men and women filling his ebullient composition with their brandished limbs.

The influence in this painting of Kandinsky, who exhibited regularly in London at the Allied Artists Association around this time,[18] soon gave way to more severe alternatives. 'Vision of Ezekiel' (cat.13, pl.2), the finest painting he executed during this formative year, is consistent in its desire to subject every figure to the same schematic organisation of form. Like the rectangular platform on which they recline, leap and genuflect, these pared-down bodies are reduced to their essential components. Several elaborate preliminary drawings testify to the singleminded care with which Bomberg integrated them with their bare, stage-like setting. But these sober studies give no hint of the incandescent colour he employed in the final canvas, where most of the figures are painted in a blinding combination of pale yellow and light pink. As well as announcing the advent of an adventurous colourist, 'Vision of Ezekiel' remains entirely faithful to its biblical source. For Bomberg appears to have taken his cue from the passage in the Book of Ezekiel where God guides the prophet to 'a valley which was full of bones'. Ezekiel finds himself commanded to speak to the bones, and the outcome is miraculous: 'there was a noise, and behold a shaking, and the bones came together, bone to his bone.'[19] Eventually the resurrected figures spring to life

David Bomberg, 'Study for Vision of Ezekiel' *c*.1912 (cat.11)

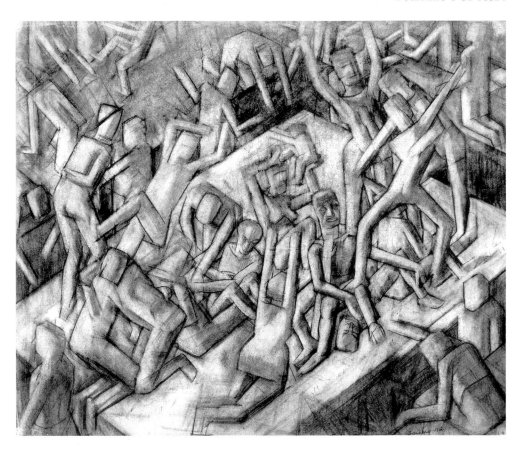

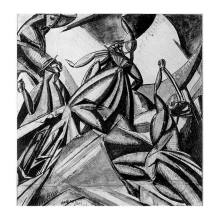

Wyndham Lewis, 'Kermesse', 1912 Ink, wash and gouache on paper $11\frac{3}{4} \times 11\frac{1}{4}$ (30 × 29) *Private Collection*.

once more – a revelatory event which Bomberg's colours convey with appropriate exaltation. Skeletal and yet animated by jerking energy, they are filled with wonder at their momentous return from the dead.

He may have settled on this passage from Ezekiel after his mother's sudden death in October 1912. Rebecca Bomberg meant an enormous amount to her son, and he could well have found consolation in this attempt to interpret the story of the bones' regeneration. In a larger sense, though, the choice of an Old Testament source shows how important Jewish culture remained to Bomberg. Like Chagall, who brought about an idiosyncratic fusion of the Hasidic tradition and the Parisian avant-garde, he here retained his indigenous interests in a painting more aware than before of continental innovation. Parallels for 'Vision of Ezekiel's precise, almost geometric fragmentation of form can be found in the contemporaneous work of both Picabia and Severini, as Wyndham Lewis pointed out soon afterwards.[20] And Lewis himself had recently completed a major Cubo-Futurist painting called 'Kermesse' for the newly-opened Cave of the Golden Calf in Heddon Street. This huge canvas has since been lost, but its three Dionysiac figures were described by Fry in terms that apply to Bomberg's picture as well: 'long before one has begun to inquire what it ['Kermesse'] represents, one has the impression of some plastic reality brought about by deliberately intentional colour oppositions'.[21] Lewis, who was eight years older than Bomberg and fast becoming recognised as a revolutionary force in British painting, made a point of visiting the Slade student at his Tenter Buildings home in the winter of 1912. Despite

differences in class and temperament, which would ensure that Bomberg never affiliated himself with Lewis, it was a memorable encounter. 'We had talked ourselves silly when he left – dawn, the next morning', Bomberg recalled. 'I recognised in the conversation, a Slade man honouring the same pledge to which I was staking my life – namely a Partizan.' [22]

Bomberg's alignment with the most insurrectionary of young British artists did not prevent him from continuing, for a while at least, to develop the kind of draughtsmanship which the Slade would have approved. An impressive 'Head of a Poet', a study of his friend Isaac Rosenberg, shows how assured his drawing had now become. It won the Henry Tonks Prize in 1913, and revealed in its overt respect for tradition the side of Bomberg that led him to haunt the National Gallery and venerate Michelangelo.[23] The other, more questioning and restless side of his imagination impelled him in a very different direction. A trip to Paris in May 1913 with another new friend, Jacob Epstein, confirmed his involvement with the European avant-garde. Sent there by the Director of the Whitechapel Art Gallery to select a 'Jewish Section' for a major exhibition of *Twentieth Century Art. A Review of Modern Movements,* he met many of the city's leading artists. 'Picasso was appreciative of my aims,' Bomberg remembered later, 'Derain more comprehending and Modigliani gave me a roll of drawings . . . to commemorate our meeting and my appreciation of his approach'.[24]

First-hand encouragement from such men undoubtedly spurred Bomberg on, and after returning to London he painted an even more uncompromising declaration of his commitment to pictorial renewal: 'Ju-Jitsu' (cat.29, pl.7). The title of this audacious little picture indicates that its origins lay in an East End gymnasium or wrestling hall. As a 1913 drawing called 'Jewish Theatre' attests (cat.15), Bomberg had begun to draw inspiration from the urban environment he knew best. His elder brother Mo was a boxer, and Bomberg's boyhood friend Joseph Leftwich recalled that Mo and his friends 'had a place called The Judaeans – an ordinary shop in Cable Street which was converted into a gymnasium'.[25] Ju-jitsu was practised there, and the preliminary drawing for the painting reveals that several figures are engaged in a fight within a strange, split-level interior (cat.28). The final picture is far less explicit, for Bomberg has imposed a sixty-four-square grid on the scene and splintered it into particles charged with darting kinetic energy. A battle is fought between the heraldic structure of the grid and the painting's figurative elements, and their dynamic conflict suggests that Bomberg wanted this complex formal interplay to act as an equivalent to the ju-jitsu performance. Although a partial use of the grid strategy can be found in contemporaneous work by Juan Gris,[26] it is employed with a more thorough-going emphasis in 'Ju-Jitsu'. Taking a device which he would first have encountered in the teaching of Sickert, who often used a squared-up grid to help in the transition from preliminary drawing to final painting, Bomberg transforms it into a subversive force. The chequerboard patterning of this bold picture, which he completed before leaving the Slade in the summer of 1913, shouts out his determination to revitalise the language of painting with flamboyant assurance.

The certitude of works like 'Ju-Jitsu' ensured that Bomberg, after a brief and disputatious association with the Omega Workshops, found himself included in the most experimental section of a major exhibition. As its title suggests, the December 1913 *Exhibition by the Camden Town Group and Others* attempted to bring together all the rival factions of the British avant-garde in a grand survey at Brighton City Art Galleries. 'Cubism meets

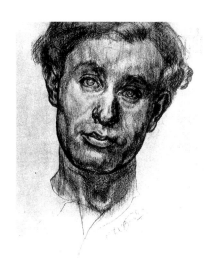

David Bomberg, 'Head of a Poet' (Isaac Rosenberg), 1913 pencil on paper $28\frac{1}{2} \times 10\frac{3}{4}$ (72.6 × 27.9) Work now lost. Photograph *Tate Gallery Archive.*

Impressionism, Futurism and Sickertism join hands and are not ashamed', declared the optimistic catalogue,[27] voicing conciliatory sentiments which would lead to the creation of the London Group a few months later. But Lewis insisted on writing a separate essay for the 'Cubist Room', where he exhibited with friends like Wadsworth, Etchells, Epstein and Nevinson. Bomberg, who always retained a stubborn sense of independence, would not have appreciated Lewis's claim that they belonged to a 'volcanic' group of painters who 'appeared suddenly above the waves following certain seismic shakings beneath the surface'. But he would hardly have disagreed with Lewis's declaration that 'all revolutionary painting today has in common the rigid reflections of steel and stone in the spirit of the artist . . . and realisation of the value of colour and form as such independently of what recognisable form it covers or encloses'.[28]

In March 1914, at the London Group's first exhibition, Bomberg had the opportunity to fulfil his promise on the grand scale. The principal painting he displayed there, 'In the Hold', (cat.36, pl.9) was a monumental assertion of his involvement with the metropolitan context he knew best. 'I want to translate the life of a great city, its motion, its machinery, into an art that shall not be photographic, but expressive', he told an interviewer from the *Jewish Chronicle,* arguing that 'the new life should find its expression in a new art, which has been stimulated by new perceptions.' [29] 'In the Hold' implemented these beliefs with spectacular conviction. Turning once again to an East End locale, he concentrated this time on a dockland scene where heroic figures are labouring in the bowels of a ship. But the representational meaning can only be grasped to the full in an elaborate chalk drawing (cat.35), where its links with the labourers and implements in Ford Madox Brown's 'Work' become surprisingly apparent. By the time the painting was completed, however, Bomberg had disrupted its figurative content even more drastically than in 'Ju-Jitsu'. Each square of his grid

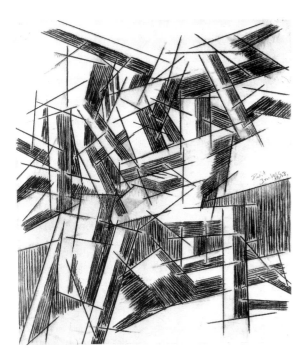

David Bomberg, 'Study for In the Hold'
1913 (cat.34)

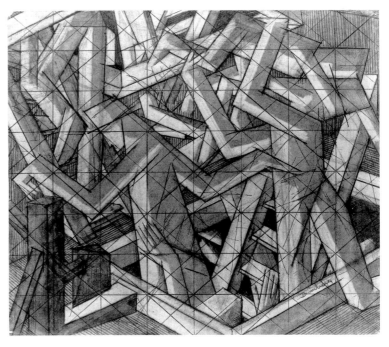

David Bomberg, 'Study for In the Hold'
1913–14 (cat.35)

is now divided, not simply in half but in quarters, and they conduct a ferocious assault on figures, trap-doors and ladders. This fusillade of geometrical components shatters the scene so ruthlessly that it threatens to become an abstract image, celebrating the autonomy of splintered form and high-voltage colour alone.

Bomberg certainly appeared to welcome such an outcome when he talked about 'In the Hold', describing how the grid's superimposition meant that 'the subject itself is resolved into its constituent forms which henceforth are all that matter.' But he also declared, in the same interview, that they 'may be contemplated from innumerable aspects',[30] and the action of the grid succeeds in opening 'In the Hold' to a whole range of possible interpretations. The workers in the preliminary drawing look heroic enough to imply that Bomberg intended the picture as a tribute to the dockers' power. For many years workers at the Port of London had played a militant role in the fight for better working conditions, and their strikes proved how much could be gained through concerted industrial action. But the final painting suggests that their redoubtable tradition of manual labour was being overtaken, and broken up, by the expansion of machine-age inventiveness. Just as Boccioni had extolled working-class exertion and prophesied its dissolution in his masterpiece 'The City Rises', shown at the Futurists' first London exhibition, so Bomberg dignifies dockland labourers and at the same time assails their bodies with schematic fragments redolent of impersonal mechanisation.

The vehement visual cacophony of the painting indicates, too, that he meant to convey the agitation and strain experienced by the passengers in their efforts to leave the ship. The drawing for 'In the Hold' (cat.35) shows that the labourers are hauling human bodies from the depths of the vessel, and they may well belong to immigrants arriving in London after a long voyage. Bomberg would have known, both from his parents' accounts and the testament of Jewish friends, just how traumatic such occasions could be for the weary and disorientated travellers. Mark Gertler remembered his own family's disembarkation after a long and harrowing journey, relating how 'everybody is pushing and shoving. It doesn't feel friendly. All is chaos, selfish and straining. I am being pushed and hustled. Some women are screaming and men shouting roughly.' [31] The grid's explosive effect on the figures in Bomberg's painting may, therefore, be seen as a metaphor for the broken lives of the immigrants he knew so well.

'In the Hold' was shown again, with other examples of his work, in the 'Jewish Section' he organised for the Whitechapel Art Gallery's survey of *Twentieth Century Art* in May 1914. Alongside British painters like Gertler, Wolmark, Meninsky and Rosenberg, Bomberg included work by Kisling, Nadelman, Pascin and Modigliani. Although described in the press as either a Cubist or a Futurist, he kept his distance from both movements and pointed out that 'where I part company from the leaders of the Futurist movement is in this wholesale condemnation of old art. Art must proceed by evolution.' [32] In this respect, he agreed with the Vorticists, for Ezra Pound disassociated the new English movement from Futurist iconoclasm and announced that 'we do not desire to cut ourselves off from the past.' [33] But Bomberg refused Lewis's invitation to contribute illustrations to the Vorticists' magazine, and in the very same month that *Blast's* first issue appeared he asserted his autonomy even more strongly by staging the Chenil Gallery one-man show.

The fifty-five pictures he displayed there were accompanied by a terse and defiant credo in the catalogue. 'I APPEAL to a *Sense of Form*', he proclaimed, pinpointing his principal

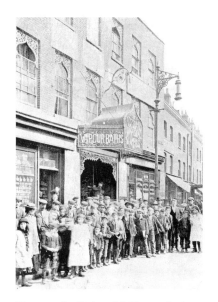

Photograph of Schevzik's Vapour Baths
in Brick Lane, Whitechapel, not dated.
Tower Hamlets Library.

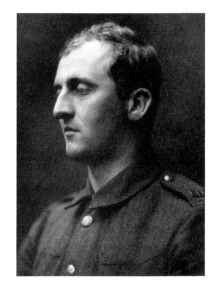

G. C. Beresford. Photograph of
T. E. Hulme, *c*.1914–15.
Private Collection, London.

source of inspiration by explaining that 'I look upon *Nature*, while I live in a *steel city*'. The machine-age metropolis was his shaping environment, and in order to do justice to the rapidly changing character of modern urban life he had committed himself to '*searching for an Intenser* expression . . . where I use Naturalistic Form, I have *stripped it of all* irrelevant matter.' [34] The most compelling manifestation of this aim was to be found, not within the exhibition, but 'outside the Chenil Galleries, on the outer wall of the house, rained upon, baked by the sun, and garlanded with flags.' [35] So forceful did this large painting of 'The Mud Bath' appear (cat.42, pl.11) that it provoked commotion in the busy street: Bomberg described how 'the horses drawing the 29 bus used to shy at it as they came round the corner of the King's Road.' [36]

Despite the Union Jacks embellishing its frame, and thereby calling attention to the red, white and blue employed in the canvas, 'The Mud Bath' was a serious affirmation of his standpoint. Even if its title appears uncannily prophetic of the gruesome experience awaiting soldiers in the trenches of the First World War, Bomberg probably meant to refer to another East End landmark – Schevzik's Vapour Baths in Brick Lane, where members of the Jewish community would immerse themselves in the water and afterwards enjoy herrings, beigels and lemon tea. A massage with mud may well have been on offer there, for Schevzik used to advertise his premises by vouchsafing to provide the 'Best Massage in London: Invaluable Relief for Rheumatism, Gout, Sciatica, Neuritis, Lumbago, and Allied Complaints'.[37] Bomberg doubtless realised that this purifying activity paralleled his own struggle to purge art of its superfluities. The figures who leap, dive and stretch their limbs around the bath's blaring red rectangle – a water-filled successor to the platform in 'Vision of Ezekiel' – are all lean, athletic embodiments of energy. Dispensing now with the intervention of a grid, Bomberg lets their muscular movements dominate the entire composition and fill it with a dynamism that stems in part from the cleansing operation he had performed on them. They hurl themselves round the dark pillar like primitive dancers surrounding a totem pole, and the clean-cut precision of their anatomical structure gives the entire painting a knife-edge sharpness and poise.

This lucid, strenuous and zestful image appears to celebrate a moment of liberation, when bodies finally emancipate themselves from '*all* irrelevant matter' and unleash their full vitality by the water's edge. It also proposes, with equal confidence, that humanity has taken on something of the identity of the machine age. Levers, pistons and cogs are evoked in the rigidity of these tensile figures, as if Bomberg were fulfilling the prediction made by Hulme in a lecture a few months before. 'The new "tendency towards abstraction" will culminate, not so much in the simple geometrical forms found in archaic art', Hulme had declared, 'but in the more complicated ones associated in our minds with the idea of machinery.' [38] The amalgam of the human and the mechanistic in 'The Mud Bath' demonstrates how far Bomberg agreed with Hulme's views, and other British artists were actively exploring a similar vision. Lewis's robot-like figures and Epstein's gaunt rock driller are only the most outstanding of the many images generated by a new awareness of the machine's pervasive power. It was a preoccupation shared by the continental avant-garde as well: not only the Futurists, whose advances Bomberg spurned, but Paris-based sculptors like Duchamp-Villon and Archipenko, whose bronze 'Boxers' employs forms very close to the thrusting limbs in 'The Mud Bath'. Bomberg singled out Archipenko, along with Matisse and Picasso, when

telling an interviewer about the artists he admired most.[39] For all its extremism, though, his prodigious painting continued to uphold his profound respect for Michelangelo. Even if he railed in the Chenil catalogue against 'the Fat Man of the Renaissance', the one picture Bomberg most enjoyed studying at the National Gallery was Michelangelo's unfinished 'Entombment' panel. Its muscular dynamism and taut diagonal tension appealed directly to the creator of 'The Mud Bath', who declared that 'the modern pictures . . . had their beginning with the Old Masters and Michael Angelo was the chief of these.' [40]

Alexander Archipenko, 'Boxers', d. 1914 bronze, $23\frac{1}{2}$ inches high. *Private Collection.*

The woman to whom he gave this explanation was soon to become his first wife. Alice Mayes, an *aficionado* of the Russian Ballet and already separated from her first husband, met Bomberg around Christmas 1914. She raised his spirits at a time when he felt disheartened by the onset of war and by his inability to sell the work exhibited at the Chenil show. They began living together in a studio flat near the Cumberland Market, where Alice spent arduous hours posing for a large war drawing of exhausted soldiers hemmed in by the harsh surroundings of their 'Billet' (cat.53). Although working so intensively from a model might suggest a move away from the concerns of 'The Mud Bath', he continued to pursue the 'Pure Form' obsessions of his 1914 art as well. After once more refusing Lewis's invitation to publish a drawing in the second issue of *Blast*,[41] he did agree to appear in the special non-members section of the 1915 Vorticist Exhibition. Here, with other non-Vorticists like Duncan Grant and Nevinson, he displayed paintings and drawings with titles that still assert uncompromising formal priorities: 'Decorative Experiment', 'Small Painting' and 'Design in White'. They may well have been as removed from representational intent as 'Abstract Design' (cat.47, pl.14); but it is important to stress that Bomberg, even at the height of this experimental period, still retained his central interest in the human figure.

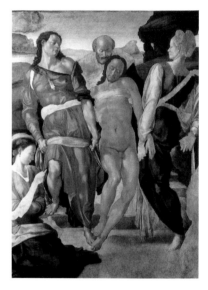

Michelangelo, detail from: 'The Entombment' (unfinished) *c.*1505–6 oil on panel $63\frac{3}{4} \times 59$ (162 × 150) *National Gallery, London.*

His decision to enlist in the Royal Engineers in November 1915 was prompted partly by financial duress. Patronage for art dwindled as the war pursued its ever more demoralising course, and Bomberg had been forced to give up painting in order to earn money 'rubbing down the enamel on second-hand cars.' [42] Responding to Kitchener's call seemed, at that moment, a preferable alternative, for Bomberg was throughout his life patriotically devoted to Britain. The prospect of separation led him to propose to Alice, who complied with his father's wish that she be received into the Jewish faith before marrying Bomberg in March 1916. Within weeks he had sailed for France with his battalion, and soon found himself pitched into the degradation and futility of trench warfare. Little time was available for even the swiftest drawing, but he did manage to write down terse notes which convey something of the agony he endured: 'Daily seen – six wiring-stakes driven in the ground – askew – some yards apart . . . Demons dragging strangling wire! Earth and sky – each in each enfolded; hypnotised: sucked in the murky snare; stricken Dumb.' [43] Although compelling visual images could have been made from such experiences, Bomberg was only able to execute a few small drawings like 'Figures Helping a Wounded Soldier' (cat.54), where the urgency of the bending bodies contrasts with the ominous stiffness of the victim they are striving to help.

By 1917 the strain of witnessing the prolonged and wholesale destruction of human lives brought Bomberg to breaking-point. Like so many other young soldiers caught in this grotesque conflict, he found life almost unendurable. Isaac Rosenberg voiced concern about his old friend's state of mind, writing that 'I have not seen or heard of Bomberg for ages but

David Bomberg, 'Drawing: Zin (?)'
c.1914 (cat.46)

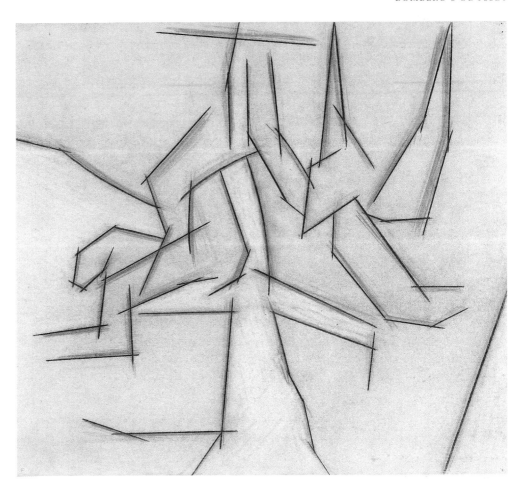

he was pretty bad 5 months ago.' [44] Eventually, the cumulative horror engendered by the slaughter of his fellow-soldiers, the death of his brother and the loss of Hulme, who was killed at Nieuport in 1917, precipitated a crisis. Finding 'life too hard to bear', he 'deliberately put the gun to his foot and pulled the trigger.' [45] The injury soon healed and Bomberg was let off lightly by his Adjutant, for by this stage in the war self-inflicted wounds had become increasingly common. He never mentioned it afterwards to anyone except Alice, and his drastic action seems to have exorcised some at least of the agony he suffered at the Front. For he managed to cope with active service more successfully after this traumatic incident, even though the hellish experiences he underwent still left their mark on the development of his art.

The transformation was profound, and it was hastened by the commission Bomberg received for a major painting from the Canadian War Memorials Fund. Like several other avant-garde painters, he was asked to produce a huge canvas recording an aspect of Canada's contribution to the war. P. G. Konody, the Fund's artistic adviser, had little sympathy with Vorticism and hoped that the former rebels would adapt their work to suit a scheme that 'throughout endeavoured to do equal justice to the claims of history and art.' [46] Bomberg was hardly the painter most likely to satisfy the documentary aspect of such a brief. He was asked in December 1917 whether 'you are prepared to paint this picture at your own risk to

be submitted for the approval of the Committee. The reason for this request is that the Art Advisor informs us that he is not acquainted with your realistic work, and cubist work would be inadmissible for the purpose.' [47]

It was a clear warning, and Bomberg must have suspected when he carried out a highly schematic oil and watercolour study that its stark idiom would be unacceptable (cat.60, pl.17.) After all, the allotted subject could hardly have been more figurative: a group of sappers at work, tunnelling towards the German salient at St. Eloi in order to blow it up and facilitate a full-scale attack on the enemy lines. His first study was so close to the style employed in 'The Mud Bath' that it did little to distinguish between the labouring men and the machines they handled in their cramped subterranean surroundings. He was no longer satisfied with this pre-war vision, for the war had impelled him to revise his attitude to industrialised society. Far from persisting in seeing the machine as an agent of construction, he realised during his prolonged nightmare in the trenches that it could be turned into an unimaginably destructive force. Inventions like the rapid-fire machine gun were capable of exterminating men's lives with obscene efficiency, and the death of Isaac Rosenberg in 1918 would have confirmed Bomberg in his hatred of a war which wrought such senseless tragedy. Somehow he needed to move away from his earlier engagement with mechanistic dynamism and assert a clear alternative – one that affirmed humanity's ability to counter and survive the relentless onslaught of machine power.

In this respect, Bomberg was well-disposed towards the notion of producing a more representational picture for Canada. The first version of his '"Sappers at Work": A Canadian Tunnelling Company' canvas (cat.61, pl.18) was an impressive attempt to celebrate heroic, collaborative labour without compromising the taut structural discipline he had acquired in his pre-war period. The men's straining bodies are now clearly differentiated from the implements they wield; and although the startling range of colours often emphasizes the flatness of limbs or pillars, he ensures that the energy of muscular, flesh-and-blood figures dominates the painting. Rather than dehumanising his soldiers, Bomberg restores to each of them a robust individuality. He sincerely believed that this festive canvas, which takes some of its exuberant distortion and *contrapposto* from El Greco's 'Christ Driving the Traders from the Temple',[48] would win the approval of the Canadian committee. But his conviction was ill-founded. When Konody inspected the painting at Burlington House, he dismissed it as a 'futurist abortion'.[49] In his view, the picture had been 'twisted into snake-like writhing forms that conveyed no meaning', and he ensured that it was 'indignantly rejected.' [50]

Bomberg was devastated by the rebuff. The enormous amount of consideration he devoted to the project had engrossed him for many months, and the brusque dismissal of his efforts demoralised a man who was still suffering from the after-effects of his purgatorial experiences in the trenches. Alice found him 'huddled in his chair by the fire – in tears' after the disastrous meeting at Burlington House, and she decided to ask Konody for a second chance. After insisting that 'no "cubist abortions" should creep into the work', he granted her request and supplied the contrite artist with a 'fresh canvas and colours.' [51] Bomberg should never have agreed to such a plan. The painting he finally produced is a skilful and carefully planned image, which makes impressive play with the severe shafts of the roof-beams and the sculptural mass created by the foreground platform. But the sappers them-selves compare poorly with their predecessors in the first version. Representational

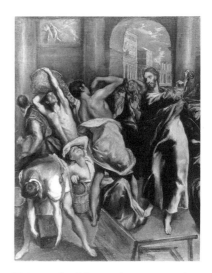

El Greco, detail from: 'Christ Driving the Traders from the Temple', *c*.1600 oil on canvas 41¾ × 51 (106.3 × 129.7) *National Gallery, London.*

David Bomberg, ' "Sappers at Work": A Canadian Tunnelling Company' (Second Version) 1919 oil on canvas $120\frac{3}{4} \times 96$ (305 × 244) *National Gallery of Canada, Ottawa.*

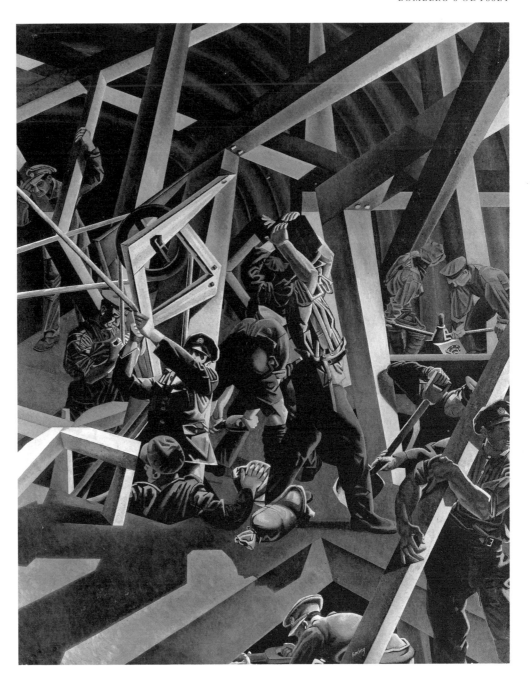

enough now to comply with Konody's demands, they lack the energy and bustling determination which gave the rejected painting its exhilaration. Each figure seems frozen in his movement by an artist whose diligence overrode the imaginative vitality that distinguishes Bomberg's finest work.

As if in recognition of the picture's dull efficiency, he never again handled figures with such laborious coldness. But after using some pre-war 'Dancer' sketches as the springboard for a remarkable booklet of *Russian Ballet* lithographs in 1919 (cat.63, pl.19), he continued to turn away from the mechanistic near-abstraction of his pre-war work. Bomberg was not alone in the desire to retreat from youthful extremism. In the aftermath of war, former

innovative artists throughout Britain and Europe were involved in similar re-examinations of their relationship with tradition. They would have understood why Bomberg, in a long sequence of pen and wash drawings (cats.64–67),[52] made the former rigidity give way to a more rounded and organic vision of humanity. He also started landscape painting, applying the structural discipline of his earlier work to a pastoral scene of barges moored on a canal so still that the trees' reflections take on a block-like solidity. The austere formal organisation of 'Barges' (cat.68, pl.20) proves that Bomberg was still attempting to benefit from the lessons he had learned before the war, and an absorbing series of oil-on-paper studies called the 'Imaginative Compositions' reveals a willingness to fuse a high degree of abstraction with a new gestural freedom in his manipulation of pigment (cats.75–79, pl.23). The brushwork animating these mysterious works, which Bomberg never exhibited at the time,[53] directly prophesies the handling he would progressively develop in the later years of his life.

But he was not ready, in the early 1920s, to build on the implications of the 'Imaginative Compositions' at once. Many of them deal with itinerants and other social outsiders, 'Vagrants' and 'Circus Players' among them. All the evidence suggests that Bomberg identified with them, for he began to feel more and more at odds with the country he inhabited. The audience in his 'Ghetto Theatre' (cat.71, pl.21) appears trapped by the rail stretching across the balcony, just as the hunched figure in 'Woman and Machine' (cat.72) looks almost welded to the drudgery of the job she is forced to carry out. Few collectors or dealers were prepared to purchase his work, even though he produced a masterpiece of muscular palette-knife painting in his poignant 'Bargee' canvas (cat.73, pl.22). Impoverished and increasingly cut off from his former friends, Bomberg was ready for drastic change.

He achieved it with the help of his friend Muirhead Bone, who proposed in 1922 that the newly-formed Zionist Organization might be willing to employ him as an official artist in Palestine. While hostile to the Zionist enterprise,[54] Bomberg was prepared to entertain Bone's idea: the possibility of a new beginning in Jerusalem appealed to an artist who now felt so alienated from the nation where he had been born. After complex and difficult negotiations with the cautious Zionists in London, the Palestine Foundation Fund finally consented to pay his passage in return for some 'drawings and paintings of Zionist recon-struction work'.[55] Bone, who also loaned him some money for the trip, had scant sympathy for Bomberg's 'experimental' art and assured the Zionists that 'Bomberg is done with *that* & means in Palestine to do sober, serious, really "record" work!'[56]

Events would demonstrate that Bomberg did not share his friend's clear-cut resolve, but his response to Jerusalem engendered a dramatic transformation of his work. The voyage to Palestine, undertaken with Alice in April 1923, awed a man whose previous travels had only extended as far as Paris. 'You must remember', he explained many years afterwards, 'I was a poor boy from the East End and I'd never seen the sunlight before.'[57] The blazing intensity of Jerusalem was as far removed from the machine age as Bomberg could possibly have desired, and it reinforced his determination to concentrate in future on regaining his lost rapport with the natural world. Palestine's primordial grandeur prompted him to scrutinise the landscape with an avidity he had never shown before, painting freely brushed studies of Jerusalem by moonlight (cats.80, 81) and, in the daytime, working towards an astonishingly meticulous rendering of the 'Mount of Olives' (cat.85).

The large painting he made of this hallowed panorama in 1923 has since been destroyed,

David Bomberg, 'Mount of Olives', 1923
Oil on canvas 28 × 36 (71.2 × 91.5) Now
destroyed.

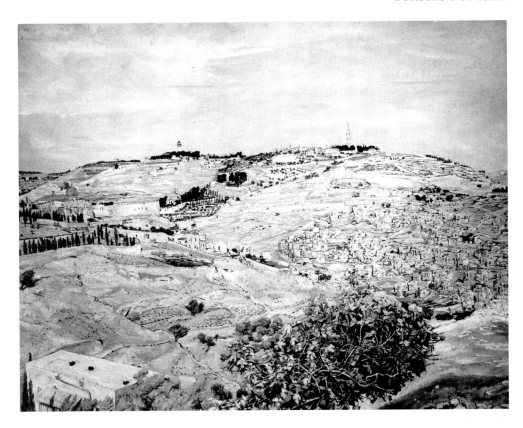

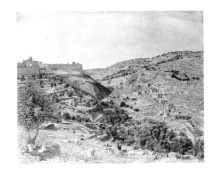

Thomas Seddon, 'Jerusalem and the
Valley of Jehoshaphat from the Hill of
Evil Counsel', 1854 oil on canvas
26½ × 32¾ (67.3 × 83.2) *Tate Gallery*.

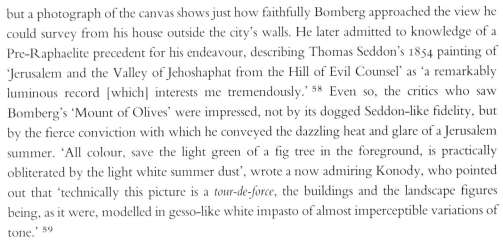

but a photograph of the canvas shows just how faithfully Bomberg approached the view he
could survey from his house outside the city's walls. He later admitted to knowledge of a
Pre-Raphaelite precedent for his endeavour, describing Thomas Seddon's 1854 painting of
'Jerusalem and the Valley of Jehoshaphat from the Hill of Evil Counsel' as 'a remarkably
luminous record [which] interests me tremendously.' [58] Even so, the critics who saw
Bomberg's 'Mount of Olives' were impressed, not by its dogged Seddon-like fidelity, but
by the fierce conviction with which he conveyed the dazzling heat and glare of a Jerusalem
summer. 'All colour, save the light green of a fig tree in the foreground, is practically
obliterated by the light white summer dust', wrote a now admiring Konody, who pointed
out that 'technically this picture is a *tour-de-force*, the buildings and the landscape figures
being, as it were, modelled in gesso-like white impasto of almost imperceptible variations of
tone.' [59]

Although 'Mount of Olives' could hardly be further detached from Bomberg's pre-war
work, in subject and style alike, the same complex temperament informs them both. Just as
he took his art to an innovative extreme in 'The Mud Bath', so he now began to explore the
possibilities of sharp-focus representation with the same singleminded tenacity. A photo-
graph of 'Mount of Olives' taken in a raking light discloses the robustness of its handling, and
his earlier passion for architectonic structure still underlies his organization of the buildings
on the hillside. Sir Ronald Storrs, the Military Governor of Jerusalem, was so captivated by
the painting that he purchased it for £100 and recommended Bomberg's 'powerfully

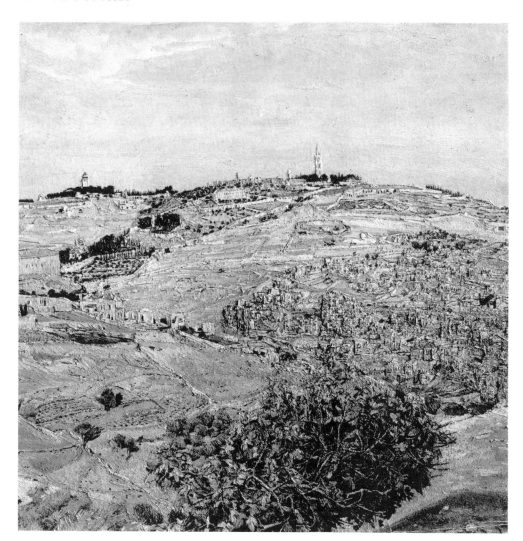

David Bomberg, Detail from: 'Mount of Olives', 1923 oil on canvas 28 × 36 (71.2 × 91.5) Now destroyed.

cosmic stare' [60] to other government officials in Jerusalem. His enthusiasm is understandable, for Storrs was obsessed by a crusading mission to preserve the city's identity from vandalism, demolition and insensitive modernisation. The vision of Jerusalem presented in Bomberg's subsequent pictures – pristine, orderly, gleaming and strangely devoid of people – coincided with the aims of a ruler who wanted his domain to be as unsullied as possible. Impelled by deep religious convictions, Storrs proudly claimed that 'we put back the fallen stones, the finials, the pinnacles and the battlements . . . so that it was possible to "Walk about Zion and go round about her: and tell the towers thereof: mark well her bulwarks, set up her houses." ' [61] Bomberg's incisive views of the city were the ideal visual record of everything Storrs laboured to achieve, and the Jerusalem paintings found eager purchasers among members of the governing circle.

Delighted by the appreciative patronage he was granted for the first time in his career, Bomberg neglected to carry out the views of the Pioneer Development camps which his Zionist sponsors were expecting to receive. Instead, he responded to Storrs's suggestion that a trip to Petra would be worth undertaking, so Bomberg spent several arduous and at

times perilous weeks trekking to the 'rose red city' and painting its celebrated rockface monuments. The paintings it yielded were very uneven, for Bomberg initially felt 'crushed' by the 'immense sandstone facades of colossal proportions, one behind another, rising to a terrific height, closing us in. I felt like a tiny ant, labouring along the white river bed, with all the egotism knocked out of me.' [62] Several of the Petra pictures were disappointingly literal, but in an exceptional canvas called 'Steps to a "High Place" on al Khubdha, Petra; early morning' (cat.86, pl.24) he did convey the full sensuous voracity of his reaction to the pink rocks in expressively handled brushwork.

Few of the paintings he carried out after his return from the hazardous and demanding expedition deployed this sense of tactile immediacy. The expectations of his patrons often kept Bomberg on too tight a rein, and only in the privacy of a trip to the remote monastery of St George did he really feel at liberty to indulge in brushmarks more emancipated than the freest of the Petra canvases. The outcome was an outstandingly beautiful series of oil-on-paper studies (cats.92,93), and their unfettered exhilaration contrasts with the lack of inspiration Bomberg suffered when he finally tackled the Zionist camps. Apart from a few vigorous drawings and a small oil sketch (cats.89,90), the paintings of 'Palestine Development' testify only to the lassitude he experienced there. He could not, in all honesty, pretend to discover at these pioneer sites the driving sense of purpose that would have gratified the Keren Hayesod.

Nor could Bomberg avoid recognising that his marriage to Alice had by now foundered. In order to escape from the mounting friction in their relationship, she agreed to visit London with his Palestine work and arrange an exhibition. It proved a difficult task. Puzzled by the change of direction in his paintings, the collectors, curators and dealers were far less

Photograph of Bomberg painting on the roof of the Banco di Roma, Jerusalem, 1925. *Artist's Family*.

enthusiastic than his Jerusalem patrons had been. Alice reported that the 'general attitude' towards his art seemed to be: ' "So many styles, how is one to know the real Bomberg." Damn them. It would make you sick if I repeated all the twaddle people talk about your work.' [63] Despite the bewilderment, she finally established that the Leicester Galleries were prepared to stage a one-man show of the Palestine pictures in February 1928. Bomberg, who admitted that 'I am out of funds',[64] agreed to the proposal, and in 1927 he carried out a lyrical painting of 'Roof Tops, Jerusalem' (cat.94, pl.26) which showed a new willingness to disregard his patrons' preferences. The breadth of handling and summary organisation of masses in this seductive picture imply that he was by now tired of painstaking topography. In a letter to Alice about some collectors who were 'coming to see the snow picture', he wrote that 'I hear they are expecting a worked out picture of detail whereas this is only complete in construction & tone. If I miss the sale on account of its "roughness", it will be because I did not want to put in such detail as would make it loose [sic] dignity'.[65]

Although Bomberg was right to assert an independent course, it heralded the end of his Palestine period. He could no longer count on the governing circle's support, especially after Storrs's departure for Cyprus, and the shock of an earthquake in Jerusalem jolted him into an abrupt departure. After a stop-over in Paris, where he briefly re-examined his earlier obsession with the machine-age city by viewing Fritz Lang's 'Metropolis' at the cinema, he reached London at the end of the year and began assembling the fifty-six paintings included in his Leicester Galleries show. Most of the newspaper critics welcomed his change of direction when the exhibition opened: they had, after all, complained about the extremism of his work in 1914. But the tightness and conventionality of the majority of exhibits disappointed his old allies and the critics who had regarded him as one of Britain's most audacious painters. Bomberg executed too many dull pictures in Palestine, and four years later he admitted that 'living in the midst of Colonial government social life . . . was not conducive to the freer and more unrestricted expression which after all is the fundamental quality of an artist's work. I became aware of this after I left Palestine . . . but decided to break altogether when I realised its effect on me'.[66]

Bomberg was encouraged to explore a more untrammelled path by Lilian Mendelson, a remarkable woman whom he first met just before his departure for Palestine. She had spent the intervening years unhappily married to the art dealer Jacob Mendelson, and when Bomberg encountered her again in 1928 Lilian was about to institute proceedings for divorce. Later in the year, she left Mendelson and moved with her little daughter Dinora to a house in West Hampstead where Bomberg joined them. A painter herself,[67] and fully capable of drawing a perceptive charcoal study of his vital yet troubled face (p.56), Lilian agreed with the doubts he harboured about the Palestine work. 'We recognised the total commitment to art in each other',[68] she recalled later, and before long the old spirit of expansiveness and outsize energy entered Bomberg's work once again. He even painted, for his sister Kitty, a spectacular silk shawl which evoked the exclamatory dynamism of 'The Mud Bath' (cat.109, pl.33). But there was no point in looking backwards for more than a moment. He knew that the future lay principally with an ever-deepening investigation of landscape, for the Palestine sojourn had at least convinced him that machine-age dehumanis-ation could be countered by attempting to recover an accord with nature.

Since the English countryside did not provide him with the stimulus he needed, Bomberg

David Bomberg, 'Convent and Tower,
San Miguel, Toledo' 1929 (cat.103)

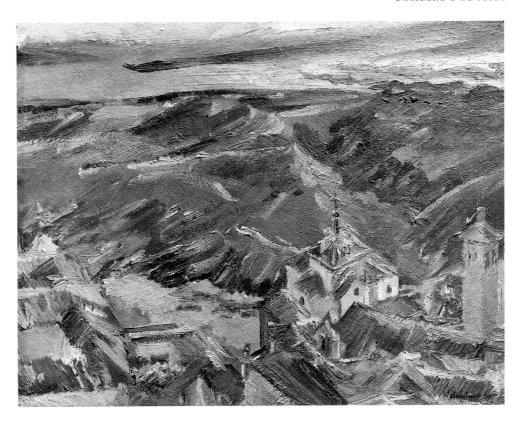

borrowed some money from Kitty and set off, at her suggestion, for Spain. His admiration
for El Greco doubtless helped him settle in Toledo, and after renting a small house opposite
the Alcazar in September 1929 he decided that the city fulfilled his expectations. Surveying
Toledo from 'my little Bit of a platform roof', he told Lilian excitedly that 'it is *Romantic*'.[69]
Apart from the wealth of well-preserved and impressive architecture stretching around his
vantage-point, the city's interaction with the surrounding countryside stirred Bomberg's
imagination. It offered him a complex challenge, but he declared that 'as long as I can find a
broader manner of treating the infinite amount of detail I am contented.'[70] The abundance
of outstanding oils carried out during his short stay at Toledo testifies to the extraordinary
stimulus it provided. In canvas after canvas Bomberg's brushmarks gain a new forcefulness
and expressive identity as he charts the structure of the cathedral rising above the huddle of
roof-tops around it, or gazes down from the Alcazar on the meeting-place between the tight
cluster of city buildings and the gaunt, uninhabited hills beyond. Sometimes he studies the
same prospect at different times of day, engrossed by the successive transformations it
undergoes as the lucidity of autumn sunlight gives way to the penumbral mystery of dusk.
The Toledo period marks a great turning-point in Bomberg's career, the moment when he
abjures the failings of his Palestine work and discovers how to convey his own impassioned
response to the landscape he surveys with such rapt, singleminded avidity.

 The example of El Greco sustained him during these tireless months, and he based his
canvas of 'Toledo and River Tajo' (cat.98, pl.28) on the left half of 'View and Plan of
Toledo', the panoramic painting in the El Greco Museum which Bomberg described as 'a
kind of imaginative aeroplane view'[71] of the city. The wildness and visionary intensity of

the Spanish master drove him on, encouraging him to leave timidity behind and let his agitated manipulation of pigment carry its own vital charge. But he never allowed this frank declaration of mark-making to take over completely. Always attentive to the thing seen, Bomberg remained rooted in an empirical involvement with the landscape he so greedily observed. It was a central priority: every liberty he took with paint remained subservient, in the end, to his search for the fundamental rhythms of nature. Later in life, while continuing to laud 'the great El Greco', he explained that 'from him you can learn that drawing and painting is one process and this is where the truth of life's structure comes in.' [72] He came closest to attaining this underlying aim in Toledo when painting smaller oils, usually on the outskirts of the city, where the architecture gives way to a white mist which surges over the hills like a tide cleansing and unifying the terrain it envelops (cat.106, pl.32).

Returning to London after such an eventful and concentrated bout of painting was bound to be an anti-climax. The old problems returned, and an attempt to earn money through commissioned portraits ended in failure. Bomberg turned instead to a scrutiny of his own features, in powerful charcoal drawings and oils of increasing breadth and richness of texture. Lilian was prepared to act as a patient and understanding model, too, whether exposing her naked vulnerability in a half-length canvas or donning a red hat so fiery in colour that it inspired Bomberg to paint one of his most blazing and unfettered portraits (cat.111, pl.35).

He was also prepared, at a time when the Depression led to mounting privation and protest demonstrations by the unemployed, to paint banners for the Hunger Marches. Kitty and her husband Jimmy Newmark, both 'fervent Marxists',[73] persuaded him to join the Communist party, and Lilian remembered that 'David read all through *Das Kapital* at the time.' [74] They attended mass rallies in Trafalgar Square, where on one occasion Jimmy Newmark found himself the victim of an unprovoked charge by baton-wielding constables. 'David, who was an enormously powerful man, became incensed by this', he recalled, 'and tried pulling the stones away from the plinth outside Canada House to throw at the police!' [75]

Although this political engagement did not enter into the paintings Bomberg produced, he was sufficiently intrigued by Communism to visit Russia in the autumn of 1933. At first he was impressed, telling Lilian that 'a visit out here is a better education in working class politics than can be obtained in any other way.' [76] He threw himself into plans for 'an art exhibition in London of the 15 years painting of Red Army & 15 years of Soviet Art',[77] and he entertained hopes that Russia could provide a far better 'deal for artists' than Britain seemed willing to supply. After a while, however, his optimism dimmed. Stalin had by then begun to shackle Soviet art with dogmatic ideological constraints, and Bomberg despised the results. 'We find that where the painter departs from the actual life around and strives for Socialist Realism', he wrote, 'the paintings do not inspire in the way they are meant to; the conception is derivative in composition and technique and lacking in that full vision which is necessary to inspire conviction in those people who see it. The theory and tactics of the Revolution is [*sic*] one thing and the creation of a work of art another. They have little in common.' [78] Soon after his disillusioned flight from Russia, both he and Lilian resigned from the Communist Party.

In order to develop the 'full vision' which Stalinist strictures destroyed, Bomberg knew he should return to Spain. If Toledo had provided him with the breakthrough he needed, other

David Bomberg, 'Cuenca from Mount Socorro', 1934 oil on canvas 29 × 37 (73.7 × 94) *Private Collection.*

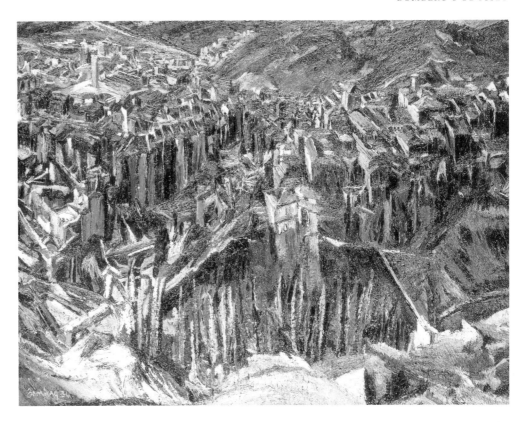

Spanish sites might help him reach an even deeper understanding of the natural forces he cherished. In 1934, armed with the proceeds of sales to three Bradford collectors[79] who showed a rare appreciation of his work, he set off with Lilian for Cuenca. Perched on a high rock ridge with rivers on either side, the ancient town provided Bomberg with an ideal interplay between buildings and the landscape they so dramatically occupied. His paintings stress the rootedness of Cuenca's houses, the way they appear to grow out of the rock on which they stand. In the most elaborate picture he carried out there, 'Cuenca from Mount Socorro', town and rock are fused in an energetic mass filled with Bomberg's heightened awareness of a geological conflict between cohesion and stress. As at Toledo, sunset fired him to see the town in near-visionary terms, where the houses appear to lose much of their substance and dissolve into a landscape suffused with the incandescence of dying light (cat.117). Unlike Toledo, however, Bomberg's brushwork now strives for a greater breadth, shedding the intricacy of the 1929 work in favour of a more summary and unified approach to form.

By no means all the Cuenca work achieved the ambitious aim he set himself. The quality is variable, and Bomberg attained a greater limpidity and freedom on a visit to Santander where Dinora rejoined her family after an unhappy spell in a London boarding-school. In the small oil study 'Mist: Mountains and Sea, Santander' (cat.119) he demonstrated that sky, land and ocean could all be encompassed in an image charged with a Turnerian conscious-ness of nature's animism. It augured well for the expedition which Bomberg now undertook to Ronda, travelling south with a modest amount of funding provided by the Bradford collectors.[80] Lilian had been to this Andalucian town before, and hoped that its impressive

setting would impel him to strive for a still more galvanic apprehension of the primordial Spanish landscape.

Her faith in Bomberg was more than justified. Ronda, a fortress-like settlement on a mighty rock plateau which rears above the surrounding plain, is split by a spectacular gorge plunging four hundred feet to the river below. Bomberg warmed immediately to the 'stupendous rent' sundering the town at its heart, and he was equally excited by Ronda's command of 'an extraordinary view of the amphitheatre of mountains by which it is surrounded.' [81] It was an ideal location for an artist wanting to define nature's fundamental dynamism, and the images he produced there are more turbulent by far than the sedate vision of Ronda presented by earlier British artists like David Roberts and William Strang.[82] Even Paul Nash's 1934 watercolour of 'Moorish Ruin, Ronda' is less mysterious and compelling than the seismic paintings Bomberg was driven to execute only a year later.[83] Despite the hardship of life in a 'primitive Catholic community' [84] where friendships with the local people were hard to make, and where children often stoned Bomberg and his family as they set off on donkeys for a painting site, he produced a substantial body of work which extended and improved on the paintings executed at Cuenca.

Some of his Ronda canvases employ a greater amount of impasto than before. It imparts an emblazoned richness to the elaborate view of the town on its glowing plateau which Bomberg painted on 'a mountain ledge three miles from Ronda across the valley' [85] (cat.126). Here his veneration of Cézanne is at its most overt, for the underlying structure of town and rock is stressed with every thrust and swerve of his brush. But this magisterial panorama is unusual among the Ronda oils for its relatively high finish and attention to detail. Most of the time, he favoured a more summary and untrammelled approach, so that the thickness of pigment in 'Ronda: In the Gorge of the Tajo' (cat.128, pl.38) takes on more of a life of its own. Although still allied to Bomberg's momentous encounter with the motif, the handling in this superb painting is characterised by a quite personal deployment of tumultuous mark-making and a readiness to emphasize the material substance of pigment more insistently than ever.

As he became familiar with his new surroundings, and scrutinised them at various times of the day and night, so Bomberg set greater store by swiftness of execution. According to Dinora,[86] his normal way of working led him to study the location for a long time after his easel had been set up. Hours would sometimes pass before he felt that the process of absorption was complete, but once the moment for action had arrived he would go to work with prodigious speed and certitude. Hence the breadth of execution and brusquely simplified organisation evident in a canvas like 'Sunset, Ronda, Andalucia' (cat.127, pl.37), where the weight, density and texture of the shadowy rockface have been grasped with an almost tactile completeness. The sense of touch had been important to Bomberg ever since the Slade days, when he respected Berenson's insistence on 'tactile values' and pondered on Fothergill's declaration that 'all drawing of forms that merely reproduces the image of the retina, and leaves unconsulted the ideas of touch, is incomplete and primitive.' [87] At Ronda, Bomberg finally learned how to convey his subjective experience of mass in all its fullness.

The stay was made even more memorable by the birth of Bomberg's only child, Diana. But the joy of fatherhood in his mid-forties could not alleviate the perennial problem of money, and the family's decision to leave Ronda was precipitated by an inability to pay the

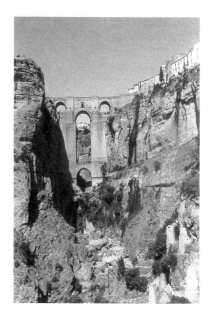

Leslie Marr. Photograph of Ronda, with the bridge spanning the ravine, c.1959. *Mr and Mrs Leslie Marr, Scotland.*

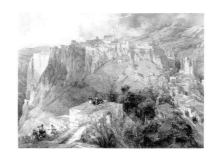

David Roberts, 'Ronda', 1834 Watercolour on paper 9¼ × 13 (23.5 × 33) *Tate Gallery.*

David Bomberg, 'Ronda' 1935 (cat.121)

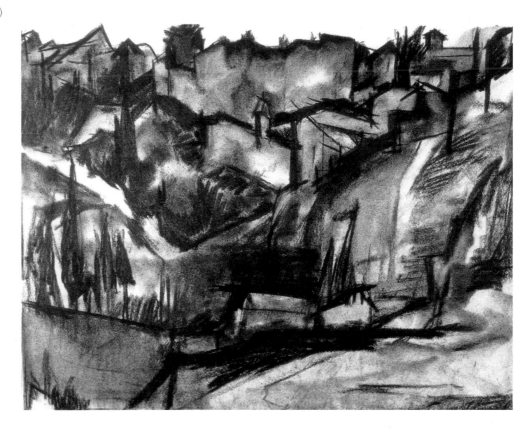

rent for their rudimentary house. They moved north once more, heading for the Asturian Mountains where Bomberg doubtless expected to be challenged by scenery more rugged and epic in its immensity than Ronda could provide. He was not disappointed. High above the valley of La Hermida, where they lodged in a farmhouse at the tiny settlement of Linares, the landscape yielded intoxicating possibilities for the painter bold enough to measure himself against them. With Turnerian relish, he braved thunderous conditions in order to turn the flux of 'Storm over Peñarrubia' (cat.130, pl.39) into an image which combines transience and monumentality in equal measure. He extended his palette by catching the variegated hues of the sky in 'Sunrise in the Mountains' (cat.131, pl.40); while in the largest and most satisfying of the Asturian paintings, he caught the dramatically contrasted play of light in the 'Valley of La Hermida' itself (cat.132, pl.41). Here, in a canvas that brings his Spanish period to a climax, he managed to stress the landscape's craggy grandeur even as he quickened it with a darting consciousness of the sudden transformation wrought by the sun's shafts as they ignite one side of the valley with their flaring radiance.

If Bomberg had been able to stay in the Asturian Mountains, and further enrich the pictorial discoveries he had made during his Spanish year, he would probably have sustained the momentum established here well enough to escape the unproductive despondency of his life in the late 1930s. But the onset of internal dissension in Spain became so alarming that the family hurried down to Santander in time to catch a boat for England just before the Civil War broke out. Back in London, Bomberg found great difficulty in recovering the sureness of purpose he had enjoyed in Spain, and an exhibition of his recent work at the Cooling

Galleries in June 1936 was treated with disdain by most critics. Like his previous one-man show at Bloomsbury Gallery four years earlier, it was largely ignored by the reviewers. Worse still, none of the pictures on view there found a buyer during the exhibition.[88] The gallery's perplexed proprietor told Lilian that 'he'd never had an exhibition which didn't sell anything before',[89] and Bomberg was forced to realise that his dwindling reputation had now reached a wretchedly low level.

Why was he ignored with such humiliating consistency? Part of the answer to this complex problem can be found in the undaunted independence with which Bomberg pursued his own concerns. He belonged to no group or movement, had few friends among his contemporaries, spent long periods away from home and persisted in developing a form of painting which lay far outside the mainstream of contemporary British art. Shunned by the Royal Academy, which wanted nothing to do with an artist whose 'aims and ideals' were 'expressed in often revolutionary terms',[90] he fared no better with the avant-garde of the 1930s. At a time when fashionable innovation centred either on Surrealism or Abstraction at its most cool and refined, Bomberg's Jewish fervency seemed anomalous and even irrelevant. Moreover, the notorious reticence of English taste shied away from anything that smacked of embarrassing emotionalism. For many decades the German Expressionist tradition found little favour in Britain, and in such a context Bomberg's growing commitment to an impassioned vision of the world was bound to find no favour. Andrew Forge has pointed out that, having announced in 1914 that 'my object is the *construction of Pure Form*', Bomberg gradually came to recognize that 'whatever the artist means by form is something that he himself feels subjectively. It was this intuition that separated his work finally from most of his contemporaries. For many painters who had started at the same point and with the same interests had clung to the idea that "pure form" was something that could be realised in a completely impersonal, objective way; and that the less individual, the less particular the approach to it the purer and the more exact its realization.' In such a climate, Bomberg's mature perception of form as 'the artist's *consciousness* of mass'[91] appeared unbridled and heretical. 'Although I recognize that your work has many qualities', Kenneth Clark wrote to him in 1937, 'it does not appeal to me very strongly and I would not be acting sincerely if I were to buy it.'[92] The rest of London's most influential curators, critics and collectors agreed with the Director of the National Gallery, and Bomberg found himself consigned to a limbo from which he never again escaped.

The anti-semitism which harmed Epstein also played a part in the hostility Bomberg experienced during the 1930s, and he did his best to persuade his fellow-members of the London Group that Fascism should be fought wherever it flourished. The Spanish Civil War was the focus of his concern in this respect, and he proposed that the London Group 'be prohibited from exhibiting with reactionary groups; that the London Group . . . consolidate with the AIA and Surrealist Groups in their support of Anti-Fascism in politics and art; that funds be granted for Spanish Medical Aid; and that Honorary Membership in the London Group . . . be extended to certain left-wing poets and writers.'[93] But the Spanish tragedy, which he so keenly abhorred, contributed to a darkening of Bomberg's mood. Although the family portraits he executed in 1937 of Lilian, Dinora and the baby Diana are at once tender and resilient (cats.134, 138–9), a sequence of self-portraits reveals deep introspection. One of them, a strange amalgam of two faces in a single head, appears to explore some irreconcile-

David Bomberg, 'Dinora' 1937 (cat.138)

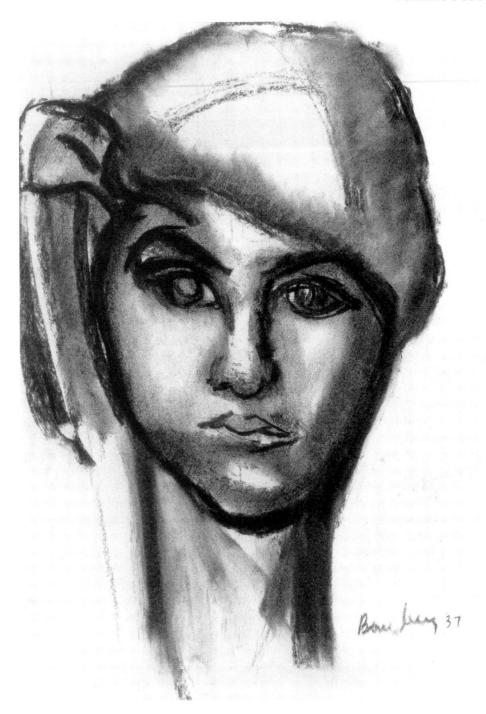

able psychic division, while the finest in the series presents Bomberg as a phantom-like figure confronting the inevitability of dissolution (cats.137,135, pl.43).

Their overt strain of melancholy helps to account for his inability to paint over the next few years. Besieged by fits of depression, Bomberg lapsed into silence as an artist while the turmoil in Europe grew ever more uncontrollable. But the advent of another world war was responsible, eventually, for releasing him from this affliction. It reinforced a belief he had first expressed in a letter to Kenneth Clark in February 1937, urging that the British government

should adopt a programme of financial aid for artists similar to Roosevelt's Federal Art Scheme. Clark agreed, without holding out any hope for the implementation of such a plan in Britain,[94] and yet two years later the declaration of war against Hitler suddenly provided him with the opportunity he desired. The War Artists' Advisory Committee was formed under his chairmanship, armed with substantial funds to facilitate 'the employment of artists to record the war.'[95] Bomberg was quick to offer his services, having already declared in a letter to *The Times* that 'in a war fought for freedom and progressive culture, the artist surely has a vital role to play.'[96] He was, however, turned down, and his second application in July 1940 met with the same response. While many painters of less ability received plentiful commissions, presumably because they satisfied the government's desire to document the war as accurately as possible, Bomberg was obliged to apply for menial jobs with firms like Smith's Motor Accessories Works in Cricklewood.[97]

Eventually, in February 1942, his frustration had become intolerable enough for him to write a desperate letter to Clark's committee, delivering the warning that 'if I am forced out of my profession into either destitution or acceptance of dilutee labour . . . the responsibility for this must rest with the Artists Advisory Committee in general & my professional Colleagues on that Committee in particular.'[98] The protest was aimed specifically at his erstwhile ally Muirhead Bone, a member of the committee, and this time Bomberg's outcry elicited a reluctant response. He was awarded a small commission to 'make a painting of an underground bomb store for a fee of 25 guineas',[99] a subject possibly chosen because Bone remembered the subterranean context of his 'Sappers at Work' canvases of 1918–19. So in early April 1942, amidst security so tight that he was not even allowed to tell Lilian where he was going, Bomberg took the train to Burton-on-Trent. Then the Adjutant drove him to RAF Fauld at Tutbury, where the disued gypsum mines had been converted into eerie storage-chambers capable of holding ten thousand tons of high-explosive bombs. Photographs of this weird and unsettling locale were later sent to Bomberg, and they show just how macabre it must have been. The men responsible for supervising the lethal weaponry seem unconcerned as they methodically check each of the armaments in their care, but Bomberg's reaction to the missiles was filled with foreboding. He later told his son-in-law Leslie Marr that he was 'frightened at the possibility of bombs exploding while he was working there. He said that he often asked the men, "Are they fused?", "Are they safe?", "Will they go off?" '.[100]

Although the committee would have liked Bomberg to produce a painting that emphasized the growing invincibility of Britain's armoury, he could not comply with such an expectation. Bent on imaginative truth rather than propaganda, he spent his fortnight in the mines making image after image of a store riven by the explosive power of the bombs it contains (cats.144–150, pls.44,45). Working on paper after his meagre supply of canvas ran out, he returned again and again to the destructive potential of the caves' cargo. The urgency with which Bomberg brushed in this disquieting vision suggests that the site reawoke traumatic memories of the First World War, and he was determined to incorporate in the commissioned picture his awareness of the twentieth century's capacity to inflict unprecedented devastation on the world.

The brushwork in these wildly handled paintings possesses a fiercer character than anything he had attempted before. It sweeps, twists and stabs through the interstices of the

Photograph of men examining and stacking 500lb bombs in the bomb store, RAF Fauld, January 1942. *Central Press Photos, London/Artist's Family.*

mines, ensuring that bombstacks and roof-pillars alike are caught up in the feverish rhythm of Bomberg's forceful mark-making. Rather than contenting himself with anodyne pictures of the deceptively quiescent missiles slumbering in their shelters, he saw them as agents of death waiting for the opportunity to wreak titanic havoc on German cities. Such a vision could not be contained within the boundaries of one modest canvas, and after the long years of creative nullity he was unwilling to prevent his newly-released energies from driving him towards a far grander aim. At the end of April he submitted two paintings and four drawings along with his commissioned picture, explaining in a letter that 'the Visit was a thrilling one', and asking for funds to execute 'a great Memorial Panel' of the bomb store as well.[101]

To his chagrin, the committee rejected the proposal outright. Its members did not even accept the commissioned painting, preferring instead to take three of the drawings he had sent in (cats.142–3). Refusing to believe that their verdict was final, Bomberg continued working on large studies for the big picture he regarded as the culmination of his bomb-store experiences. 'I have in view a panel 10 × 12 feet constructed on imaginative groupings expressing the purpose of the whole rather than simple sections', he wrote to the committee in June, adding that 'the theme would be action that goes with an urgent issue.'[102] It was bigger by far than anything he had produced since the Great War, and two substantial oil-on-paper images afford a vivid idea of his plans for the 'Memorial' painting. The most complete of the pair is dominated by a stockpile of bombs, handled with an electric vitality which stresses motion rather than a reassuring stasis (cat.151, pl.46). They seem to be on the point of revolving, like catherine wheels about to discharge their force into the surrounding darkness. Indeed, the cataclysm implied in their incipient movement reaches its fulfilment at the top of this disturbing image, where Bomberg's pigment flares into an inflammatory blaze. The explosion appears to have begun within the store, and in his second painting (cat.152) the figures who are introduced to the scene lunge and heave in an arena permeated with uncanny suggestions of a ruined mine laid waste by some fearful blast.

If the committee's members had ever seen these studies, they would have dismissed them as the outpourings of a man whose imagination had become unjustifiably apocalyptic. After all, the bomb-store pictures present a space as contradictory and threatening as the nightmarish interiors of Piranesi's 'Carceri' etchings, which Bomberg copied around this time.[103] But the fact is that his intimations of disaster were borne out in the very place which had inspired his work. On 27 November 1944, long after he finally gave up hope of securing the funds to realise his Memorial Panel, the bomb store at Burton-on-Trent was devastated by the largest explosion ever recorded in Britain. The detonation of one bomb precipitated a terrifying chain reaction which caused 3,500 tons of high-explosive bombs to blow up, killing nearly seventy people and two hundred cattle in the nearby fields. One farm was obliterated, and the villages of Hanbury and Tutbury were so badly damaged that they suffered a complete breakdown in public services. In Geneva and Rome the tremor caused by the blast was severe enough to be registered as an earthquake.[104] The calamity was probably accidental in origin, the direct result of hiring unskilled supplementary labour when the acceleration of allied bombing raids stretched the bomb store's capacity to breaking-point. Ironically enough, news of the tragedy was hushed up so well that Bomberg never heard about it. But if he had travelled up to see the site after the explosion, the stripped and desolate terrain would have reminded him of the crater-filled battleground of the First

Photograph of the bomb-store site after the explosion, November 1944.
Private Collection.

World War. Above all, though, the disaster revealed the singular prescience of the paintings he had made in the ill-fated depot, and they still retain their unnerving power to warn of the dangers inherent in any accumulation of mass-destructive armaments today.

Between 1939 and 1944 Bomberg made unsuccessful applications for over three hundred teaching-posts, in the vain belief that he should not have to expend his energies in a job wholly unrelated to his work as an artist. During this dark period, when his rejection by the War Artists' Advisory Committee continued to rankle, Lilian tried to restore his spirits by purchasing some flowers and bringing them to their home in Queens Gate Mews. After a few days she suggested that he paint them, and once the notion took hold Bomberg eagerly obtained more and more flowers in early-morning visits to Covent Garden. The outcome was a group of paintings which rejoiced in the exuberance of the blooms and leaves thrusting their impetuous way out of vases scarcely able to contain them (cats.153–4, pls.47,48). Just as he had discovered the animism informing the Spanish landscape, so he now revelled in the vivacity of petals and stalks that threaten to burst the confines of the picture-frame. While he savoured their surging growth, however, Bomberg invested many of the flower paintings with another dimension as well. They explode from their vases with a vehemence reminiscent of the bomb-blasts so familiar to anyone living in London during the years of Hitler's blitz.

The flower paintings offered Bomberg the stimulus he needed to cope with the rejection which continued to thwart him at every turn. Seven years had passed since his last one-man show, and the only exhibition he now managed to stage of his own work was a modest survey of the 'Imaginative Compositions' at the Leger Gallery. It passed without comment, and in 1944 an especially cruel rebuff was delivered when the Central Institute of Art and Design organised from its headquarters at the National Gallery a major survey of modern British art in the United States. Unable to believe he had been excluded from an exhibition which selected a hundred painters and over twenty sculptors and engravers from a list of five thousand names, Bomberg wrote to the Institute's Secretary for clarification. His reply confirmed Bomberg's omission, declared that it was 'the best selection' the committee could make, and concluded: 'I am sorry you feel hurt about it.' [105] Bomberg reacted with sardonic speed. 'You make me laugh', he wrote by return of post. 'It's not a question of hurt – it is of merit. If you don't think I come within the first hundred – I do.' [106]

There was little point in beating against such imperturbable indifference, and Bomberg was better employed when he concentrated on drawing and painting the blitzed cityscape of London. He reduced his draughtsmanship to its most skeletal in order to convey the gutted, sooty wreckage of a metropolis battered almost beyond recognition by Nazi bombing-raids. Charcoal was the ideal medium for the purpose, and 'Evening in the City of London' (cat.158) evokes the charred desolation of an area reduced to little more than a gaping framework of burned-out structures interspersed with levelled plots. The melancholy of this gaunt panorama is nevertheless offset by the triumphant mass of St Paul's on the horizon, and in his painting of the same view Bomberg ensures that Wren's spire rises to the very top of the composition (cat.159, pl.50). The cathedral's miraculous survival became a symbol of Britain's resilience to many painters, writers and photographers of the period. Bomberg shared their vision, and the sight of St Paul's presiding intact over a wounded city still glowing in the aftermath of Luftwaffe bombs gives his painting a redemptive significance.

David Bomberg, 'Evening in the City of London' 1944 (cat.158)

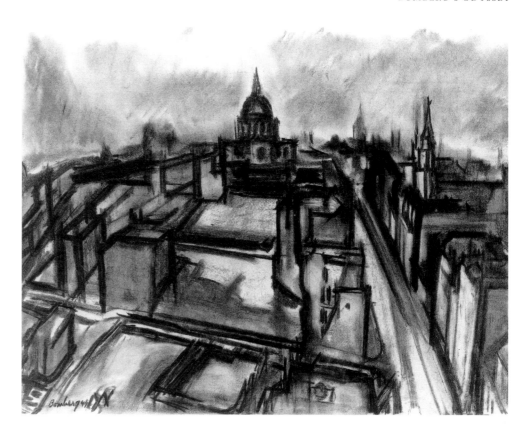

But the building may have sustained the beleaguered artist on a personal level too, embodying a defiant will to survive in the teeth of the most overwhelming adversity. 'Evening in the City of London' certainly earned him some rare praise when he placed it on view in the 1944 London Group show. After telling Lilian that 'as usual the effort was made to put my paintings anywhere but on the walls,' he reported that 'Ivon Hitchens came up to tell me it was the only painters painting of bombed London he had seen.' [107]

As the war gave signs of nearing its end, Bomberg managed at last to secure a toehold in the teaching profession. The Bartlett School of Architecture employed him in the autumn of 1945 to lead its students on Saturday drawing expeditions to the Victoria & Albert Museum, St Paul's and Westminster Abbey, where Richard Michelmore recalled Bomberg emphasizing that 'no holds are barred, the end justifies the means, whereas in all the training I had experienced the means justified the end.' [108] He adopted the same approach at Dagenham School of Art, where he taught for a while in 1945 before securing towards the end of the year a part-time post at the Borough Polytechnic. It was something of a miracle that such a sturdily independent man, who always spoke his mind even when his opinions offended the people best placed to offer him their patronage, was tolerated at the Borough at all. Despising the 'low standard' of contemporary art education, he was convinced that 'a great driving force is more necessary now than ever before to get the studentship on to a high cultural level.' [109] He was determined to provide that 'force', despite Lilian's well-founded fears that teaching would take too much of his energy away from his own painting. At the Borough he managed to assemble a group of young men and women who, dissatisfied with

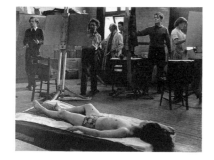

Photograph of Bomberg (centre) with his students at the Borough Polytechnic. *Artist's Family*.

the parochial and excessively timid training on offer in most other British art schools, found Bomberg's example profoundly liberating. Frank Auerbach, who joined the class in 1947 at the age of sixteen, described his teacher as 'probably the most original, stubborn, radical intelligence that was to be found in art schools.' [110]

At the heart of Bomberg's legendary work as a teacher lay his mature conviction that humanity could only be saved by countering the threat of uncontrolled technological advance. Recent experiences in the bomb store had reinforced his previous consciousness of the machine age's limitless capacity for destruction, and he declared that 'with the approach of scientific mechanization and the submerging of individuals we have urgent need of the affirmation of [man's] spiritual significance and his individuality.' [111] Bomberg's concentration on landscape painting since his Palestine years had been motivated by the belief that this 'significance' could best be affirmed through studying the fundamental laws and rhythms of nature. His own move from mechanistic near-abstraction to a more organic understanding of structure was guided by a desire to offset the coldness and sterility of an art alienated from the natural world. Bomberg wanted his work to become ever more attuned to what he described as 'the seasons, the winds, Tides & Ocean Swell',[112] and he summarized his quest by asserting, in a memorable phrase, that 'our search is towards the spirit in the mass.' [113]

Although Bomberg always resisted demands to define exactly what this grand and resonant dictum meant, Dennis Creffield remembered how clear the implications of this phrase became in the classes he attended at the Borough. For him, ' "the spirit in the mass" is that animating principle found in all nature – its living vibrant being – not simply the sheer brute physicality of the object.' [114] The explanation is close to Bomberg's own pronouncements, but he preferred to stress the role played by the artist as well: 'Mass is nothing unless it is the poetry in mankind in contemplation [of] Nature.' [115] Such a preoccupation needed to be accompanied by an emphasis on structural clarity, and Bomberg did not fail to provide it. Having been interested in Bishop Berkeley's ideas ever since his Slade days,[116] he now drew particular attention to Berkeley's 'theory of Optics – proving that impression by sight is two-dimensional – that the sense of Touch and associations of Touch produce on sight the illusion of the third dimension.' [117] Bomberg was adamant that the tactile sense gave vital form and body to the information received by the eyes, helping artists to free themselves from the limits of conventional perception and develop a more intuitive means of encompassing the totality of nature. Ultimately, by 'sensing the magnitude & scope of mass & finding the purposeful entities to contain it in the flat surface',[118] Bomberg knew that he was bringing himself closer to 'God the Creator'.[119] Indeed, he argued that 'the secrets of George Berkeley's philosophy of the metaphysic of mind and matter lay in its divinity, and we could not follow in its footsteps unless we were of that.' [120]

This almost messianic determination, to help save the world from remorseless technological advance, gave Bomberg's classes a seriousness of purpose unmatched in other British art schools of the period. 'The teaching was intense, ruthless, sparing neither criticism nor praise, but always constructive, helpful and very serious', recalled Leslie Marr, who found Bomberg an inspiration after the tedium of his years in the RAF. 'Our classes at the Borough were quite unlike the general run of art classes', Marr explained; 'we did not sit and fiddle with pencils, yawn, and wait for the break and now and then have our drawings corrected. We worked in a charged atmosphere; it was exciting, exhausting, frustrating, occasionally very

rewarding. We participated in a common search, almost a monastic one.' [121] Here Bomberg waged incessant war against what he termed 'corruption in the name of Drawing – the "Hand and eye" disease',[122] and Cliff Holden described the prevailing atmosphere in the white-tiled room on the top floor of the polytechnic building as 'a sort of battle between a trinity of teacher, student and model, a fight which could not take place away from the materials.' All the same, Holden added that 'in this fight he was anything but restrictive',[123] and most of Bomberg's students were enormously stimulated by the teaching of a man who urged that 'the hand works at high tension and organizes as it simplifies, reducing to bare essentials, stripping of all irrelevant matter obstructing the rapidly forming organization which reveals the design. This is the drawing.' [124]

His approach enraged most other art college teachers, who still viewed the work of Picasso and Matisse with enormous suspicion. Roy Oxlade, who has written an admirable account of Bomberg at the Borough, remembered 'being warned at my own art school, Bromley College of Art, that I was trying to run before I could walk' [125] by attending Bomberg's classes. But students like Auerbach remained loyal, respecting a teacher who encouraged him to attain something more than a 'trivial success which might lead people away from grasping the form on the level on which the form is grasped in the great works of art of the world. It was those standards and his impatience with anything less that I found stimulating.' [126] So did Auerbach's friend Leon Kossoff, who enlisted at the Borough despite the efforts of his teachers at St Martin's School of Art to prevent him from studying under Bomberg. The inspiration he found there was decisive, for Kossoff maintained that 'although I had painted most of my life, it was through my contact with Bomberg that I felt I might actually function as a painter. Coming to Bomberg's class was like coming home.' [127]

The very real danger of devoting too much of his time to the Borough students was only averted, in the early years of teaching, by painting expeditions every summer. The three trips Bomberg undertook during the later 1940s, to Devon, Cornwall and Cyprus, enabled him to achieve a progressively deeper and more impassioned rapport with the country locations he favoured. In Devon, he found a prospect over Bideford Bay from Instow which fired him to paint several eloquent images, most notably 'Sunset, Bideford Bay, North Devon' (cat.165, pl.51). Bomberg never liked the overcast English climate, but here he turns it to advantage by recreating the tumultuous, cloud-laden sky with gestural brushwork of great suppleness and immediacy. The vitality of his handling in these canvases prevents them from becoming too melancholy, even though the boat that appears in at least two of the paintings possesses poignant links with the dying fall of Tennyson's 'Crossing the Bar'.[128]

Perhaps the elegiac undertow in the Devon pictures derived partially from Bomberg's awareness that he was painting far less than he would have liked. Little survives from 1946 except the Instow canvases and a few flower paintings (cats.163–4), for his commitment to teaching soon led him to become heavily involved with the group formed by some of the Borough students. Although Cliff Holden was its first President, he made it clear that the Borough Group's members had all 'sought out Bomberg as the only hope of salvation in British painting at the time.' [129] In June 1947 they held their first exhibition at the little-known Archer Gallery, where Holden showed his paintings alongside Christine Kamienieska, Edna Mann, Dorothy Mead, Peter Richmond and Lilian, who had begun

attending the Borough classes with Dinora.[130] Poorly attended and ignored by the reviewers, the show failed to gain any significant measure of respect for a group whose catalogue essay admitted that 'this work is anathema in the eyes of contemporary tonal painters because it does not approximate to the refined surface quality of their own paintings. And in its naked structure we are certain our work would be rejected from [*sic*] any exhibition in England.' [131]

United by their opposition to the prevailing condition of British painting, the Borough Group's members were not unduly disheartened by the exhibition's reception. Bomberg was behind them, after all, and they followed the stoical example he set. 'In spite of neglect he never once, while I knew him, spoke a bitter word about his treatment', wrote Creffield. 'The nearest he came was to quote – "the labourer is worthy of his hire". His emphasis was always on the positive. He held that creativity is the most important human activity – and he made you feel proud to be an artist.' [132] This attitude sustained him throughout his next painting expedition, travelling in 1947 to Cornwall with Lilian, Diana, Dinora, her daughter Juliet and Leslie Marr. They pitched their tent on a propitious coastland site near Zennor, and the ancient bareness of this undefiled setting inspired the most outstanding British landscapes Bomberg ever painted.

Lacking the drama of the ravine-sundered Ronda rockface, the area around the Trendrine farm nevertheless awoke in him a compulsive response. The very first canvas he painted there, 'Trendrine in Sun, Cornwall' (cat.170, pl.53), transmitted the full tactile intensity of Bomberg's desire to project himself into the heart of the landscape. The broad strokes of burning orange pigment are declared more forcibly than ever before as they course down each side of a valley leading to the bay beyond. They act with extraordinary directness as transporters of his wish to reach out and touch the terrain he surveys. The Cornwall Bomberg discovered here is markedly different from the country interpreted by Ben Nicholson at nearby St Ives. In contrast to his exquisite refinement, fusing Cubist severity with the 'primitivism' of Alfred Wallis, paintings like Bomberg's 'Trendrine, Cornwall' [133] (cat.168, pl.52) explore a turbulent locale where the rising ground appears to be pushing up against us with a physical pressure made more vehement by his incendiary colours. Where Nicholson maintains a respectful and understated distance, Bomberg closes on the land like an impetuous lover who grasps, probes and caresses nature with sensual abandon. Nor was he discouraged when the summer heat gave way to a storm. 'Sea, Sunshine and Rain' (cat.171) reveals his Turner-like readiness to expose himself to the volatility of a moment when rain slashes violently across the sky at the same time as the sun still struggles to penetrate the downpour. By holding these conflicting forces in a forthright yet subtle balance, and investing them with the finality of an artist emboldened by greater assurance than hitherto, Bomberg succeeded here in producing an image that fulfils his own definition of a painting as 'the monument to a memorable hour.' [134]

Back in London, the momentum established with such panache during the Cornish summer slowed to a halt. Bomberg became embroiled once more in the increasingly divisive debates about the Borough Group, some of whose members resented the inclusion of his relatives in an exhibition they held at the Hampstead Everyman Cinema in December 1947.[135] After Holden resigned from the presidency Bomberg took his place, establishing the Group on a more formal basis at a meeting in January 1948. Leslie Marr, now a member,

provided permanent hanging space for their work at his bookshop in Newport Court, and in the summer the Group's *Second Annual Exhibition* opened at the Archer Gallery. This time, the reaction was rather more encouraging, and in July the members reached a wider audience when they participated in the London County Council's first open exhibition of paintings at Embankment Gardens. Bomberg liked the idea of showing his work at a free-for-all event attended by 'very many thousands of the public, who do not normally visit Art Exhibitions.' [136] He only regretted that established painters had refused to join in, for he declared in a letter to the *New Statesman* that 'we should have been happy to share our tarpaulins with other artists of renown and distinction had they come out to join us.' [137]

Bomberg's interest in an event which bypassed the conventional network of dealer's galleries was spurred by a continuing inability to stage an exhibition of his own. The small selection of 'Imaginative Compositions' he had displayed at the Leger Gallery in 1943 turned out to be the last one-man show he ever held. No dealer was prepared to take him on, and Bomberg's insistence on speaking his mind with devastating honesty won no friends among those best able to promote his work. Peter Richmond recalled that he 'had an old prophet's virulence about him', and described a visit to Wildenstein's gallery where Bomberg said: ' "Why don't you take this second-rate rubbish off the walls, Mr. Wildenstein? I've got some good young painters you should show." He became so vehement that Wildenstein nearly called the police and threw him out.' [138]

But at least Bomberg could always rely on the support of his family. After an architect recommended Cyprus as an ideal place for Bomberg to paint, Leslie Marr generously offered to pay for the trip.[139] In the event, Marr funded an expedition for the entire family, and the paintings Bomberg produced there amply rewarded his son-in-law's timely patronage. Marr believes that 'Trees and Sun, Cyprus' (cat.177) may have been the first canvas Bomberg completed on the island,[140] and it inaugurates the Cyprus sequence with conspicuous fluency and aplomb. Painted from a high position at Platres, where he set up his easel beneath 'a square of white canvas supported on four poles,' [141] it reveals how Bomberg relayed his tactile sensations by rubbing and prodding with his fingers as well as deploying the brush. The repertoire of exuberant marks conveys his euphoria at finding himself in the intense glare and heat of a summer sun far more potent than anything he had experienced for many years.

Despite problems caused by poor accommodation and illness among the family, he managed to sustain his painting at this exalted level of awareness throughout the expedition. The works executed at St Hilarion, where a ruined fortress on an eminence commanded exceptional views of the sea and sky as well as the richly foliated earth, were very remarkable. He was capable of evoking its immensity on a modest scale in the beautiful 'Sunset, Mount Hilarion' (cat.178, pl.56), a canvas alive with the heightened empathy he enjoyed when contemplating the last flaring animus of the landscape near a day's end. But he was equally able to meet the challenge of the same rugged location during the hours of overwhelming heat. 'Castle Ruins, St Hilarion' (cat.173, pl.54) is carried out on the grand scale, allowing Bomberg's brushstrokes to surge towards the fortress heights with a vigour enhanced by his almost tropical use of colour. The entire painting is caught up in a dithyrambic desire to uncover and identify with the energy raging through the landscape like a wild summer fire.

Even when a calmer mood prevailed, after the family had moved to the monastery of Ay Chrisostomos, Bomberg lost none of his intensity. The most arresting painting he executed there is punctuated by the erect form of an ancient cypress, and its blackness has affected other areas of the composition as well (cat.179, pl.57). But this mood of sobriety is countered both by an affirmative blaze on the red hillside and by a terse vigour of handling, for Bomberg was fortified throughout the Cyprus trip by the exhilarating realisation that his work had become ever more attuned to the 'spirit in the mass' which he valued so profoundly.

It seems difficult to believe that, having reached such a climactic level of achievement in Cyprus, Bomberg could plummet into a creative void on his return. But for the next four years he did not paint at all. Incapable of recovering the vision which had driven him forward during the memorable summer of 1948, and devoting more time than he should to the students he helped with selfless generosity, Bomberg immersed himself in the activities which culminated in the Borough Group's third and final annual exhibition at the Arcade Gallery in March 1949. Ten of his own pictures were included this time, along with forty-eight other exhibits submitted by a membership which now included Creffield. Many years later Creffield wrote that 'I am increasingly amazed and respectful of [Bomberg's] humility in showing his work in company with a group of comparative beginners. I cannot imagine another artist of his age and stature doing so – only Blake or Van Gogh perhaps? It shows his total commitment to his teaching, to his students and to his idea of art – his value of art was greater than the concern for his own reputation.' [142] He certainly did not benefit from the exhibition himself, despite the greater amount of critical attention it received at this Bond Street venue. Wyndham Lewis, in his role as art critic of *The Listener*, confessed his amazement at the fate Bomberg had suffered over the years since the two men knew each other: 'What happened to Bomberg after 1920? Was he one of the lost generation that really got lost? Or has he an aversion to exhibition? He ought to be one of the half-dozen most prominent artists in England.' [143]

Although this estimate of Bomberg's true stature was accurate enough, Lewis's claim would have been greeted with incredulity by most of his readers. Bomberg's name meant little to them, and the events of the next few years did nothing to advance his reputation. In 1950 the Borough Group broke up, after internal divisions became irreparable, and the following year he was omitted from the wide-ranging selection of British artists invited to make work for the Festival of Britain celebrations. He continued to teach with inspirational effect at the Borough where, apart from Auerbach and Kossoff, his students now included Cecil Bailey, Anthony Hatwell, Gustav Metzger, Richard Michelmore, Garth Scott and Roy Oxlade. But as Oxlade pointed out later, 'the requirements of the National Diploma in Design and Bomberg's teaching were totally incompatible, which meant that within the Art School structure of the time his influence was subversive.' [144] It was inevitable, therefore, that he was finally relieved of his position at the Borough in 1953, and an exhibition by the newly-formed Borough Bottega at the Berkeley Galleries near the end of the year did not win its participants much attention.

The Bottega was the last attempt to bring Bomberg's students together as a concerted group, and it reflected his belief that the quattrocento system of apprentice workshops 'proved better than the system of academic training that followed in the 17th Century.' [145]

He saw his Borough teaching in those terms, but the internecine disputes which lay behind the Bottega took their toll on Bomberg's health. Indeed, the foreword he wrote for the catalogue of its exhibition turned out to be the last statement he published on art before leaving England for good. After paying tribute to 'the source at the mountain peak, George Berkeley Bishop of Cloyne and to Paul Cézanne, father of the revolution in painting', he reaffirmed his commitment to an aesthetic that offered a humanist corrective to machine-age alienation: 'Whether the paintings or sculptures of the future are carried out in ferro-concrete, plastic, steel, wire, hydrogen, cosmic rays or helium, and oil paint, stone, bronze, superseded as anachronisms, it is reality that man is yet subject to gravitational forces and still dependent on sustenance from nature and a spiritual consciousness, an individual with individual characteristics to remain so for aeons of time.' [146]

In February 1954, soon after the Bottega exhibition closed, Bomberg left London with Lilian and travelled back to their beloved Ronda. Their decision to make the move was understandable, in view of the productive time they had spent there nearly twenty years before. Bomberg had recently started painting again, having ended the long spell of inactivity when Dinora encouraged him to paint her portrait (cat.180, pl.58). So he naturally hoped that Ronda would engender a late flowering of his own work. The hope would be fulfilled, but Bomberg's other initial aim was frustrated before he and Lilian had a proper chance to settle in part of an old palace on the edge of the town's precipitous cliff-face. Here, in the Villa Paz, they had intended to start a school of painting and drawing which would pursue the principles upheld at the Borough classes.[147] Within months, however, the owners of the Villa had forced them to vacate the premises in favour of some wealthier Spanish tenants, and the school foundered.

The disappointment did at least give Bomberg more time to concentrate on his own work. He benefited hugely from the release, finding in a painting like 'Ronda towards El Barrio, San Francisco' (cat.186, pl.59) a new means of declaring the quite personal character of brushstrokes which act as metaphors of his ever-deepening desire to embrace the land-scape, and identify himself with the life it embodies. However liberated his mark-making may seem, it is always dedicated to attaining a greater understanding of the mysterious process whereby an artist arrives at an enhanced perception of nature's inner rhythms. 'The structure is not presented pat', wrote David Sylvester in a perceptive essay; 'it unravels as the spectator looks at the painting, and he re-lives the process of discovering it. For the painting is not a painting of a structure, but a painting of the discovery of a structure.' [148] As these late Ronda works proceed, moreover, they disclose a poignant awareness of the tension between vibrant energy and evanescence, substance and dissolution. Working now from an isolated, semi-derelict house outside Ronda, situated on a promontory facing the town, the ageing Bomberg became increasingly conscious of transience.

It was expressed most overtly in a series of figure paintings like 'Vigilante' (cat.190, pl.63), where the bodies appear to be shedding their solidity and melting into the light. The faces are often shrouded or visored as they confront the imminence of their own mortality, nowhere more so than in an impassioned canvas where Bomberg allows his own hooded presence to dominate the composition. He called it 'Hear O Israel' (cat.191, pl.64), as if in final acknowledgement of his continuing kinship with the Jewish tradition, and the figure's arms close round a copy of the Torah. The painting's title refers to the words of the Shema, which

Brochure for the School at Villa Paz, Ronda, 1954. *Collection the artist's family.*

Leslie Marr. Photograph of La Casa de la Virgen de la Cabeza, 1959. *Mr and Mrs Leslie Marr.*

should be the first a Jewish child learns and the last a Jew says before he dies. Bowed in introspection, the figure in Bomberg's picture seems burdened by an awareness of death's proximity. But the great flood of light rushing upwards from his right sleeve does carry with it a redemptive force.

Bomberg needed all the reserves he could muster to withstand the difficulties which beset him towards the end of his life. In the autumn of 1956 he received a letter from William Roberts protesting about a Tate Gallery exhibition called *Wyndham Lewis and Vorticism*.[149] Most of the show was devoted to a retrospective survey of Lewis's own work, but in a final section entitled 'Other Vorticists' Bomberg was represented by a single work: the 'Jewish Theatre' drawing he had made during his Slade period (cat.15). It was a derisory misrepresentation of his achievement in the 1914 period, confirming that the British art establishment was not prepared to ascertain and honour what he really had produced during his long career. After attempting to laugh off the news from Roberts, he began drafting a reply which then triggered the desire to write a detailed account of his life. Cast in the form of long letters to *The Times* that were never sent, these rambling documents reveal how obsessive Bomberg had become about rectifying the injustice and distortion perpetrated by the Tate exhibition. It hung over him for many weeks, driving away all thought of continuing to work at his art and pushing him into a severe depression. The isolation of his life at Ronda came to symbolize the marginal position he found himself occupying in the history of modern British painting.

When he did eventually take up his brushes again, the humiliation of the Tate affair was all too evident in a harrowing 'Last Self-Portrait' (cat.192, pl.65). Bomberg's face has been

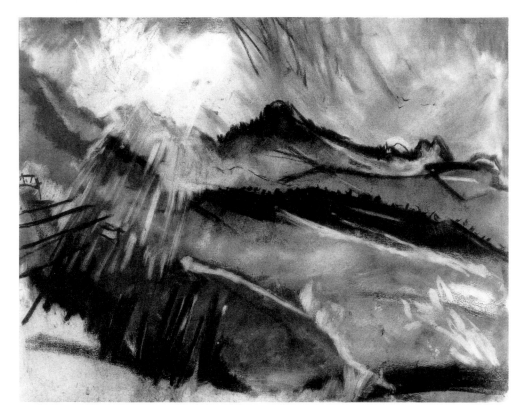

David Bomberg, 'Evening Light, Ronda' 1956 (cat.200)

David Bomberg, 'The Tajo, Ronda'
1956–7 (cat.201)

assailed by a battering so severe that his features are almost impossible to identify. By subjecting himself to this near-obliteration, he conveys more powerfully than any orthodox likeness could the full extent of his despair. But even as he declares this disintegration in the most painful manner imaginable, the pyramidal structure of the body reasserts a determination to continue wielding the brushes clasped so proudly in his hands. They counteract the intimation of death, and so does the light suffusing his shroud-like coat with its affirmative force. Although the man of sorrows exposes his predicament openly enough, he prepares for the end in a blaze of transfiguring radiance.

The same intensity characterizes his last sublime charcoal drawings of the landscape around Ronda. Many of them stress the terrain's starkness, and the gaunt underlying structure of plain and rock is defined by a draughtsman supremely confident of discarding anything that might impede his search for essential form. Ultimately, though, these brooding studies are alive with Bomberg's consciousness of the 'spirit' which prevents them from lapsing into cold, inert matter. Its immanence can be felt even in the darkest of the drawings he carried out at night, where the earth's bareness is alleviated by the refulgence of the moon. 'Evening Light, Ronda' (cat.200) dramatizes the dying sun's ability to burst across shadowy country and transform it with broken strokes of light. Terminal darkness is stubbornly countered, especially in the luminosity pervading 'La Casa de la Virgen de la Cabeza: Night' (cat.203).[150] The land here is given a more subordinate position than before, so that Bomberg can lift his eye above it and allow the softly glowing sky to irradiate the drawing with a visionary beneficence.

Illness finally prevented him from working altogether, and in May 1957 he was

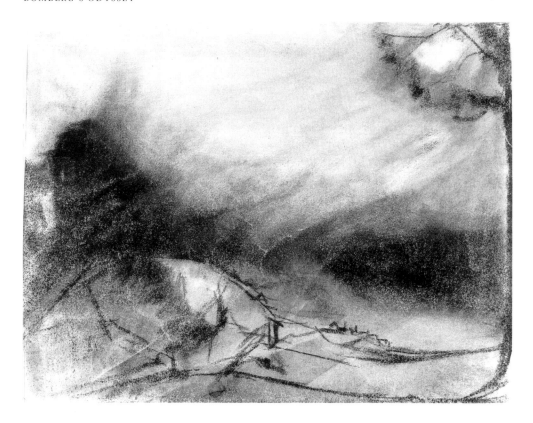

David Bomberg, 'La Casa de la Virgen de la Cabeza: Night' 1956–7 (cat.203)

hurriedly taken to hospital in Gibraltar. Severely weakened, he stayed there for several months and Lilian resolved never to let him resume the old life at Ronda. The aim now was a return to England when he had recovered sufficient strength for the journey. In August the doctors let him go, but after a serious relapse on the boat he was rushed straight to St Thomas's Hospital in London. Two days later he died, and only then did the attempt to grant him recognition begin. The retrospective exhibition he had wanted for so long was staged a year later by the Arts Council.[151] Although it omitted early masterpieces like 'In the Hold' and 'The Mud Bath',[152] and excluded his 'Bomb Store' work entirely, enough was assembled to convince many visitors of Bomberg's achievements. At that point, in 1958, his later work was admired most of all. Then, with the ascendancy of abstract art, the focus shifted to his early achievements. Each generation has focused on the aspect of Bomberg's work which accords most closely with its own interests, and the resurgence of figurative painting in the 1980s has once again prompted a keen awareness of the expressive possibilities opened up by his later works.[153] Now that both Frank Auerbach and Leon Kossoff have been accorded a deservedly high position in contemporary British art, the time seems propitious for a proper understanding of Bomberg's importance.

But it can only be reached by grasping the totality of his work rather than isolated segments. Bomberg's career was uneven, and he came to regret the meticulous style developed during his Palestine years.[154] The apostasy he underwent after arriving in Jerusalem becomes far more comprehensible, however, once the reasons for his disillusionment with the machine age are fully appreciated. The First World War shattered his

vigorous earlier engagement with mechanized civilisation, and during the 1920s he became convinced that humanity was threatened by unchecked technological advance. Discovering an ever more recuperative relationship with nature seemed, for him, the only way to offset the destructive forces which made such rapid progress during his lifetime, and he declared in 1953 that 'we are resolutely committed to the structure of the organic character of mass.' [155] Since those words were written, the dangers he feared have escalated at an even more alarming rate. We are therefore peculiarly well-placed to appreciate why Bomberg took such a complex path in his Odyssey from the 'steel city' to the 'spirit in the mass', overcoming every discouragement in order to follow the stubborn imperatives of his own irrepressible imagination.

NOTES

[1] After 'The Mud Bath' had been displayed in Bomberg's first one–man show at the Chenil Gallery in 1914, it remained in storage until its dramatic reappearance at the 1960 Herbert Art Gallery retrospective in Coventry.

[2] Information kindly supplied to the author by Professor E. Boyland.

[3] Bomberg's retrospective shared the Heffer Gallery's space with a show by the newly–formed Borough Bottega. The exhibition was called *David Bomberg paintings and drawings 1915–1953. The Borough Bottega paintings and drawings by members.*

[4] Roy Oxlade, 'Bomberg and The Borough: An Approach to Drawing', unpublished MA thesis for the Royal College of Art, London, 1976, p.260.

[5] The Tate's 1923 purchases were 'Sleeping Men' (1911, cat.6) and 'Study for "Sappers at Work": A Canadian Tunnelling Company' (Second Version) (1918–19). The artist's wife and family presented a 1943 'Flowers' painting (cat.154) to the Tate in 1952.

[6] David Bomberg to Sir Evan Charteris (draft), 23 July 1937. Tate Gallery Archive. The other three submitted paintings were 'Sierra de Ronda, Andalucia', 'Belfry and Convent, Ronda Spain, Evening', and 'Head of a Man'.

[7] David Fincham to David Bomberg, 29 July 1937. Tate Gallery Archive.

[8] David Bomberg to Siegfried Giedion (draft), 27 July 1953. Tate Gallery Archive.

[9] T. E. Hulme, 'Modern Art.IV. – Mr. David Bomberg's Show', *The New Age,* 9 July 1914.

[10] David Bomberg, unpublished writings, *c.*1956. Tate Gallery Archive.

[11] *Ibid.*

[12] Desmond MacCarthy, 'The Post–Impressionists', introduction to the exhibition catalogue of *Manet and the Post–Impressionists,* Grafton Galleries, London 1910.

[13] The title of MacCarthy's article in *The Listener,* 1 February 1945.

[14] John Fothergill, 'Drawing', *Encyclopaedia Britannica,* London 1910–11, p.555.

[15] Paul Nash, *Outline. An Autobiography and Other Writings,* with a preface by Herbert Read (London 1949) p.92.

[16] Joseph Hone, *The Life of Henry Tonks* (London 1939) p.103.

[17] T. E. Hulme, 'Modern Art.IV', *op. cit.*

[18] Kandinsky's now destroyed 'Composition I' (1910), which he exhibited at the Allied Artists Association in 1910, seems especially close to 'Island of Joy' in subject and organisation alike.

[19] Ezekiel 37: 1–5, 7–10.

[20] For the comparison with Severini, see Wyndham Lewis's essay 'Room III (The Cubist Room)', in the catalogue of *Exhibition by the Camden Town Group and Others,* Public Art Galleries, Brighton, December 1913–January 1914, p.12. Lewis's reference to Picabia occurs in 'A Review of Contemporary Art', *Blast No.2* (London 1915) p.41.

[21] Roger Fry, *The Nation,* 20 July 1912.

[22] David Bomberg, unpublished writings, *c.*1957. Tate Gallery Archive.

[23] According to Bomberg's Slade contemporary Clare Winsten (interview with the author, 10 November 1980), 'he wanted to be a second Michelangelo.'

[24] David Bomberg, unpublished writings, 1953–4. Tate Gallery Archive.

25 Joseph Leftwich, interview with the author, 15 September 1980.

26 See, for example, Gris's 1912 painting 'The Watch'.

27 J. B. Manson, 'Introduction. Rooms I–II', in the catalogue of the *Exhibition by the Camden Town Group and Others, op. cit.,* p.8.

28 *Ibid.,* pp.9–12.

29 'A Jewish Futurist. A Chat with Mr. David Bomberg', *Jewish Chronicle,* 8 May 1914.

30 *Ibid.*

31 Quoted by John Woodeson in *Mark Gertler. Biography of a Painter 1891–1939* (London 1972) p.7.

32 'A Jewish Futurist', *op. cit.*

33 Ezra Pound, 'Wyndham Lewis', *The Egoist,* 15 June 1914.

34 David Bomberg, Foreword to the catalogue of *Works by David Bomberg,* Chenil Gallery, London, July 1914.

35 *Daily Chronicle,* 25 June 1914.

36 Alice Mayes to the author, 17 July 1973.

37 Quoted by A. B. Levy, *East End Story* (London n.d., 1951) p.26.

38 T. E. Hulme, 'Modern Art and Its Philosophy', *Speculations. Essays on Humanism and the Philosophy of Art,* ed. Herbert Read (London 1924) p.97. The essay was based on a lecture Hulme delivered to the Quest Society on 22 January 1914.

39 'A Jewish Futurist', *op. cit.*

40 Alice Mayes, 'The Young Bomberg 1914–1925', unpublished memoir (1972) p.3. Tate Gallery Archive.

41 'David was adamant that he should be "adequately represented"', recalled Alice, 'and demanded that five drawings be included in the publication – or none.' ('The Young Bomberg', *op. cit.,* p.10).

42 *Ibid.,* p.11.

43 Inscribed on the back of an undated war sketch in blue crayon owned by Anthony d'Offay.

44 Isaac Rosenberg to Sydney Schiff, late 1917, quoted by Jean Liddiard, *Isaac Rosenberg: The Half Used Life* (London 1975) p.239.

45 Alice Mayes, 'The Young Bomberg', *op. cit.,* p.21.

46 'The Canadian War Memorials', unsigned Introduction to the catalogue of the *Canadian War Memorials Paintings Exhibition – 1920 – New Series. The Last Phase,* Toronto and Montreal 1920.

47 Harold Watkins to David Bomberg, 29 December 1917. Tate Gallery Archive.

48 Bomberg singled out El Greco for special praise, as an 'inventor' whose art 'curiously coincides with the work of Paul Cézanne', in his lecture on 'Modern Art', 4 March 1922, possibly delivered at the Whitechapel Art Gallery as 'The Modern Feeling in Painting'. He later gave Lilian Bomberg a large colour reproduction of 'Christ Driving the Traders from the Temple' as a birthday present.

49 Alice Mayes, 'The Young Bomberg', *op. cit.,* p.28.

50 P. G. Konody, *The Observer,* 12 February 1928.

51 Alice Mayes, 'The Young Bomberg', *op. cit.,* pp.28–9.

52 Well over a hundred drawings were completed in this series, and Bomberg grouped them under twelve thematic titles: The Visitor, Mother & Child, The Square Floor, Family Group, Ballerina, Bargees, Opera, The Staircase, Men & Women, The Table, Lock–up, and Ostlers.

53 The 'Imaginative Compositions' were first shown at the Bloomsbury Gallery in November 1932, and subsequently at the Leger Gallery in 1943.

54 Sir Ronald Storrs, in *Orientations* (London 1937, p.495), recalled that 'Bomberg, though entirely Jewish, was strongly anti–Zionist'.

55 Leonard Stein to David Bomberg, 28 March 1923. Tate Gallery Archive.

56 Muirhead Bone to Leonard Stein, 4 April 1923.

57 Peter Richmond, interview with the author, 6 August 1985.

58 David Bomberg to S. C. Kaines Smith, 30 August 1928. Birmingham City Art Gallery.

59 P. G. Konody, *The Observer,* 12 February 1928.

60 Sir Ronald Storrs, *Orientations, op. cit.,* p.495.

61 *Ibid.,* p.366.

62 'Petra. Duologue between Mr. David Bomberg and Mrs. Steuart Erskine', unpublished script of proposed talk for BBC Radio, 1928, pp.4–5. Tate Gallery Archive.

63 Alice Bomberg to David Bomberg, 3 November 1926. Tate Gallery Archive.

64 David Bomberg to Alice Bomberg, 23 December 1926. Tate Gallery Archive.

65 David Bomberg to Alice Bomberg, 6 March 1927. Tate Gallery Archive.

66 David Bomberg to Vincent Galloway, 6 December 1932. Ferens Art Gallery, Hull.

67 She had attended Putney Art School and evening classes at the Regent Street Polytechnic.

68 Lilian Bomberg, interview with the author, 10 October 1980.

69 David Bomberg to Lilian Mendelson, 7 September 1929. Tate Gallery Archive.

70 David Bomberg to Lilian Mendelson, 23 September 1929. Tate Gallery Archive.

71 *Ibid.*

72 Josef Herman, 'The Years in Wales, 1944–1953/5 II', *The Scottish Art Review,* vol.XIII, no.4 (1972) pp.11–12.

73 Kitty Newmark, interview with the author, 20 November 1980.

74 Lilian Bomberg, interview with the author, 4 November 1980.

75 James Newmark, interview with the author, 20 November 1980.

76 David Bomberg to Lilian Mendelson, 11 September 1933.

77 *Ibid.*

78 David Bomberg, from writings on 'Art and Society: 1934–1938', Tate Gallery Archive.

79 They were the wool merchant Arthur Crossland, the draper Asa Lingard and the solicitor Wyndham T. Vint.

80 Both Crossland and Lingard contributed £25 each towards the cost of the Ronda trip.

81 David Bomberg, 'The Artist's Note Accompanying the Picture', 16 July 1936, sent with his 1935 'Ronda' painting to the Canadian National Exhibition.

82 David Roberts's large oil version of the subject (*c.*1835, coll. Revd Canon Ivor Walters) is reproduced as plate 42 in the catalogue of *David Roberts*, Barbican Art Gallery, London, November 1986–January 1987. A copy of William Strang's 1913 etching 'Plaza Mayor, Ronda' is owned by Glasgow Art Gallery and Museums.

83 Nash's watercolour is owned by the Graves Art Gallery, Sheffield.

84 Lilian Bomberg, interview with the author, 8 December 1980.

85 David Bomberg, 'The Artist's Note', *op. cit.*

86 Dinora Davies–Rees, in conversation with the author.

87 John Fothergill, 'Drawing', *Encyclopaedia Britannica*, op. cit.

88 Archibald Ziegler informed the *Jewish Chronicle* (25 December 1936) that 'not one single painting was purchased' from Bomberg's Cooling Galleries exhibition.

89 Lilian Bomberg, interview with the author, 22 January 1981.

90 *Manchester Guardian*, 26 June 1936.

91 Andrew Forge, Introduction to the catalogue of *David Bomberg 1890–1957*, an exhibition held at the Arts Council Gallery, London, autumn 1958, pp.4–5.

92 Kenneth Clark to David Bomberg, 1 December 1937. Tate Gallery Archive.

93 Recorded in the 'Minutes of the Annual General Meeting of the London Group', 12 February 1937, p.2.

94 Kenneth Clark to David Bomberg, 20 February 1937. Tate Gallery Archive.

95 Meirion and Susie Harries, *The War Artists. British Official War Art of the Twentieth Century* (London, 1983) p.159.

96 David Bomberg to the Editor of *The Times* (not published) 20 October 1939. Tate Gallery Archive.

97 Bomberg's application was turned down by Smith's in a letter dated 7 November 1941. Tate Gallery Archive.

98 David Bomberg to E. M. O'Rourke Dickey, 12 February 1942. Imperial War Museum Archives.

99 E. M. O'Rourke Dickey to David Bomberg, 23 February 1942. Imperial War Museum Archives.

100 Leslie Marr to the author, 3 April 1987.

101 David Bomberg to E. M. O'Rourke Dickey, 28 April 1942. Imperial War Museum Archives.

102 David Bomberg to E. M. O'Rourke Dickey, 5 June 1942. Imperial War Museum Archives.

103 Frank Auerbach told the author that Bomberg kept a volume of Piranesi's *Carceri* etchings in the Borough Polytechnic class for students to consult if they wished.

104 For an eye–witness account of the tragedy, see James Major, 'Britain's Biggest Bang! RAF Fauld, Tutbury, Staffs', Harper Adams Magazine, n.d., pp.87–9.

105 T. A. Fennemore to David Bomberg, 22 May 1944. Tate Gallery Archive.

106 David Bomberg to T. A. Fennemore, 23 May 1944. Tate Gallery Archive.

107 David Bomberg to Lilian Bomberg, 13 October 1944. Tate Gallery Archive.

108 Richard Michelmore to William Lipke, quoted in Lipke's *David Bomberg. A Critical Study of his Life and Work* (London 1967) p.89.

109 David Bomberg to the Vice–Chancellor of Durham University, 26 November 1945. Tate Gallery Archive.

110 Frank Auerbach, interview with Catherine Lampert in the catalogue of *Frank Auerbach*, an exhibition held at the Hayward Gallery, London, May–July 1978, p.20.

111 David Bomberg, Foreword to the catalogue of *Exhibition of Drawings and Paintings by the Borough Bottega and L. Marr and D. Scott*, held at the Berkeley Galleries, London, November–December 1953.

112 David Bomberg, unpublished writings, n.d. Tate Gallery Archive.

113 David Bomberg, Preface to the catalogue of the *Third Annual Exhibition of the Borough Group*, held at the Archer Gallery, London, March 1949.

114 Dennis Creffield to the author, 11 April 1985.

115 David Bomberg, unpublished writings, n.d. Tate Gallery Archive.

116 Bomberg remembered that. in his interview with Professor Brown for a place at the Slade, 'we spoke about the Bishop of Cloyne' (unpublished writings, n.d., Tate Gallery Archive); and John Fothergill paid tribute to Berkeley's ideas in his essay on 'The Principles of Teaching Drawing at the Slade School', published in *The Slade* (London 1907).

117 David Bomberg, 'Syllabus. Series of Lectures on Drawing and Painting', 22 May 1937. Tate Gallery Archive.

118 David Bomberg, unpublished writings, n.d. Tate Gallery Archive.

119 *Ibid.*

120 David Bomberg, Foreword to the catalogue of the *Exhibition of Drawings and Paintings by the Borough Bottega*, op. cit.

121 Leslie Marr, quoted by William Lipke, *op. cit.*, p.19.

122 David Bomberg, unpublished writings, n.d. Tate Gallery Archive.

123 Cliff Holden, 'David Bomberg: an artist as teacher', *Studio International* (March 1967).

124 David Bomberg, 'The Bomberg Papers', ed. David Wright and Patrick Swift, *X, A Quarterly Review*, vol.1, no.3 (June 1960).

125 Roy Oxlade, 'Bomberg and The Borough', *op. cit.*, p.25.

126 Frank Auerbach, interview with the author, broadcast on BBC Radio 3, 18 November 1985.

127 Leon Kossoff, interview with the author, 16 January 1981.

128 Lilian Bomberg, in an interview with the author (11 February 1981) revealed that 'Crossing the Bar' had a special meaning for them during the Devon expedition.

129 Cliff Holden, 'David Bomberg: an artist as teacher', *op. cit.*

130 Although Allan Stokes was also included in the catalogue, Dorothy Mead later made clear that 'he was never at any time a member of the group' ('The Borough Group', unpublished memoir, n.d., sent to Lilian Bomberg. Tate Gallery Archive).

131 'Approach to Painting', published in the catalogue of the *Exhibition of Painting by the Borough Group* held at the Archer Gallery, London, 2–28 June 1947.

132 Dennis Creffield to the author, 11 April 1985.

133 According to Lilian Bomberg (interview with the author, 11 February 1981), 'Trendrine, Cornwall' was painted from a place in front of the campsite looking inland towards the hills behind his tent – the opposite view to the one he painted in 'Trendrine in Sun, Cornwall'.

134 David Bomberg, 'Reflections on Art and Artists', n.d., quoted in William Lipke, *David Bomberg, op. cit.*, p.126.

135 It was not an official Borough Group exhibition.

136 *Kensington News*, 18 March 1949.

137 David Bomberg to the Editor of the *New Statesman*, 10 July 1948.

138 Peter Richmond, interview with the author, 6 August 1985.

139 Leslie Marr to the author, 3 April 1987.

140 *Ibid.*

141 *Ibid.*

142 Dennis Creffield to the author, 11 April 1985.

143 Wyndham Lewis, 'Round the London Galleries', *The Listener* (10 March 1949).

144 Roy Oxlade, 'Bomberg and The Borough', *op. cit.*, p.170.

145 David Bomberg, Foreword to the catalogue of *Exhibition of Drawings and Paintings by the Borough Bottega, op. cit.*

146 *Ibid.*

147 In the brochure they issued in 1954, the school was described as 'Borough Bottega de Londres en Ronda Andalucia Spain' (Tate Gallery Archive).

148 David Sylvester, 'The Discovery of a Structure', *David Bomberg 1890–1957,* catalogue of the exhibition held at the Tate Gallery, March–April 1967, p.10.

149 The Tate Gallery's *Wyndham Lewis and Vorticism* exhibition was held in July–August 1956.

150 Lilian Bomberg always regarded 'La Casa de la Virgen de la Cabeza: Night' as 'the culmination of the set of last drawings' (interview with the author, 13 March 1981).

151 The Arts Council exhibition contained 49 oil paintings and 22 watercolours and drawings.

152 The only pre–1919 painting in the exhibition was 'Ju–Jitsu'.

153 The Whitechapel Art Gallery held a very well–timed exhibition of *David Bomberg. The Later Years* in September–October 1979.

154 Lilian Bomberg remembered him exclaiming, in a moment of anger after the 1928 Leicester Galleries exhibition, that he had fallen into the trap in Jerusalem of 'painting picture postcards for government officials' (interview with the author, 29 September 1980).

155 David Bomberg, Foreword to the catalogue of *Exhibition of Drawings and Paintings by The Borough Bottega, op. cit.*

Chronology

All documents now in the possession of the Tate Gallery Archive are from the David Bomberg Archive TGA 878 generously donated in May 1987 by Mrs Dinora Davies-Rees and her daughter Mrs Juliet Lamont.

1890

5 DECEMBER Born in Birmingham, where the Bomberg family lived at 18 Florence Street. David was the fifth child of a Polish immigrant leather-worker, Abraham Bomberg, and his wife Rebecca.

1895

Family moves to the Whitechapel area of London, where they live first at Brushfield Street and then at 20 Tenter Buildings, St Mark Street. Bomberg remains there, and later paints in his own adjoining studio, until 1913.

c.1906–7

Apprenticed to the German immigrant lithographer Paul Fischer at Islington. Studies at Walter Bayes's evening classes at the City and Guilds evening classes. Meets Ossip Zadkine. Visits New English Art Club exhibitions.

1907

John Singer Sargent introduces himself while Bomberg is drawing in the Victoria & Albert Museum. He befriends Bomberg, asks him to pose as a model, and introduces the young artist to Solomon J. Solomon, RA.

1908

Breaks his indentures with Fischer in order to pursue a career as an artist.

1908–10

Attends W. R. Lethaby's evening classes in book production and lithography at the Central School of Arts and Crafts, and Sickert's evening classes at the Westminster School.

1910

NOVEMBER Visits Roger Fry's *Manet and the Post-Impressionists* exhibition at the Grafton Galleries, where he sees Cézanne's work for the first time.

Photograph of Abraham and Rebecca Bomberg with two of their younger children, *c*.1905. *Artist's Family.*

Tenter Buildings (on left) in St Mark Street, Whitechapel, *c*.1926. *GLC Photograph Library.*

1911

APRIL Enters Slade School of Art with the aid of a loan from The Jewish Education Aid Society. Taught by Fred Brown and Henry Tonks, he is also stimulated by an exceptional generation of fellow-students including Isaac Rosenberg, Stanley Spencer, Paul Nash, William Roberts, Edward Wadsworth and Mark Gertler (p.13). Wins several awards, among them a Certificate of Drawing in 1912.

1912

OCTOBER Bomberg's mother Rebecca dies at the age of 48.

DECEMBER Wyndham Lewis visits his Tenter Buildings studio, thereby acknowledging Bomberg's promise as an innovative young painter.

1913

JANUARY Exhibits three works with the 'Friday Club' at the Alpine Gallery.

MAY—JUNE Visits Paris with Jacob Epstein, in order to select work for an exhibition of *Twentieth Century Art* at the Whitechapel Art Gallery. Meets Picasso, Derain, Modigliani, Max Jacob and Kisling.

SUMMER Takes a holiday with Isaac Rosenberg at Sandown, Isle of Wight, where the police arrest them briefly for drawing the island's military fortifications.

AUTUMN Short and stormy affiliation with Roger Fry's Omega Workshops.

DECEMBER Exhibits six works in the 'Cubist Room' of *The Camden Town Group and Others*, a major survey of the British avant-garde held at Brighton Art Galleries.

1914

EARLY Moves to 14 Lamb's Conduit Street to stay with his brother Mo and his wife.

FEBRUARY Exhibits two works in the 'Friday Club' show at the Alpine Club Gallery.

MARCH Founder-member of the London Group, in whose first exhibition he shows five works including 'In the Hold' (cat.36). *Poems by John Rodker* published with a 'Dancer' cover by Bomberg.

SPRING Turns down Lewis's invitation to reproduce his work in the first issue of *Blast*. Also refuses to join the Rebel Art Centre, although unites with its members in disassociating themselves from Marinetti and Nevinson's Futurist polemics.

APRIL T. E. Hulme reproduces his drawing 'Chinnereth' in *The New Age* (cat.31).

MAY—JUNE Exhibits five pictures in the Whitechapel Art Gallery's *Twentieth Century Art: A Review of Modern Movements* survey, for which he organizes a Jewish section including Modigliani.

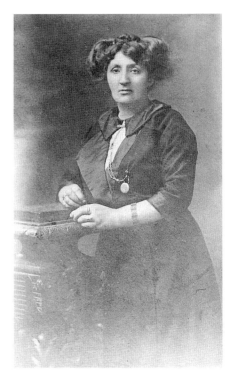

Photograph of Rebecca Bomberg, the artist's mother, *c*.1908. *Artist's Family.*

"Jewish World" photograph.

Mr. David Bomberg, a recognised leader in the futurist movement, has been invited to form a specifically Jewish section at the forthcoming Art Exhibition at the Whitechapel Art Gallery. Above is seen a sample of his work.

Photograph of Bomberg and 'Ju-Jitsu' at about the time of the Whitechapel Art Gallery's *Twentieth Century Art* Exhibition. Reproduced in the *Jewish World*, 18 March 1914, under the headline 'Jews and Cubism'. *Tate Gallery Archive.*

Photograph of Alice Mayes, Bomberg's first wife, c.1923. *Artist's Family.*

JULY First one-man show of 55 works staged at the Chenil Gallery, Chelsea, where 'The Mud Bath' is hung outside the gallery (cat.42). Publishes a militant credo in the catalogue, and T. E. Hulme devotes a long and admiring article to the exhibition in *The New Age*. Augustus John succeeds in selling two of his works to the New York collector John Quinn.

WINTER Moved into an informal artists' commune at Ormonde Terrace, where admires performances of Russian Ballet dancer Maria Wajda. Meets Alice Mayes, soon to become his first wife.

1915

EARLY Moves with Alice to 11 Robert Street, NW1.

JUNE Exhibits six works in the 'Invited To Show' non-members section of the first Vorticist Exhibition, at the Doré Galleries.

SUMMER Displays 'Billet' (cat.53) in the New English Art Club exhibition.

NOVEMBER Enlists in the Royal Engineers, from which he subsequently transfers to the 18th King's Royal Rifles.

1916

MARCH Marries Alice Mayes, who is received into the Jewish faith for the purpose.

JUNE Active service in France.

1917

DECEMBER Receives commission from the Canadian War Memorials Fund for a large painting of 'Sappers at Work', and transferred to a Canadian Regiment near St Eloi (the site of the offensive commemorated in his picture).

1918

Released from active service and continues work on Canadian commission in France. Also executes war drawings (cats.54–8) and writes war poems.

NOVEMBER Returns to England and completes first version of 'Sappers at Work' (cat.61, pl.18), which the Canadian committee rejects.

1919

JULY Completes second version of 'Sappers at Work', which finds favour with the Canadians. Demobilized from the service. The Bomb Shop publishes his *Russian Ballet* booklet, with text and lithographs by Bomberg (cat.63). Declines invitation from his friend the Dutch architect Robert van't Hoff to join De Stijl at Leyden. Visits Paris to meet Picasso and makes unsuccessful attempt to arrange a one-man show there.

SEPTEMBER Stages exhibition of ink-wash drawings (cats.64–7) at Frank Rutter's Adelphi Gallery, a show favourably reviewed by Herbert Read.

NOVEMBER Displays five works at the London Group, the first time he has exhibited there since 1914.

1920–22

Lives with Alice on a farm at Alton, Hampshire.

1920

JANUARY Displays one work at the New English Art Club.

MAY Displays five works at the London Group.

JUNE–JULY Displays one work at the New English Art Club.

1921

One drawing, 'The Exit', reproduced in Wyndham Lewis's new magazine *The Tyro: A Review of the Arts of Painting, Sculpture and Design, No. 1*. Delivers lecture at Brasenose College, Oxford, on 'The Development of Painting'.

1922

Visits Lugano with Alice to stay and paint with Ben and Winifred Nicholson. Delivers lecture at the Whitechapel Art Gallery on 'The Modern Feeling in Painting'.

APRIL Displays four works with the 'Friday Club', and lives at 3 Cleveland Gardens W2 until April 1923.

OCTOBER Displays two works in the London Group, where he is listed as a non-member.

1923

Displays one work in the New English Art Club.

MARCH Holds one-man exhibition at Heal's Mansard Gallery.

APRIL Leaves for Palestine with Alice, on a trip funded by the Keren Hayesod (Palestine Foundation Fund). Settles in Jerusalem and finds enthusiastic patrons among the governing circle of Jerusalem, most notably the Military Governor Sir Ronald Storrs.

1924

APRIL–MAY First trip to Petra.

JUNE–DECEMBER Second trip to Petra, assisted as with the first trip by Sir Ronald Storrs.

1925

Concentrates on painting in and near Jerusalem, apart from a brief and largely unsuccessful expedition to Pioneer Settlements in order to fulfil his obligations to the Zionists and the Keren Hayesod.

1926

Trip to the Monastery of St George, Wadi Kelt, where he produces some outstanding oil studies (cats.92–3). Displays one Palestine painting at the New English Art Club.

1927

MAY–JUNE Displays three works in Whitechapel Art Gallery exhibition of *Jewish Art and Antiquities*.

AUTUMN Returns from Palestine, staying in Paris briefly before settling once again in London. Alice, by now irrevocably estranged, stays in Palestine.

1928

FEBRUARY Holds one-man exhibition of *Paintings of Palestine and Petra* at the Leicester Galleries, with catalogue prefaces by Sir Ronald Storrs and Sir Alexander Kennedy.

MARCH Displays five works in London Group retrospective exhibition, 1914–28.

JUNE Holds one-man show of Palestine and Petra paintings in his own studio, 6 William Street, Knightsbridge.

NOVEMBER Joins Lilian Mendelson and her daughter Dinora in their house at 10 Fordwych Road, NW2.

1929

FEBRUARY Holds one-man show of Palestine and Petra paintings at the Ruskin Gallery, Birmingham. S. C. Kaines-Smith, Director of the Birmingham Art Gallery, writes the catalogue foreword.

AUGUST First trip to Spain, where he settles for a few months in Toledo.

OCTOBER Three works included in the Whitechapel Art Gallery's exhibition of *Contemporary British Art*.

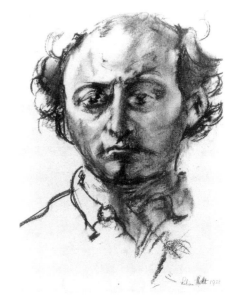

Lilian Holt, 'David Bomberg', 1928 charcoal on paper 15 × 10¾ (38.1 × 27.9). *Reading Museum and Art Gallery*.

Photograph of Lilian Mendelson with her daughter Dinora, 1925. *Artist's Family*.

Photograph of David Bomberg *c.*1930, at
10 Fordwych Road, London NW2.
Artist's Family.

Photograph of (left to right) Bomberg, Jimmy
and Kitty Newmark at Merstham, 4 August
1931. *Artist's Family.*

1930

SPRING Travels to Morocco and the
Greek Islands before returning to London
ill with jaundice. Settles with Lilian at
10 Fordwych Road once again.

1931

Displays five works at the second annual
exhibition of the National Society.
Trip to Derbyshire to paint poster
commissioned by Shell-Mex. The
landscape of 'Cavedale' he submitted was
deemed unsuitable.

1932

FEBRUARY—MARCH Displays five
works in the National Society exhibition.
Six-week painting trip to Scotland and
Derbyshire with Lilian, who from now on
accompanies him on all his painting
expeditions.

JUNE Included in exhibition of
contemporary British art at the Hamburg
Kunstverein.

AUGUST Article on the Petra paintings
published in *The Studio* by Bomberg's
brother-in-law James Newmark.

NOVEMBER Holds one-man show at the
Bloomsbury Gallery of *Sixty Imaginative
Compositions, Spanish and Scottish
Landscapes and Other Work.*

1933

Encouraged by sister Kitty and her
husband James Newmark, both Bomberg
and Lilian join the Communist Party.
Bomberg paints banners for
demonstrations and attends mass
unemployment rallies.

FEBRUARY—MARCH Displays five
works at the National Society exhibition.

JULY—DECEMBER Visits Russia, staying
mainly in Moscow and gradually growing
disillusioned with Communism's effect on
art. On his return to London, he and Lilian
resign from the Communist Party.

1934

FEBRUARY—MARCH Displays five
works at the National Society exhibition.

MAY Leaves for Spain with Lilian, living first at Cuenca.

NOVEMBER Moves south to Ronda in Andalucia.

1935

FEBRUARY–MARCH Displays five recent Spanish landscapes at the National Society.

SPRING Trip to Santander to collect Dinora, joining the family from her boarding-school in London.

MAY Birth of Bomberg's only child, his daughter Diana.

JULY Moves to Linares, a small settlement high in the Asturias Mountains above the valley of La Hermida.

NOVEMBER Onset of civil unrest in Spain forces Bomberg and his family to take boat back to London.

1936

JUNE Holds one-man show of *Recent Paintings of Spain* at Cooling Gallery.

JULY *Ronda* (cat.126) included in a British Council touring exhibition of *Contemporary British Painting* at the National Gallery of Canada.

AUTUMN Painting trip to North Wales.

NOVEMBER Displays two works in the London Group, as a non-member.

1937

Moves with Lilian and the family to 66A Lymington Road, NW6.

JANUARY Holds retrospective exhibition of 25 works with Margarete Hamerschlag and Horace Brodzky at the Foyle Art Gallery.

OCTOBER–NOVEMBER Displays five works in the London Group, where he is once more listed as a member.

NOVEMBER Designs costumes and sets for Co-operative Society production of Handel's *Belshazzar* (cats.140–141), and then abandons project in December after a disagreement over payment.

1938

FEBRUARY–MARCH Displays five works in the National Society.

MAY Abortive scheme to paint in South Africa.

OCTOBER Goes to live in John Rodker's cottage at Strood in Essex, and then moves to Turville Heath, Oxfordshire.

Photograph of David (centre) and Lilian Bomberg on a picnic with Spanish friends near Cuenca, June 1934. *Artist's Family.*

Photograph of Bomberg, with the baby Diana, Ronda, 1935. *Artist's Family.*

NOVEMBER–DECEMBER Displays five works at the London Group.

1939

Lives until 1940 at 17 Greville Place, NW6.

MAY Included in *Mural Painting in Great Britain: 1919–1939*, an exhibition held at the Tate Gallery.

NOVEMBER–DECEMBER Displays three Spanish landscapes in the London Group.

1941

Lives in Edwardes Square, W8 until 1942.

16 SEPTEMBER Marries Lilian.

1942

FEBRUARY Commissioned by War Artists Committee to produce a painting of an underground bomb store for 25 guineas.

APRIL Travels to RAF Fauld, Tutbury, near Burton-on-Trent, where he works for two weeks.

JUNE Commissioned painting rejected by War Artists Committee, who accept three bomb store drawings instead. They also refuse Bomberg's request for a commission to paint a large 'Memorial Panel' based on the bomb store.

OCTOBER–DECEMBER Ordnance survey work in Southampton.

1942–48

Lives at 41 Queen's Gate Mews, SW7.

1943

OCTOBER–NOVEMBER Displays three works at the London Group.

NOVEMBER Holds one-man show of *Imaginative Compositions* (cats.75–9) at the Leger Gallery.

1944

Teaches drawing to gun crews in Hyde Park and afterwards holds various part-time teaching posts at Hammersmith, Battersea and Clapham.

SUMMER Painting expedition to North Wales.

OCTOBER–NOVEMBER Displays three works at the London Group, including *Evening in the City of London* (cat.159).

27 NOVEMBER Bomb store at RAF Fauld blown apart in largest explosion ever recorded in Britain.

DECEMBER Proposed book of blitzed London cityscape drawings (cats.158, 160–162) to be published by John Rodker is not realised.

1945

Obtains part-time teaching post at a school in Dagenham.

1945–9

Teaches drawing one day a week at the Bartlett School of Architecture, London.

1945–53

Teaches drawing at the Borough Polytechnic, London, first one day a week and then for an increasing number of hours until around 1948, when his teaching begins to be reduced. By the end he is teaching evenings only.

1946

JANUARY Bryan Robertson publishes article on Bomberg in *The Studio*.

MARCH–APRIL Displays a Spanish landscape at the London Group.

SUMMER Painting expedition to North Devon.

1947

MAY–JUNE Displays four works at the London Group.

JUNE *Exhibition of Paintings by The Borough Group* held at the Archer Gallery. Foreword to catalogue, 'Approach to Painting', written by Bomberg, who does not exhibit.

AUGUST Six-week painting trip to Cornwall.

1948

JANUARY Cliff Holden resigns from presidency of Borough Group, and Bomberg replaces him. Formal list of Group's members drawn up.

FEBRUARY Leslie Marr provides space at his bookshop, 'The Bookworm' in Newport Court, for permanent exhibition of Borough Group's work.

MAY–JUNE Displays two paintings at the London Group.

JUNE *Second Annual Exhibition* of the Borough Group held at the Archer Gallery, where Bomberg shows with his students for the first time (four paintings and three drawings).

JULY Borough Group exhibits in LCC Embankment exhibition.

JULY–SEPTEMBER Leslie Marr funds family painting expedition to Cyprus. Bomberg is accompanied on the trip by Lilian, Dinora, her husband Leslie Marr, Diana, and Dinora's daughter Juliet.

1948–53

Lives at 12 Rosslyn Hill, NW3.

1949

MARCH *Third Annual Exhibition of the Borough Group* held at the Arcade Gallery, with concise catalogue preface by Bomberg who displays his own work. Wyndham Lewis reviews the show briefly in *The Listener*.

SUMMER Exhibition of pictures by Bomberg and Borough Group at Brasenose College, Oxford.

DECEMBER Displays two paintings at the London Group. Borough Group dissolved around the end of the year.

1951

FEBRUARY Displays two paintings of Cyprus at the London Group.

NOVEMBER Displays two paintings at the London Group.

Photograph of Bomberg at the Borough Polytechnic, 1947–8. *Artist's Family*.

Photograph of (left to right) Dinora Mendelson, Leslie Marr, Dennis Creffield, Dorothy Mead and Cliff Holden at the Borough Polytechnic, *c.*1948. *Artist's Family*.

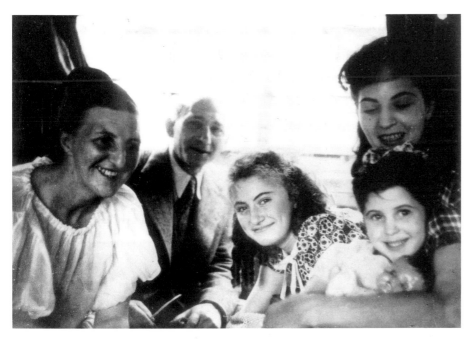

Photograph of (left to right) Lilian, Bomberg, Diana, Dinora and her daughter Juliet in a train travelling to Cyprus, July 1948. *Artist's Family*.

Photograph of Bomberg at Rosslyn Hill, London, *c.*1949. *Artist's Family*.

1952

DECEMBER Included in the Artists International Association exhibition, *The Mirror and the Square*. Displays a portrait and two Spanish landscapes of 1935 at the London Group.

1953–4

Lives at Dinora's house, 30 Steeles Road, NW3, where 'Mother of Venus' painted during temporary rift with Lilian (cat.183).

1953

Formation of the Borough Bottega.

EASTER Visits Paris, Chartres and Vézelay with Lilian, only producing drawings.

NOVEMBER–DECEMBER Exhibition of *Drawings and Paintings by The Borough Bottega and L. Marr and D. Scott* held at the Berkeley Galleries. Substantial catalogue foreword by Bomberg. Displays two or three pictures on Mrs Kemeny's stand at the Building Exhibition, Earl's Court. Displays three paintings at the London Group.

1954–7

Moves with Lilian to Ronda, Andalucia, where they make short-lived attempt to found a School of Painting at the Villa Paz based on Bomberg's teaching principles.

1954

JANUARY–FEBRUARY Borough Bottega exhibition, including Bomberg's work, held at Black Hall, Oxford.

MAY–JUNE Mini-retrospective exhibition of 37 works held with a Borough Bottega show at the Heffer Gallery, Cambridge.

NOVEMBER–DECEMBER Two figure paintings displayed at the London Group.

1955–7

Lives at La Casa de la Virgen de la Cabeza just outside Ronda.

1955

MARCH–APRIL Exhibition of *Paintings, Sculpture and Drawings by members of the Borough Bottega and Invited Guests* at Walker's Galleries. Foreword by Bomberg, who also exhibited.

NOVEMBER–DECEMBER Displays two paintings at the London Group.

1956

APRIL–MAY Displays two works at the London Group.

JULY–AUGUST Tate Gallery stages *Wyndham Lewis and Vorticism* exhibition. Bomberg included in 'Other Vorticists' section with one drawing only, 'Jewish Theatre' (cat.15). After the Tate show closes, William Roberts writes to Bomberg in Spain and urges him to defend his reputation as a major painter of the 1914 period.
After at first declining to comment, Bomberg writes many unsent letters to *The Times* rehearsing the history of his career. He becomes very depressed for some time.

1957

Resigns from the London Group, who immediately make him an Honorary Life Member. Helen Lessore invites him to hold a substantial retrospective exhibition at the Beaux Arts Gallery in 1958.

MAY Becomes seriously ill and is moved to hospital in Gibraltar.

AUGUST Lilian takes him back to England by sea.

17 AUGUST Arrives in London.

19 AUGUST Dies at St Thomas's Hospital, London.

David Bomberg photographed by Harold W. Fisher at 'La Casa de la Virgen de la Cabeza', Ronda, Spain 1956. *Tate Gallery Archive*.

I *The Early Years*

Far from heralding the innovations to come, Bomberg's earliest drawings disclose the extent of his respect for the past. A lost copy of Holbein's *Sir John Godsalve,* a particularly fine portrait drawing preserved in the royal collection at Windsor, convinced his family that his abilities were exceptional. The influence of Holbein can certainly be detected in the candour and finality informing Bomberg's study of his sister Rachel, drawn when he was about fifteen years old (cat.1). The sureness of the draughtsmanship displayed in this careful study, and a freer but equally intent self-portrait (cat.2), also impressed senior artists. Coming across the young Bomberg drawing from sculpture casts in the Victoria & Albert Museum, John Singer Sargent invited him to pose as a model for the Boston Library murals. Sargent then recommended the young man to the influential Royal Academician Solomon J. Solomon, whose avuncular help led, eventually, to Bomberg's place at the Slade.

But before arriving there in April 1911 he had already been exposed to the heady impact of Roger Fry's *Manet and the Post-Impressionists* exhibition. In the watercolour of 'Sleeping Men', executed at the Slade (cat.6), he continues to lean on Renaissance precedent – this time, the recumbent saints in Mantegna's 'The Agony in the Garden' seem particularly pertinent. But the quattrocento is by now fused with Post-Impressionism, for Bomberg's figures are reminiscent of Gauguin as well. Stanley Spencer, one of his student contemporaries at the Slade, shared this interest in reconciling the Renaissance tradition with recent French painting. The advent of Fry's *Second Post-Impressionist Exhibition* in 1912 helped to reinforce Bomberg's enthusiasm for experiment, and his first surviving paintings show how quickly he allied himself with the European avant-garde. 'Bedroom Picture' is still indebted to the example of Sickert, who had taught Bomberg at evening classes in the Westminster Institute before he entered the Slade (cat.5). By the time he painted 'Island of Joy' in the summer of 1912, however, the desire to produce an urban interior worthy of comparison with the Camden Town Group had been replaced by more independent ambitions (cat.9, pl.1). For this large canvas aims at a formal simplification far more severe than anything Sickert would have desired, most notably in the pared-down figures filling the upper area of the composition with their schematic, combative movement.

Although Bomberg continued to produce drawings that earned the approval of Professor Tonks, his principal teacher at the Slade (p.16), he was now committed to a radical path. The animals jerking their way down the course in 'Racehorses' are defiantly removed from naturalistic convention, recalling the brazen assertion in Fry's *Manet and the Post-Impressionists* that 'a good rocking-horse is more like a horse than the snapshot of a Derby winner' (cat.16). But the human body remained the focus of his concerns, and he drew inspiration from the stylised Jewish drama performed at his local Pavilion Theatre in Whitechapel. The heightened gestures deployed on the Pavilion's stage accorded well with his own approach to the figure, nowhere more than in a fervent yet firmly constructed drawing called 'Jewish Theatre' (cat.15). The Old Testament likewise provided him with stimulus, even as he ensured that the style of his work left traditional Biblical illustration far behind. 'Vision of Ezekiel', for all its formal audacity, still adheres to the literary source Bomberg had selected

(cat.13, pl.2). The brittle and angular figures look as if they have just been transformed from the 'dry bones' Ezekiel discovered on the valley floor, and their almost hallucinatory colours vividly convey the moment of revelation which the prophet witnessed.

When Bomberg completed 'Vision of Ezekiel' towards the end of 1912, he already deserved to be ranked among the most adventurous British artists of his generation. He would have identified himself with the most austere and uncompromising work shown in the 'English Section' of Fry's *Second Post-Impressionist Exhibition,* where Clive Bell announced in the catalogue that 'the battle is won. We all agree, now, that any form in which an artist can express himself is legitimate. We have ceased to ask, "What does this picture represent?" and ask instead, "What does it make us feel?" '

While continuing to develop his draughtsmanship at the Slade, Bomberg met Wyndham Lewis, Epstein and other artists whose work explored directions far removed from the interests of Professor Tonks. Stanley Spencer later recalled discussing with Bomberg and Gaudier-Brzeska the relationship between an outstretched arm in a Bomberg painting and a straight line conceived as an abstraction. Moreover, a flurry of exhibitions were held in London at this time of ferment, introducing Bomberg and fellow-students like Wadsworth, Nevinson and Roberts to the Italian Futurists, Picasso, Matisse, Kandinsky and Brancusi. He was able to meet some of these artists during a trip to Paris in the spring of 1913. Their example fortified his determination to pursue the direction he had already defined. Several groups of images, like the sequence of 'Family Bereavement' studies connected with the death of his supportive mother Rebecca, reveal a readiness to explore the same subject in a variety of styles, ranging from the densely elaborate to the most refined and minimal handling of form (cats.25-7). But the small figure paintings Bomberg produced around then are all united by a clear desire to concentrate on what he afterwards described as 'a purist theory of colour, light and form as an integrated organic unity relating to an inherent sense of mass' (cats.17-20, pls.3,4,5). After leaving the Slade in the summer of 1913, he developed these possibilities with extraordinary assurance, inventiveness and verve.

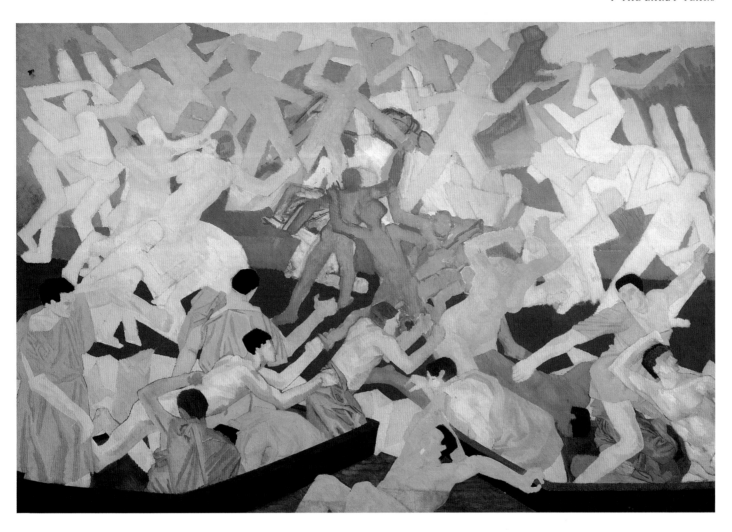

pl.1, cat.9 **Island of Joy** *c*.1912

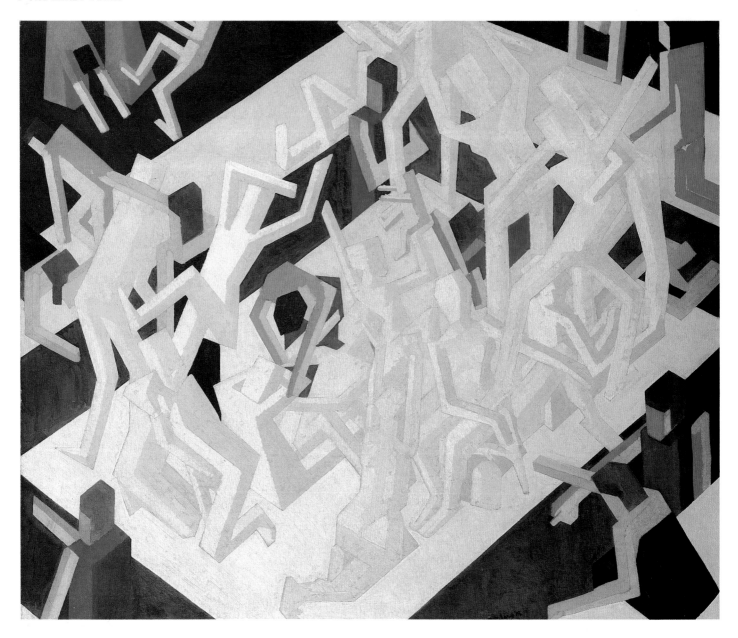

pl.2, cat.13 **Vision of Ezekiel** 1912

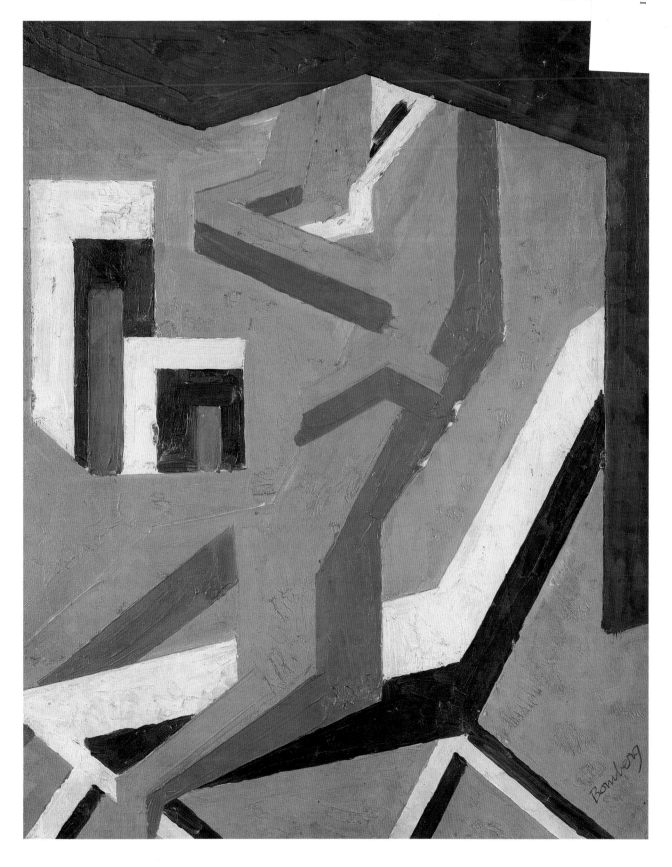

pl.3, cat.17 **Figure Study** *c.*1913

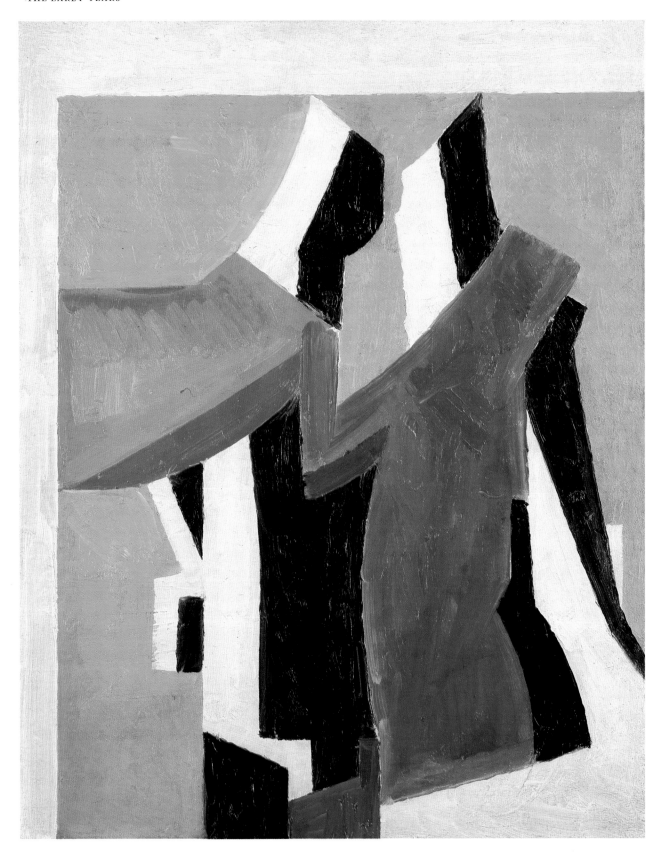

pl.4, cat.18 **Composition with Figures** 1912–13

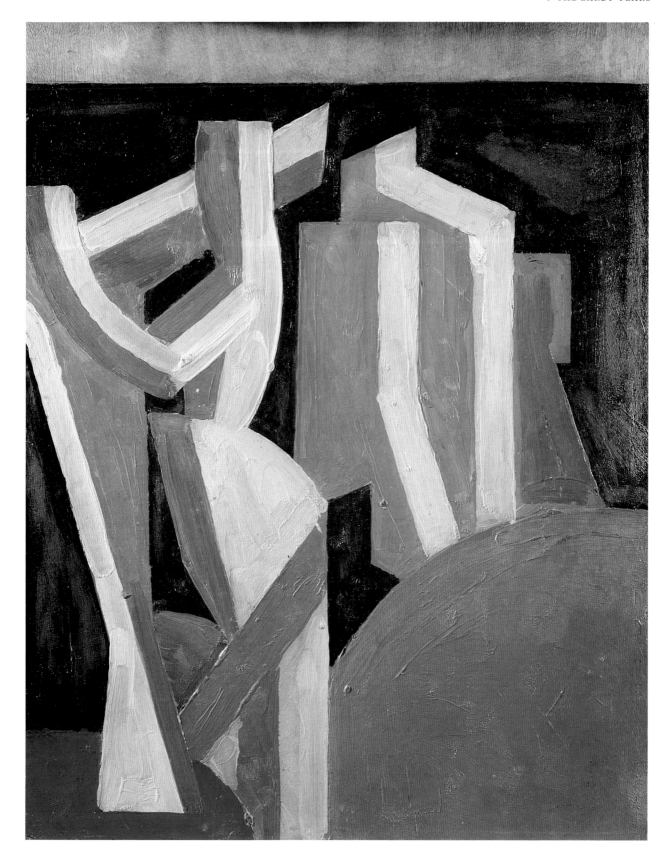

pl.5, cat.19 **Figure Composition** *c*.1913

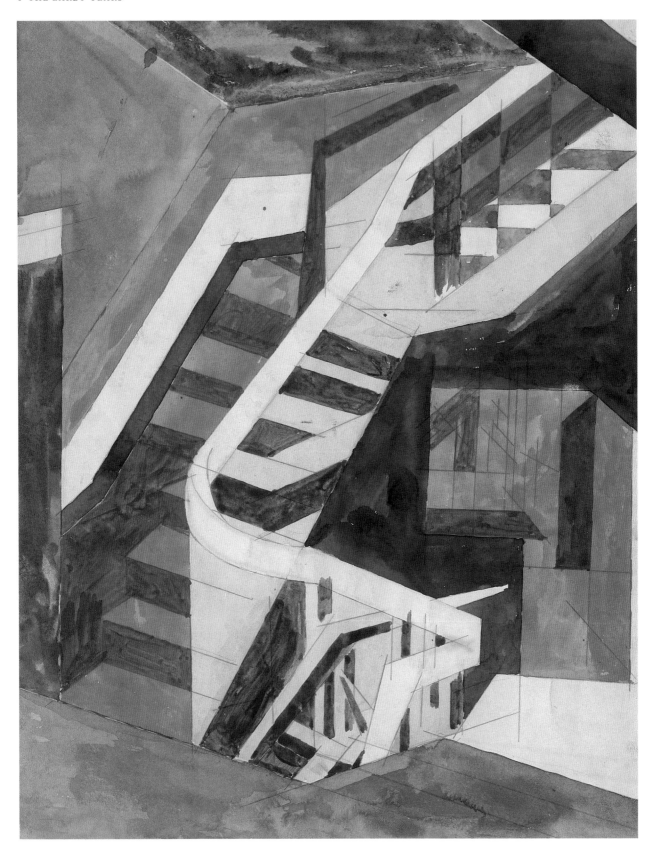

pl.6, cat.22 **Interior** *c.*1913

II The Mud Bath Period

In 'Ju-Jitsu', completed before he left the Slade, Bomberg inaugurated his sequence of paintings based on the modern city (cat.29, pl.7). Each canvas took as its starting-point an aspect of life in the East End, the area of London he knew best. But the locations varied enormously. 'Ju-Jitsu' itself was probably inspired by a gymnasium, and Bomberg took his cue from the stylised movements of the athletes in order to fashion a staccato image where figures and chequerboard squares fight with each other for pictorial supremacy. It is almost as if he imposed the grid on his chosen scene in order to express the contest in his own mind between the rival claims of figuration and abstraction.

With 'In the Hold', finished in time to be displayed at the First London Group exhibition in March 1914, he managed to convey his preoccupation with the urban world on a monumental scale (cat.36, pl.9). The grid this time exerts an even more disruptive influence on the representational subject, so that the figures labouring in the ship can be discerned only with difficulty. Bomberg's exuberance is unmistakeable, however, as he flaunts his belligerent resolve to present the viewer with a new way of seeing. Even as the segmented grid splits up the workers' bodies and the human cargo they carry, its kinetic energy intensifies their physical prowess. The result is a profoundly ambiguous image open to a rich range of interpretations, and it succeeded in establishing Bomberg as a promising new artist at the exhibition. Even Roger Fry, who had recently been in dispute with the young artist at the Omega Workshops, admitted in his review of the show that Bomberg 'has the ambition, the energy and brain power to strike out a line of his own. He is evidently trying with immense energy and concentration to realize a new kind of plasticity. In his colossal patchwork design, there glimmers through a dazzling veil of black squares and triangles the suggestion of large volumes and movements.'

Fry was right to stress Bomberg's independence. Although Wyndham Lewis displayed a 'huge kaleidoscopic design' at the 1914 London Group called 'Christopher Columbus,' which one bewildered critic described as a 'highly coloured tesselated pavement', Bomberg always shied away from an alliance with him. The two men argued over the positions their canvases occupied at the exhibition, and Bomberg was at pains to rebuff Lewis's attempts to enlist him as a member of the emergent Vorticist group. Nor did the Italian Futurists gain his loyalty. He may have owed a debt to Futurism's insistence on a vigorous engagement with mechanised dynamism, and laughingly remarked that 'Futurism is in accordance with Jewish law, for its art resembles nothing in heaven above, the earth beneath, nor the waters under the earth.' But he resisted Marinetti's overtures and refused to become, with Nevinson, a British disciple of the Italian movement. 'Art must proceed by evolution,' Bomberg explained in 1914. 'We must build our new art life of today upon the ruins of the dead art life of yesterday.'

Marinetti was among the visitors who admired the one-man show Bomberg staged at the Chenil Gallery, Chelsea, in July 1914. The fifty-five pictures displayed there amounted to an overwhelming demonstration of his forceful ability to define a singular identity at the forefront of experimental painting. The 'foreword' he published in the Chenil catalogue

could hardly have been more militant, proclaiming that 'I APPEAL to a *Sense of Form*. In some of the work I show in the first room, I completely abandon *Naturalism* and Tradition. I am *searching for an Intenser* expression. In other work in this room, where I use Naturalistic Form, I have *stripped it of all* irrelevant matter.' Bomberg did not hesitate to argue that his machine-age surroundings had shaped the vision he presented with such flair and single-minded confidence at the exhibition. 'I look upon *Nature,* while I live in a *steel city*', he declared, affirming his involvement with the fabric of the modern world rather than with total abstraction. 'Where decoration happens, it is accidental. My object is the *construction of Pure Form*. I hate the colours of the East, the Modern Mediaevalist, and the Fat Man of the Renaissance.'

Although his championship of '*Pure Form*' might seem related to Clive Bell's declaration that 'significant form' was the 'common quality' in all the finest art, Bomberg's engagement with the '*steel city*' separated him completely from Bloomsbury aesthetics. He wanted to place contemporary urban life at the very centre of his work, and 'The Mud Bath' implemented that aim by using as its springboard the activity at a Vapour Baths frequented by the Jewish community of Whitechapel (cat.42, pl.11). The figures who jostle and gesticulate with such knife-edge vitality in this clamorous masterpiece have indeed been shorn of all superfluities. Lean, metallic and fiercely energised, they embody the dynamism of the new mechanised society which the twentieth century promised to engender. The amount of impressive studies Bomberg made for this canvas testifies to the important place it occupied in his pre-war work, and the disposition of each angular component on 'The Mud Bath's surface is calculated with hairsbreadth exactitude.

The love of unfettered movement which gives this painting its exuberance also led Bomberg to study the theme of the dance. His prolonged sequence of 'Dancer' watercolours seems to have originated in his friendship with Sonia Cohen, who danced outdoors on the south coast cliff-tops with Margaret Morris (cats.48-52, pls.15,16). Bomberg followed her down there, and he also became fascinated by the performances of the Russian Ballet dancer Maria Wajda. Diaghilev's company had been admired by young British artists ever since its first triumphant London season in 1911. Bomberg was among its most ardent admirers, and later made a whole sequence of lithographs as a tribute to the Russian Ballet (cat.63, pl.19). In 1914-15, however, he concentrated on watercolours of the dance theme, interpreting the dancers' movements in near-abstract terms. His enthusiasm for Diaghilev's company was shared by Alice Mayes, who danced herself and began to live with him in 1915. The exhilaration of the 'Dancer' series may partially reflect Bomberg's new-found love for the woman who would soon become his wife.

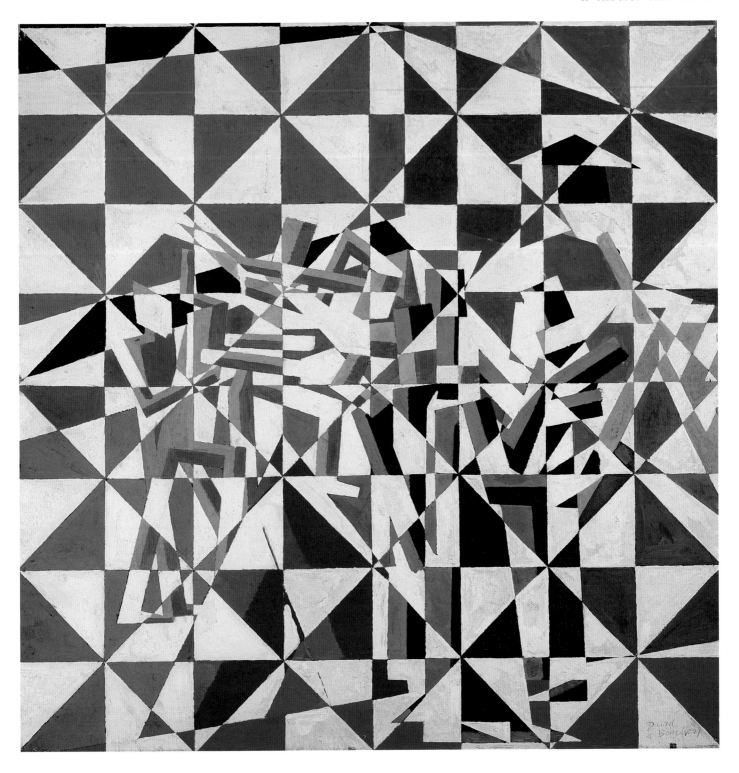

pl.7, cat.29 **Ju-Jitsu** *c.*1913

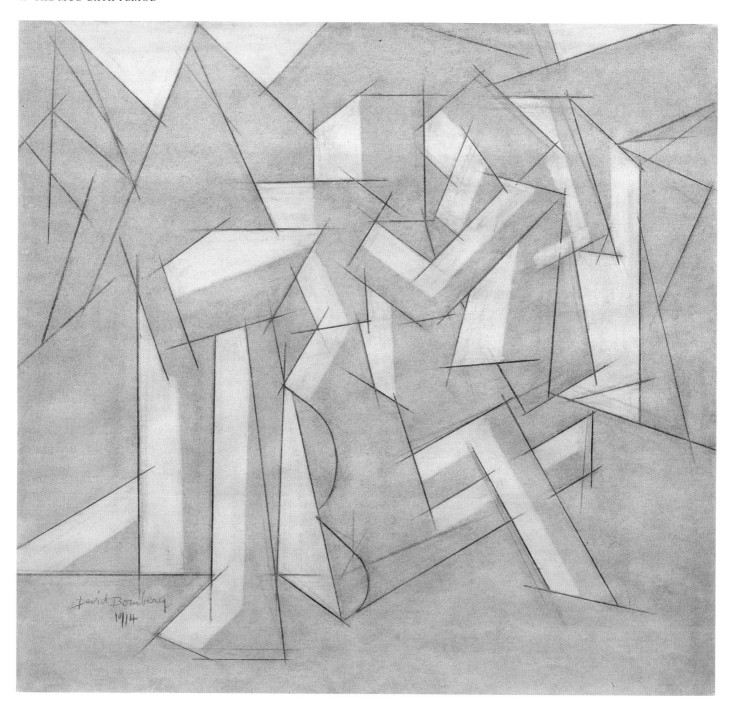

pl.8, cat.33 **Composition** 1914

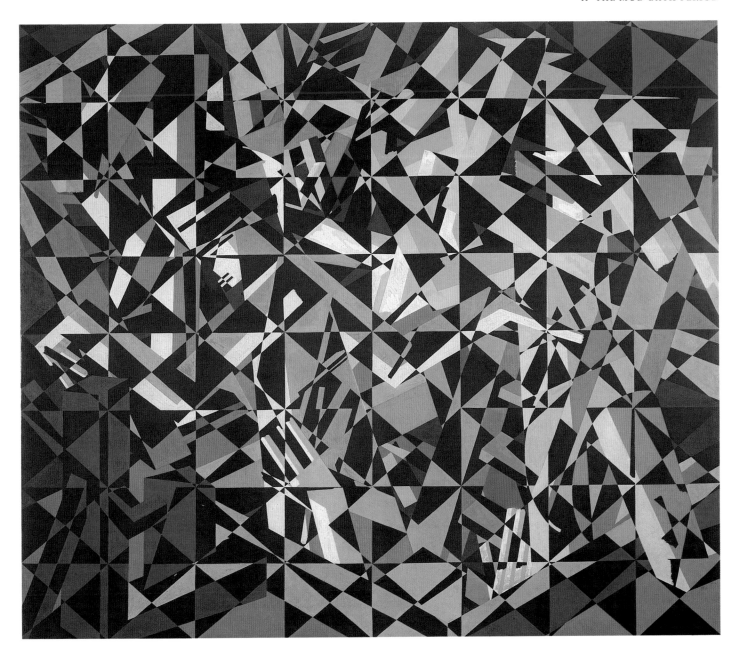

pl.9, cat.36 **In the Hold** 1913–14

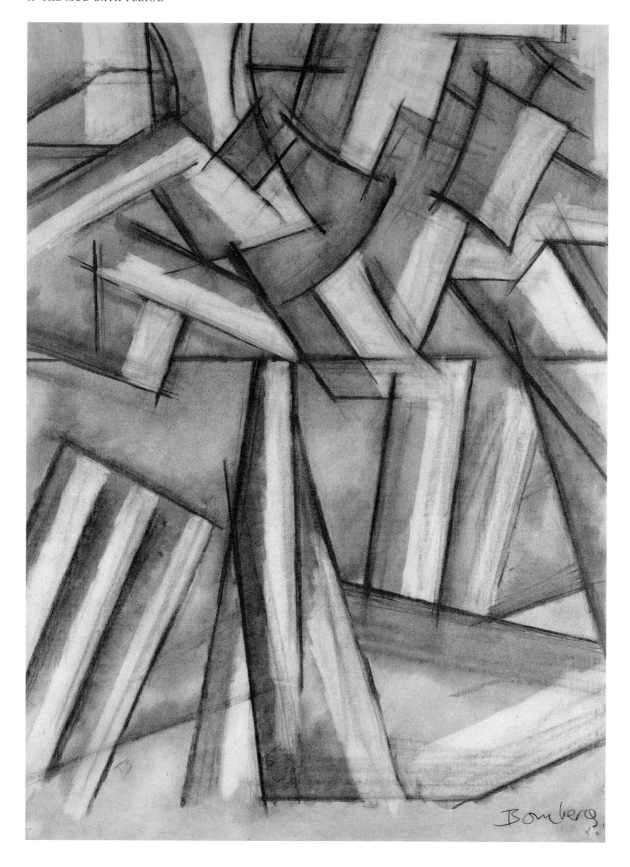

pl.10, cat.39 **Study for The Mud Bath** *c.*1914

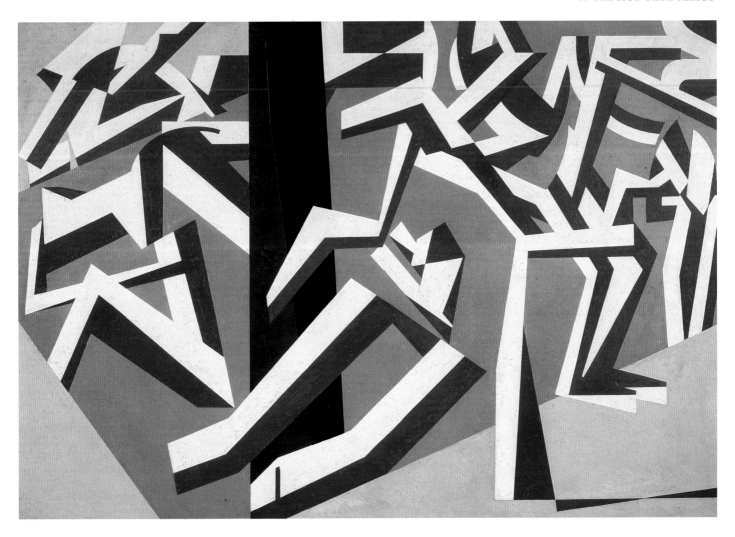

pl.11, cat.42 **The Mud Bath** 1914

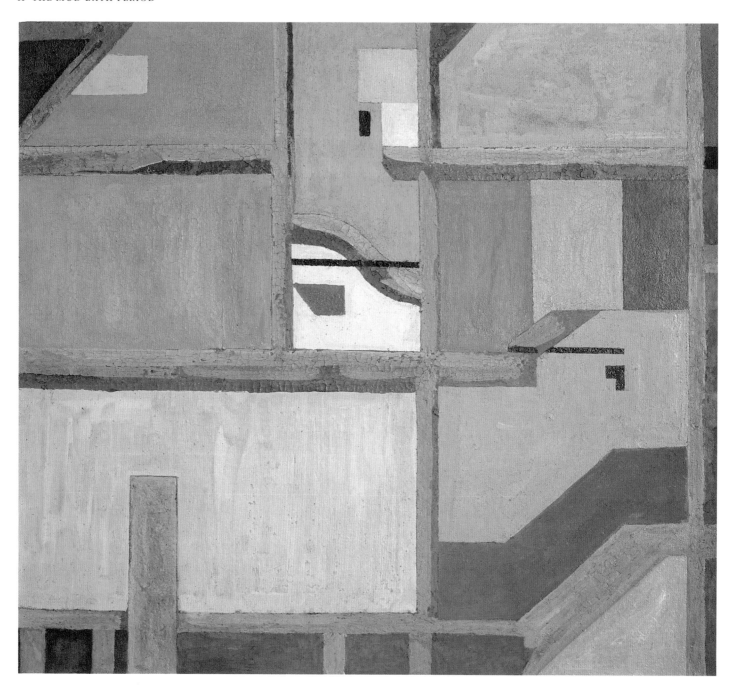

pl.12, cat.44 **Composition (Green)** *c*.1914

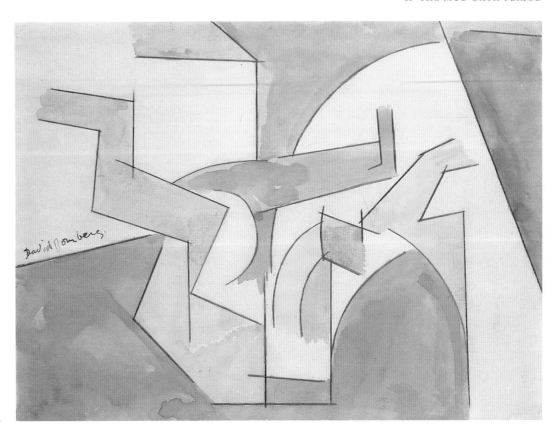

pl.13, cat.45
Abstract Composition *c.*1914

pl.14, cat.47 **Abstract Design** *c.*1914

pl.15, cat.50 **The Dancer** 1913–14

pl.16, cat.51 **The Dancer** 1913–14

III *War and Aftermath*

Judging by the mood of grim confinement in 'Billet', the elaborate drawing Bomberg produced before enlisting in the army, he viewed the war with foreboding (cat.53). There is nothing jingoistic about this overcast image, and the misgivings it reveals were fully borne out once he found himself in France. The fighting prevented Bomberg from making work of his own, apart from a few small drawings which contain tantalizing hints of the paintings he could have made (cats.54-58). But at least he escaped with his life, and was able to accept a commission from the Canadian War Memorials Fund soon after it was established by Sir Max Aitken (later Lord Beaverbrook). The invitation must have been all the more welcome in view of the British government's refusal to consider him for an official war artist's post, and Bomberg set about his task with determination. The subject, '"Sappers at Work": A Canadian Tunnelling Company', commemorated a moment in the war when British and Canadian troops managed to inflict a surprise assault on the enemy defences. According to an eye-witness account published by Major Marr, the father of Bomberg's future son-in-law Leslie Marr, the sappers' mines contributed very effectively to the offensive: 'It was quite dark, and looking out in the direction of the valley in front, all appeared quiet with the exception of Verey lights both sides regularly sent up to light up No Man's Land. At a pre-arranged moment this silence was violently disturbed. A series of mines which had been in preparation for months, were successfully exploded by our engineers. The largest of these remained a glowing mass like a huge bonfire for well over a minute. At the same time all our guns of all sizes opened fire on pre-arranged targets . . . I afterwards learned that our attack had succeeded most satisfactorily.'

The subject, involving as it did a group of energetic figures in a confined space, was ideally suited to the maker of 'The Mud Bath'. The most schematised study he produced, probably at an early stage in the painting's genesis, attaches itself firmly to the form-language he had developed before the war, and an impressive canvas could have evolved from its taut, dynamic structure (cat.60, pl.17). But there were two reasons why Bomberg could not proceed with such an image. As his other war drawings demonstrate, he was now embarked on an attempt to revise his earlier style. War had irrevocably altered his attitude towards the machine age. The devastating armoury it unleased in the trenches forced him to recoil from the mechanistic vision which had once proved such a formidable source of inspiration. He felt the need to reassert a more humanist alternative in the light of his experiences at the Front, and the first 'Sappers' canvas bears vigorous witness to this new resolve (cat.61, pl.18). But it also reflects Bomberg's awareness of the Canadian committee's expectations, and he tried hard to arrive at an image that satisfied these requirements without compromising his own imaginative integrity.

He need not have bothered. The painting was turned down, and Bomberg yielded to his wife Alice's well-meaning yet unfortunate suggestion that a second version could be executed. Although he produced an acceptable canvas after a short, intensive period of work (p.23), it was bound to dilute his original version. He never returned to the style employed in this second version, which was unavailable for loan to the present exhibition. Even Alice

admitted, many years later, that 'I still wonder if I did the right thing in speaking to Konody as I did – if it would not have been wiser to let David lose his chance of winning the three hundred pounds prize money – by withdrawing his work.' Bomberg doubtless entertained similar doubts about the advisability of the approved version, but the paintings he went on to execute in the aftermath of war show a clear resolve to move on from the *'Pure Form'* priorities of the pre-war period. The figures who inhabit pictures like 'Woman and Machine' and 'Ghetto Theatre' are couched in a more representational idiom than their predecessors of 1914 (cats.72,71, pl.21). Bomberg was now opposed to abstraction, and turned down an invitation in 1919 from his old friend the Dutch architect Robert van't Hoff to join the De Stijl movement. 'The examples of the work he showed me that the Group stood for I was not impressed with', Bomberg wrote later. 'There was evidence that they were not sensing design as that which emanated from the sense of mass . . . This I felt could only lead to the Blank Page.'

Many artists experienced an overwhelming need to 'return to order' in the 1920s, and Bomberg was among them. His future predilection for landscape paintings, rather than his earlier exclusive involvement with the human figure in an urban context, was first announced in a canvas called 'Barges' (cat.68, pl.20). Based on war memories of a canal bank in Flanders, and subsequently the sight of a similar scene in the country near London, it still adheres to the structural rigidity of his 1914 style. But the feeling for nature – the placid stretch of water, the trees reflected in its stillness – is quite new. Bomberg clearly found solace in a subject so removed from his hectic metropolitan surroundings, and in the early 1920s he concentrated on paintings, watercolours and drawings of barge life (cats.69,70,73, pl.22). The sturdy forms of bargee women fill his compositions with their redoubtable bulk. Bomberg equated the strength of these figures with their closeness to the natural order. He began to realise that his art needed to develop a similar relationship, and in 1922 he and Alice accepted an invitation from Ben and Winifred Nicholson to paint in the landscape near their Lugano villa. Nicholson's willingness to extend hospitality to Bomberg was a reflection of the high standing he still enjoyed among experimental artists: Paul Nash likewise expressed admiration for Bomberg's work in a 1922 letter to Edward Marsh. But the Switzerland trip was a 'great fiasco', according to Alice. 'David hated being hauled out in the snow on painting expeditions, expected to play the maestro and teach them how to paint. Finally there was a show-down and they paid our fares home glad to get rid of us!'

Back in London, life seemed no more congenial. The British landscape did not stimulate Bomberg, and an exhibition he held at the Mansard Gallery in March 1923 aroused little interest. He was dissatisfied enough to yearn for a complete change, and his friend Muirhead Bone helped him to achieve it. Bone contacted the Zionists' London headquarters and persuaded them, after prolonged and tortuous negotiations, that Bomberg was worth supporting. With some reluctance, the Palestine Foundation Fund eventually agreed to subsidise Bomberg's journey to Jerusalem, and he set off with Alice in April 1923.

pl.17, cat.60 **Study for 'Sappers at Work':**
A Canadian Tunnelling Company *c.*1918

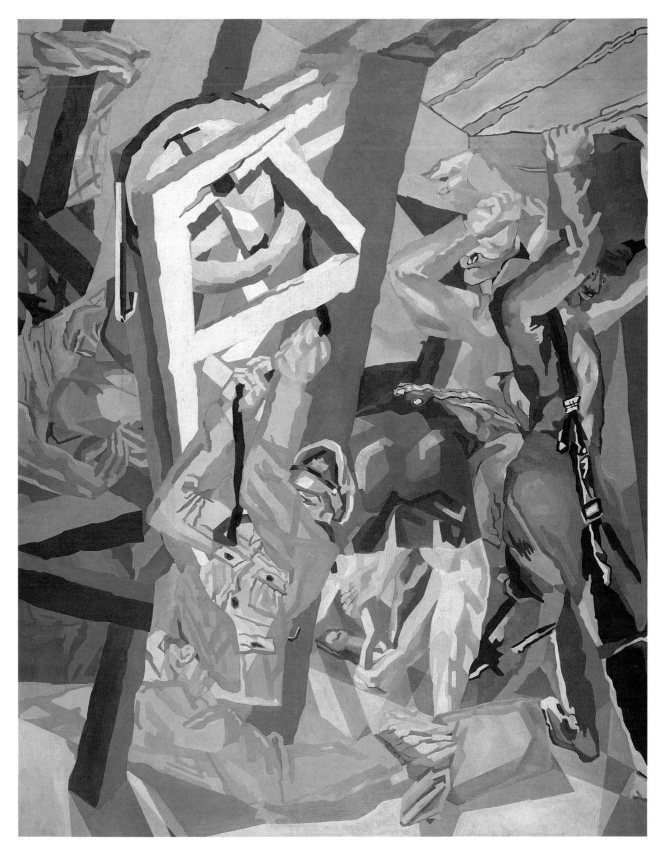

pl.18, cat.61 **'Sappers at Work': A Canadian Tunnelling Company (First Version)** 1918–19

pl.19, cat.63
Three Russian Ballet lithographs 1914–19

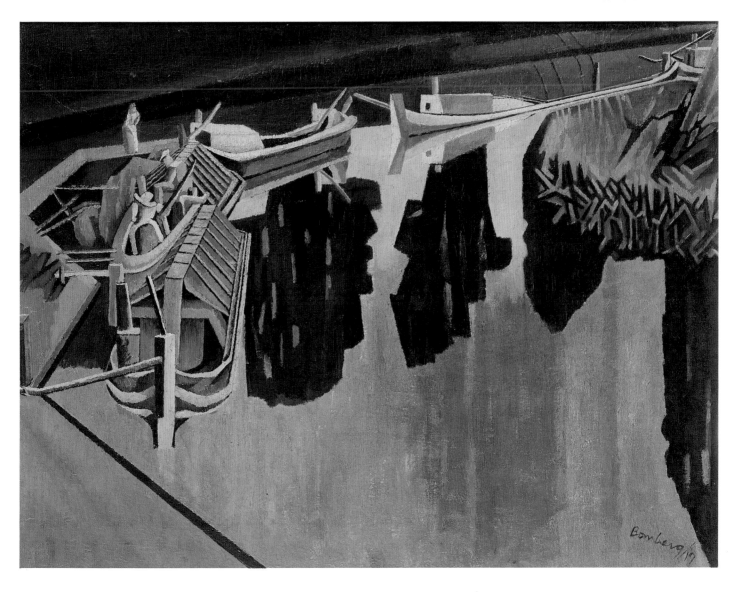

pl.20, cat.68 **Barges** 1919

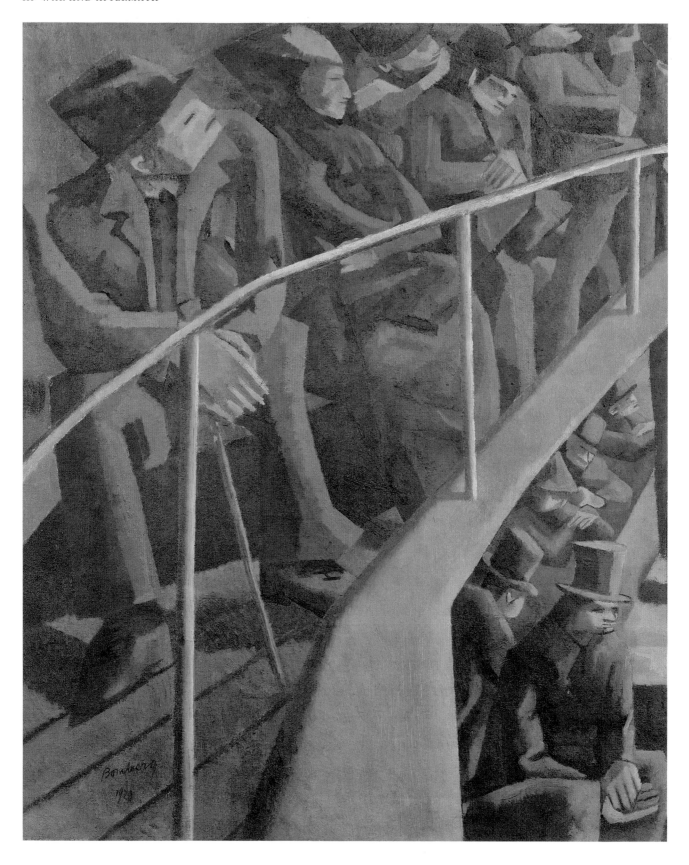

pl.21, cat.71 **Ghetto Theatre** 1920

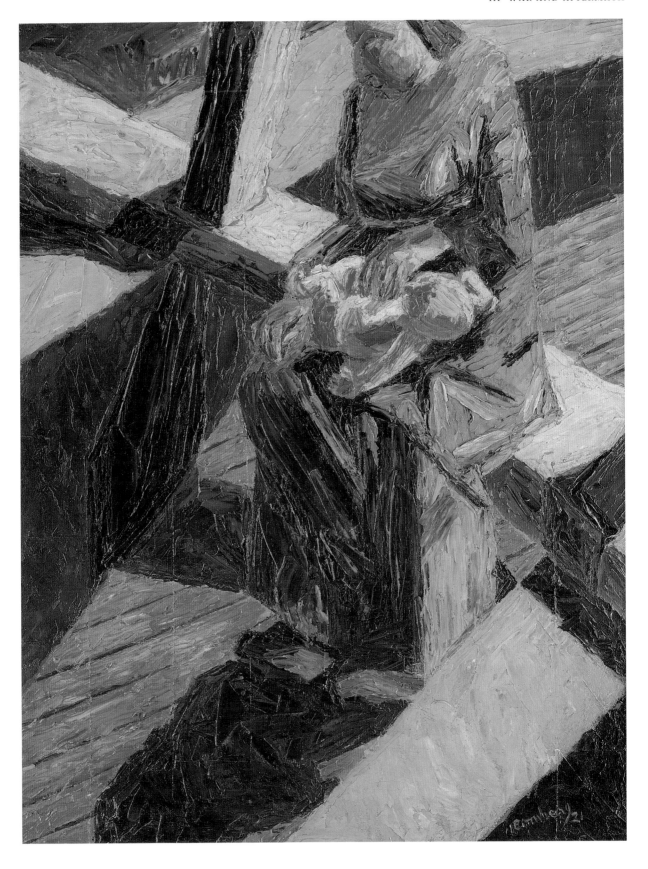

pl.22, cat.73 **Bargee** 1921

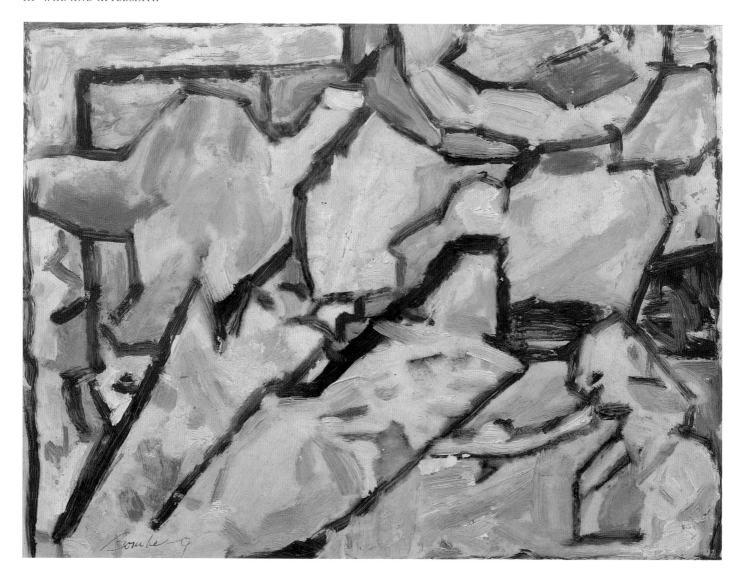

pl.23, cat.78 **The Tent** 1920–22

IV Palestine and Toledo

On his arrival in Jerusalem, Bomberg was confronted by a city far removed from anything he had encountered before. He found himself surveying 'a Russian toy city, punctuated by its red roofs, jewelled with the gildings of the Mosque spire – set against hills – patterned with walls encircling the Christian holy places – the horizontal lines accentuated by the perpendicular forms [of] the minarets.' In these exotic and unfamiliar surroundings, where no contact could be had with any artists who shared his knowledge of the continental avant-garde, he soon detached himself from the stylistic concerns of his pre-war work. Palestine presented him with a light-filled landscape so absorbing that he began to study it in a meticulous, almost Pre-Raphaelite manner (cat.85). He found patrons willing to encourage this new-found fidelity as well. Sir Ronald Storrs and other members of Jerusalem's governing circle purchased his work for substantial sums, and Bomberg basked in an approbation he had never enjoyed before. After the indifference of England, the warm response he encountered in Jerusalem was as much of a tonic as the heat and clarity of the panoramas he studied with such zeal.

Bomberg found no inspiration in the Pioneer Development camps where he was supposed to execute paintings for the Zionists (cats.89,90). Most of the pictures he produced there were listless in feeling, and he showed little hesitation in responding to Storrs's alternative proposal that he undertake a trip to Petra. The Bombergs made the long and at times perilous journey in 1924, passing through an epic Dead Sea landscape which presented to his astonished eye 'a sort of mirage stretching into infinity. In colour, like fire and ashes.' But Petra itself was a daunting proposition. Some of the canvases he painted there were dogged to a fault, and even Storrs found them disappointing after Bomberg's return. Jerusalem itself remained the cynosure of his Palestine work. In 1925 he executed the most precise and tightly organised of all his cityscapes, adopting rooftop vantages in order to concentrate on architectural structure alone (cats.87-8, pl.25). Although the near-topographical manner he adopted here contrasted absolutely with his pre-war work, the same insistence on a rigorous organization of masses informs them both.

Such an involvement with representational minutiae could not satisfy Bomberg for long. Away from the expectations of his patrons, on a trip to the remote monastery of St George, Wadi Kelt, he found himself indulging in a freer and more impassioned approach (cats.92, 93). Working in oil on paper, Bomberg emancipated his art from the tightness and prosaism which threatened to stifle his Jerusalem images. But it was a temporary liberation. While the estranged Alice returned to London and tried to organize an exhibition of his recent work, he resumed his detailed painting of the city and its environs. Only in 1927, the final year of his Palestine sojourn, did he begin to defy the predilections of his more conservative supporters and execute canvases like the limpid, broadly handled 'Roof Tops, Jerusalem' (cat.94, pl.26). One of his last pictures, a commissioned view of 'The Ophthalmic Hospital of the Order of St John', reveals in the vigorous impasto of its foreground an approach which anticipates his later landscapes (cat.95).

The exhibition of Palestine paintings he held at the Leicester Galleries in March 1928 was

generally admired by the reviewers. Bomberg received the most favourable notices of his entire career, and P.G. Konody summarised the general view that he was now 'a matured artist, free from affectation and eccentricity, with a style of his own, in which the experience gained from his youthful experiments in Cubism is sensibly applied to the structural emphasis of representational work based on close and penetrating observation of nature.' But Bomberg's artist friends regarded the Palestine work with puzzlement and disfavour. He had now removed himself from his contemporaries, and they could not understand why the exhibition lacked the sense of irresistible adventure which had made his earlier work so exciting. 'What happened to the wild trumpeter?' asked one visitor, expressing a disappointment which Bomberg now began to understand. He realised that the isolation of his Palestine period, coupled with the pressure exerted by government patrons eager for readily identifiable views of the city they loved, had led him to suppress the most ebullient part of his imagination.

Lilian Mendelson, who would become his second wife, shared his dissatisfaction. A painter herself, she encouraged Bomberg's attempts to develop a less constricted style. But he knew it could only be brought to fruition in contact with a landscape more stimulating than anything England could offer. Spain provided him with the alternative he needed, and in the autumn of 1929 he travelled alone to Toledo. The expedition proved to be a turning-point in Bomberg's development. In the remarkable sequence of paintings produced during the few months he stayed in the city, he at last broke free from his Palestine manner and discovered a more individual way of responding to the world which unfolded from his chosen vantage (cats.96–100, pls.27,28). Rather than studying the city and its surrounding country with dispassionate fidelity, he learned how to project himself into the scene and infuse it with his most ardent emotions. Andrew Forge justly observed of the Toledo canvases that 'an extraordinarily strong personal note enters his work at this point; one seems to feel oneself breathing the artist's breath in front of some of these pictures.' The example of El Greco helped him to sustain a high level of achievement in Toledo, and the smaller paintings he executed on the outskirts of the city attain an especially intense communion with the Spanish landscape (cats.102–8, pls.30,31,32).

Toledo set Bomberg firmly on the course he would pursue for the rest of his life. At the age of thirty-nine, he had at last defined his mature identity as an artist, and the work he produced after returning to London displays an even greater willingness to broaden and extend his expressive language.

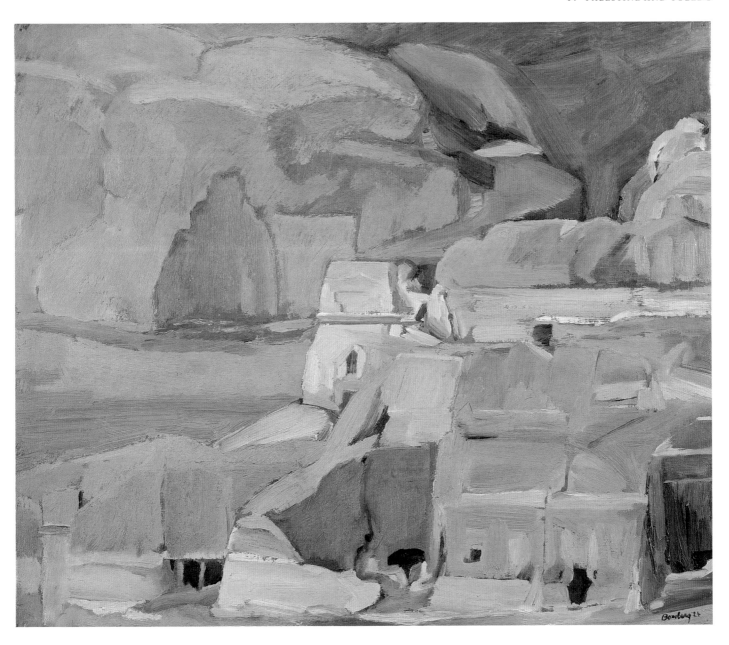

pl.24, cat.86 **Steps to a 'High Place' on
al Khubdha, Petra; early morning** 1924

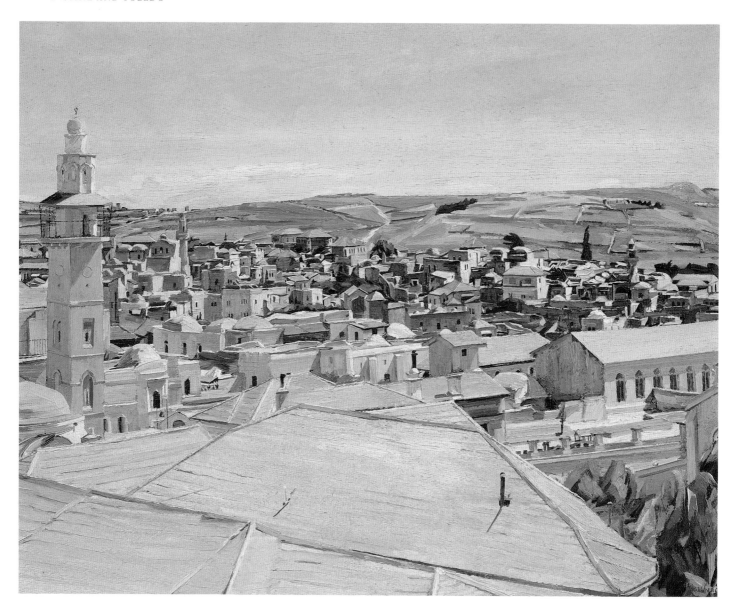

pl.25, cat.87 **Jerusalem, looking to Mount Scopus** 1925

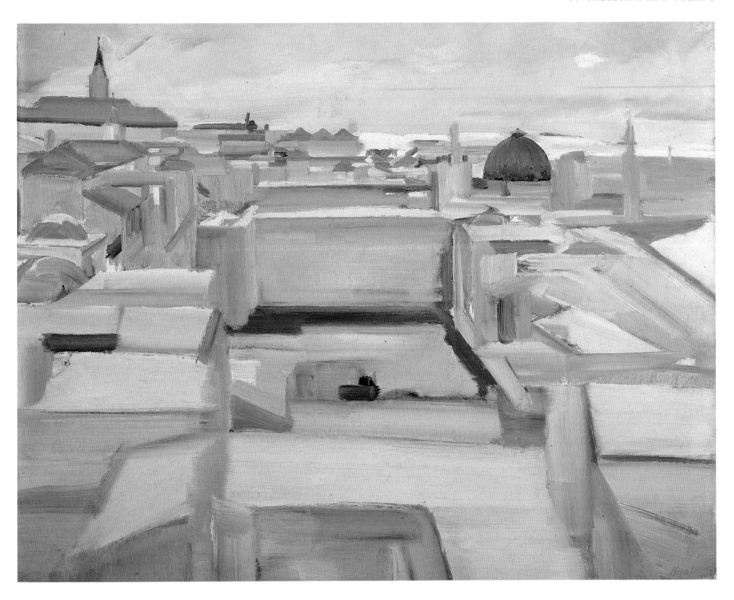

pl.26, cat.94 **Roof Tops, Jerusalem** 1927

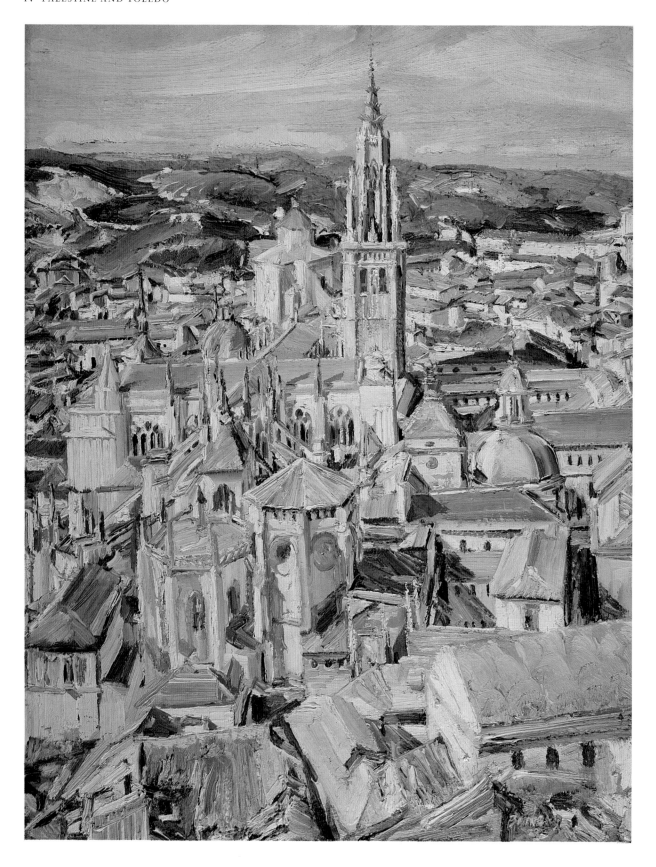

pl.27, cat.97 **Cathedral, Toledo** 1929

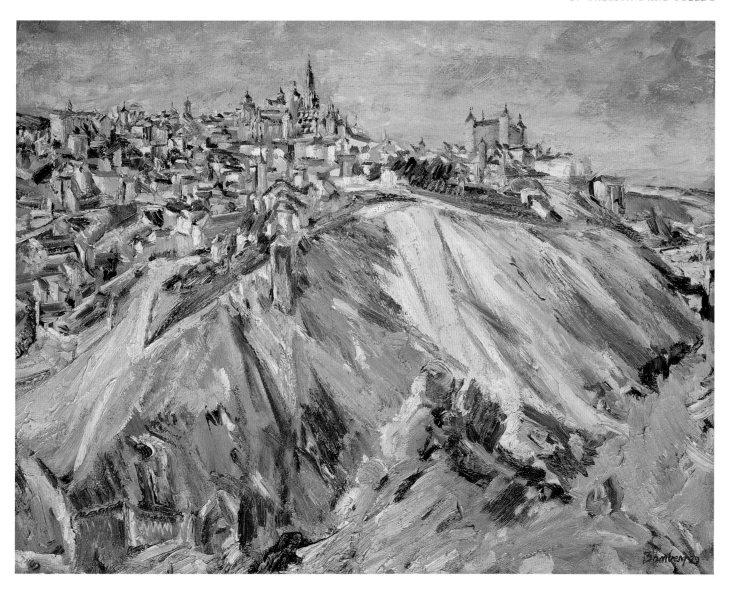

pl.28, cat.98 **Toledo and River Tajo** 1929

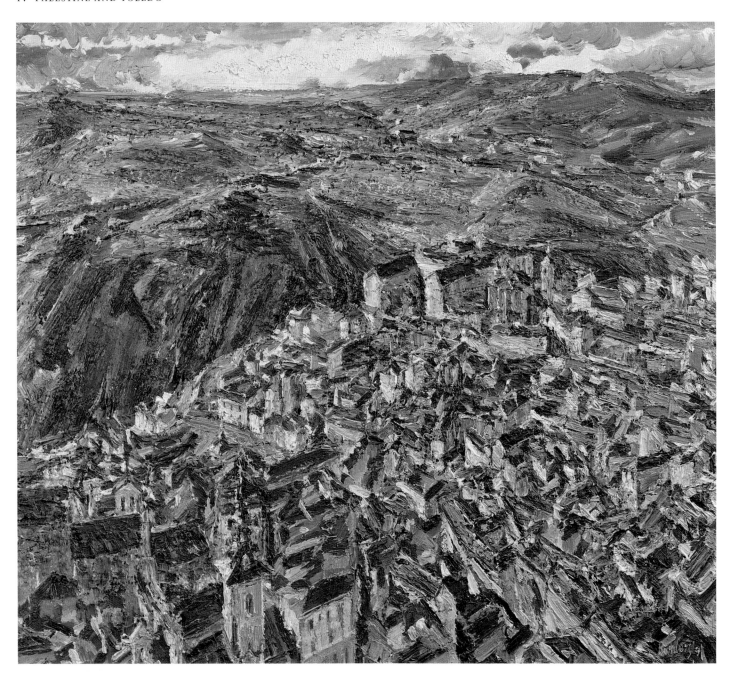

pl.29, cat.101 **Toledo from the Alcazar** 1929

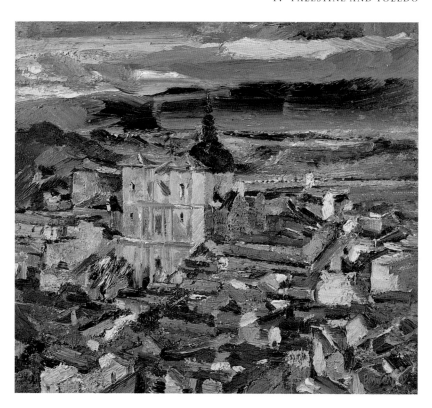

pl.30, cat.102
San Juan, Toledo: Evening 1929

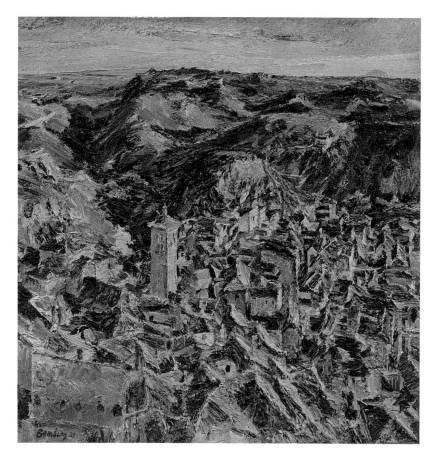

pl.31, cat.105
San Miguel, Toledo 1929

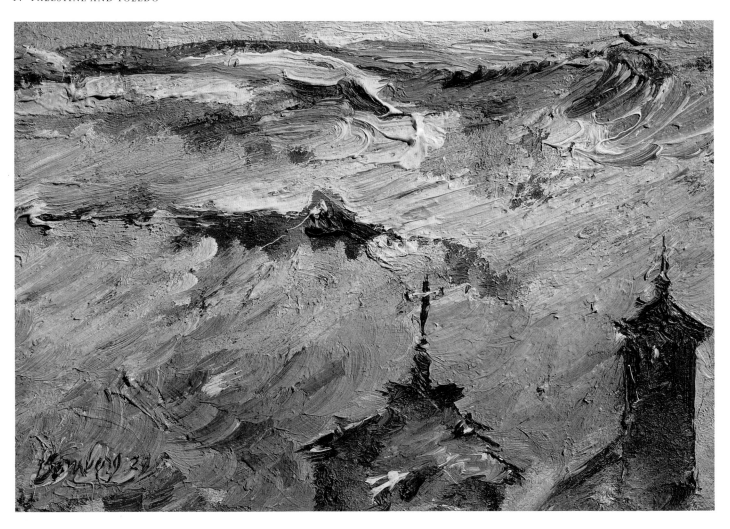

pl.32, cat.106 **Hills in Mist, San Miguel,
Toledo (The White Mist)** 1929

V Cuenca, Ronda and the Flight to Britain

The remarkable series of portraits Bomberg made in the early 1930s of Lillian and himself exhibit a new vigour, insight and readiness to give the paint a boldly manipulated eloquence. Brushwork plays a more forceful role in his art than before, and 'The Red Hat' demonstrates an especially eruptive desire to explore the possibilities of vehement mark-making (cat.111, pl.35). But Bomberg did not enjoy a similar success when he tried painting the British landscape. A trip to Scotland in 1932 yielded very uneven results, even if an exceptional canvas like 'Brierloch – Glen Kinrich, Cairngorms' managed to define his rapport with nature in a manner conspicuously more free than his Toledo work (cat.115).

Bomberg had hoped, in his short-lived enthusiasm for the Communist cause, that Russia would provide him with a congenial working environment. His expedition to Moscow in 1933 ended in disillusionment, however, and he decided the following year that Spain deserved to be revisited. The limited yet welcome promise of support from three collectors in Bradford encouraged him to undertake the journey to Cuenca. A more remote and primitive locale than Toledo, it brought him into closer contact with the landscape. The houses of Cuenca still play a part in many of the paintings he produced there, but they are now subordinated to Bomberg's increasing absorption in the bare, unsullied country surrounding them. The ruggedness and primordial grandeur of the Spanish landscape was ideally suited to the development of a more simplified and austere vision. But it was only after travelling south to Ronda that he explored the most volcanic side of his temperament.

Perched on its craggy plateau of rock, and split by a deep ravine, Ronda fired Bomberg to incorporate an apprehension of seismic violence in the work he produced there (cat.128, pl.38.) His paintings are charged now with an awareness of the landscape's explosive potential. Far from retaining a safe distance from the motif and studying it with objective reticence, he entered into a wholehearted engagement with a world riven by convulsive geological stress (cat.127, pl.37).

Bomberg studied Ronda like an insatiable explorer, travelling on a donkey to vantages sometimes several miles distant and then closing on the mighty rockface so that it seems to press up against the viewer with palpable force. He scrutinised it at very different times of day, too, from the full heat of summer sunlight to moments when the plateau's shadowy mass nearly gives way to nocturnal darkness. Even at night Bomberg did not cease his investigations. When the procession of La Virgen de la Paz wound its way through the narrow streets near his house in the old quarter, he painted the spectacle aided only by the light of the candlebearers (cat.129).

This memorable Spanish trip came to a climax when the family travelled north once more, settling for a while in the Asturian mountains. Here Bomberg painted the masterpiece of the expedition, 'Valley of La Hermida, Picos de Europa, Asturias', investing an unusually large canvas with a passionate interpretation of the landscape's density, mass and light-enlivened animism (cat.132, pl.41). But the Asturian period did not last as long as he wished. The disorder which would lead to full-scale civil war intervened, obliging him to cut short his exploration of the Spanish landscape at its wildest and most primeval. The return to

London was bound to be irksome, for Bomberg was heavily reliant on a conducive mood when he worked. Deprived of it, he experienced great difficulty in resuming the rhythm of sustained painting he had established in Spain. News of the civil war troubled him, too, and he gave vent to his concern in a heartfelt memoir of his journey. 'Whoever has lived in the Picos de Europa, Asturias, will comprehend the magnitude of the suffering in store for all those who have sought refuge in these mountain fastnesses', he wrote. 'With the flight to these mountains of the *12,000* inhabitants of the recently bombed & destroyed village of *CANGAS de ONIS* – the last point before the ascent at Cavadanaga – together with the inrush of the retreating refugees from the surrounding country to the three other points of entry to the Central Peaks, commences a story of suffering almost incomprehensible to the people of this country.' In order to ram their plight home, he even exhibited a painting in 1937 of 'a mountain which is swarming with thousands of refugees from the bombing of Cangas de Onis. The name of the mountain is not disclosed in the title of the picture for fear of giving information to the enemy as to the paths – only four in number – which lead there.'

Such an overt reference to the political events of the day would never recur in Bomberg's work. He always preferred to concentrate on his own experience, and in 1937 turned again to portraits of himself and members of his immediate family. His only child, 'The Baby Diana', was brushed in with great tenderness as she slept in her bed (cat.139), while his stepdaughter Dinora found herself posing for him with a towel wrapped around her wet hair (cat.138). The outcome was one of the most powerful drawings of the 1930s, and around the same time he portrayed Lilian in a canvas that stressed her face's strength even as it disclosed the extent of his affection for her (cat.134). A grimmer mood characterizes the self-portraits of this year, however (cats.135-7, pl.43). They disclose the full extent of his melancholy, and herald the depressive temper of the late 1930s when he abandoned painting altogether.

His spirits were further dashed by the outcome of a commission from the London Co-operative Societies' Joint Education Committee to 'design the scenery and costumes' for a production of Handel's *Belshazzar*. Stimulated by a project which involved one of his favourite composers, Bomberg produced some lively and arresting designs (cats.140-41). But before the end of the year the project foundered. 'Though I could cooperate with the musician, producer & stage manager, & they with me', Bomberg wrote, 'the Cooperative Wholesale Society could not cooperate. They were prepared to pay "Trade Union" rates of pay to everyone concerned, but not to the artists & designers.' The whole frustrating episode reinforced his wider dissatisfaction with Britain's inability to support its artists. The country ought to institute a scheme similar to the financial aid which Roosevelt's government offered its artists, Bomberg told Kenneth Clark in a 1937 letter. This time, his suggestion received a positive response, for Clark wrote back agreeing that 'there should be something in England equivalent to the United States Federal Art Scheme.' Two years later, however, when Clark had the unexpected opportunity to pioneer such a project, Bomberg found that he did not qualify for the patronage it provided.

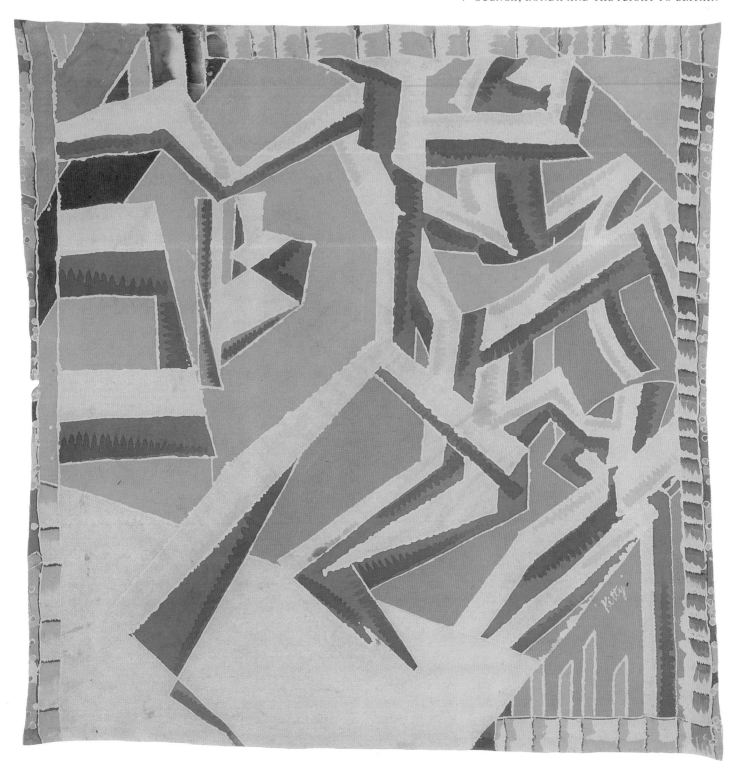

pl.33, cat.109 **Shawl: The Mud Bath** *c.*1929–30

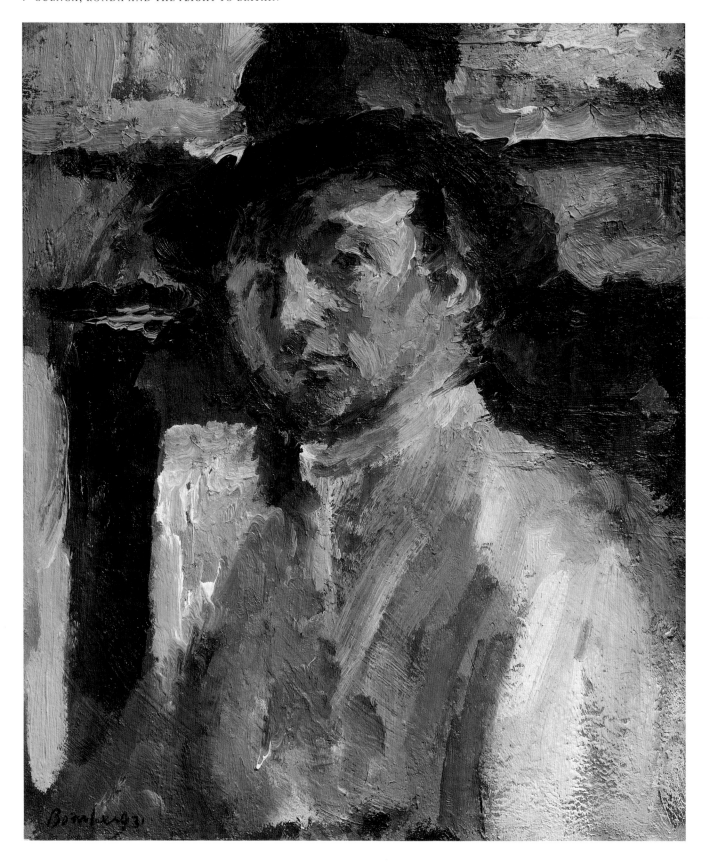

pl.34, cat.110 **Self-Portrait** 1931

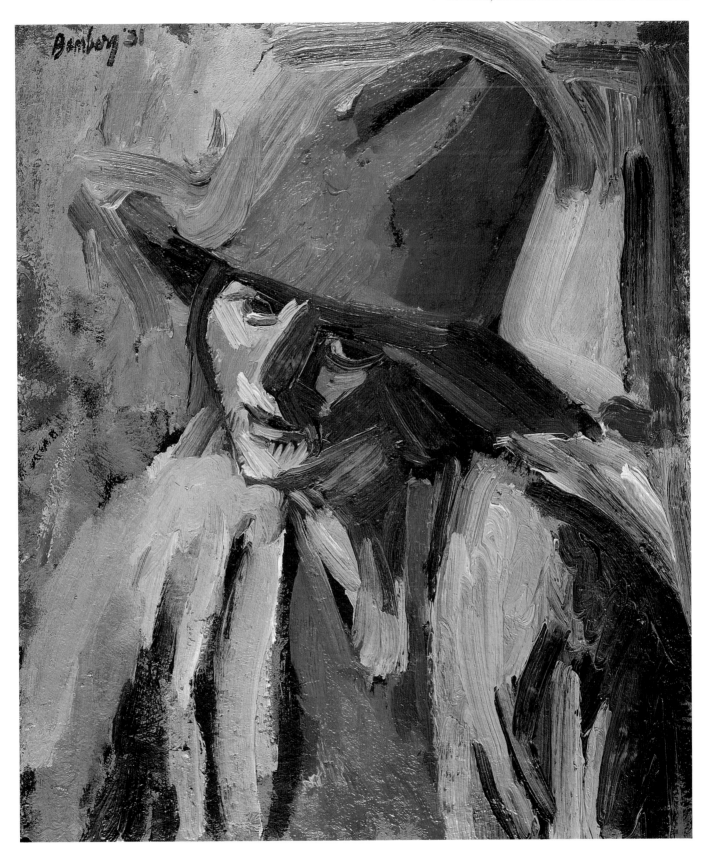

pl.35, cat.111 **The Red Hat** 1931

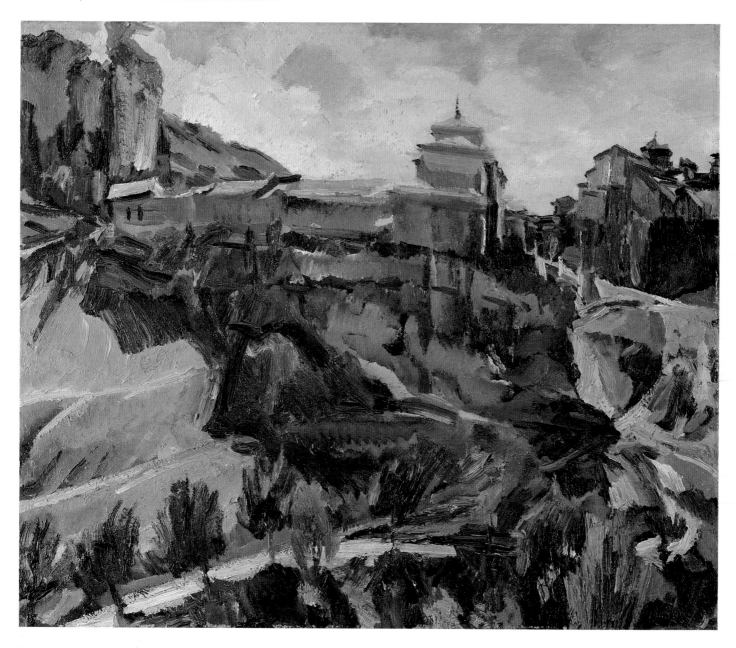

pl.36, cat.116 **Hoz del Huecar
and Convent of San Pablo, Cuenca** 1934

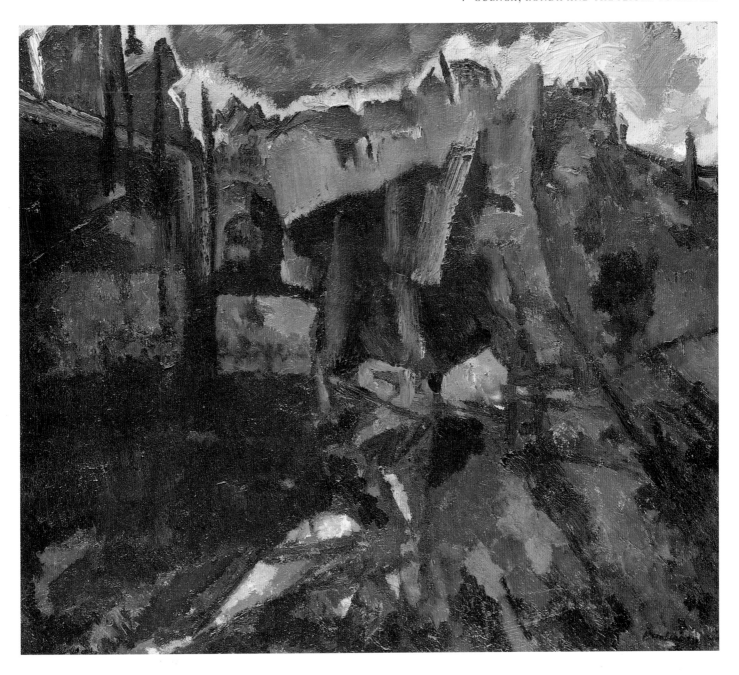

pl.37, cat.127 **Sunset, Ronda, Andalucia** 1935

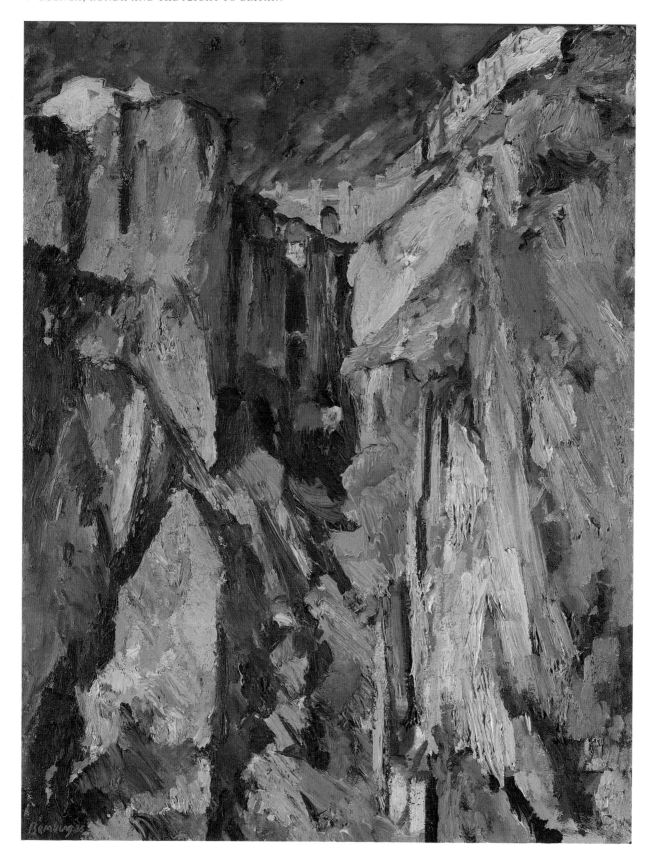

pl.38, cat.128 **Ronda: In the Gorge of the Tajo** 1935

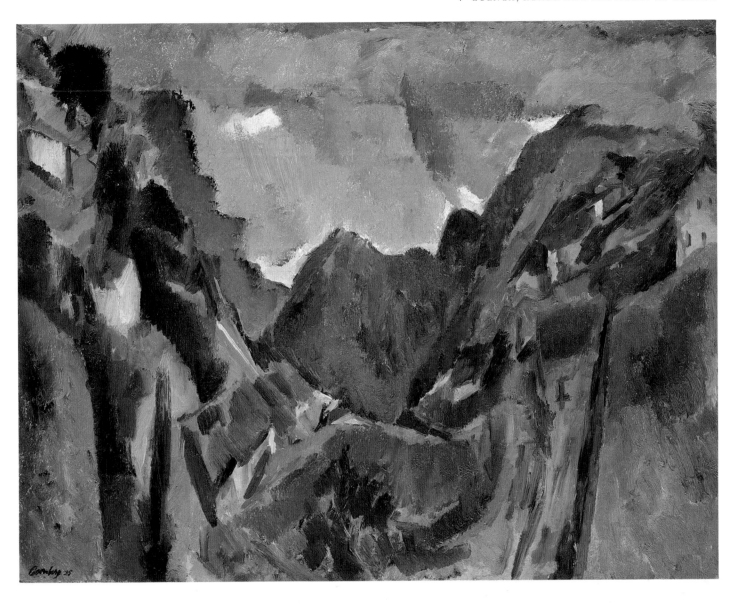

pl.39, cat.130 **Storm over Peñarrubia** 1935

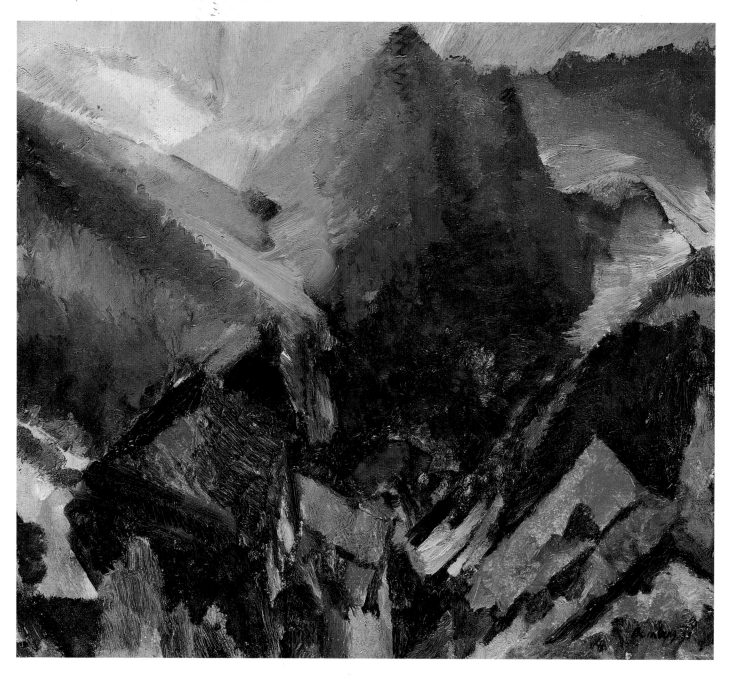

pl.40, cat.131 **Sunrise in the Mountains,
Picos de Asturias** 1935

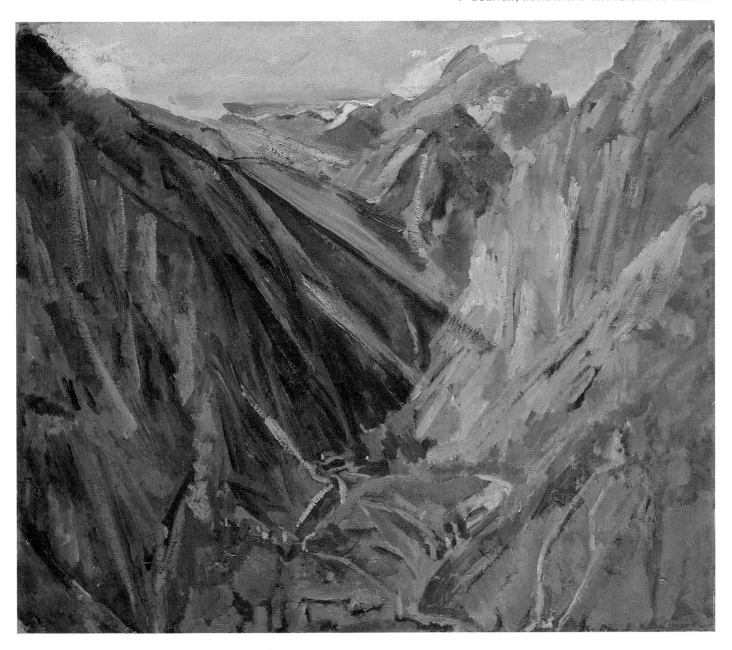

pl.41, cat.132 **Valley of La Hermida,
Picos de Europa, Asturias** 1935

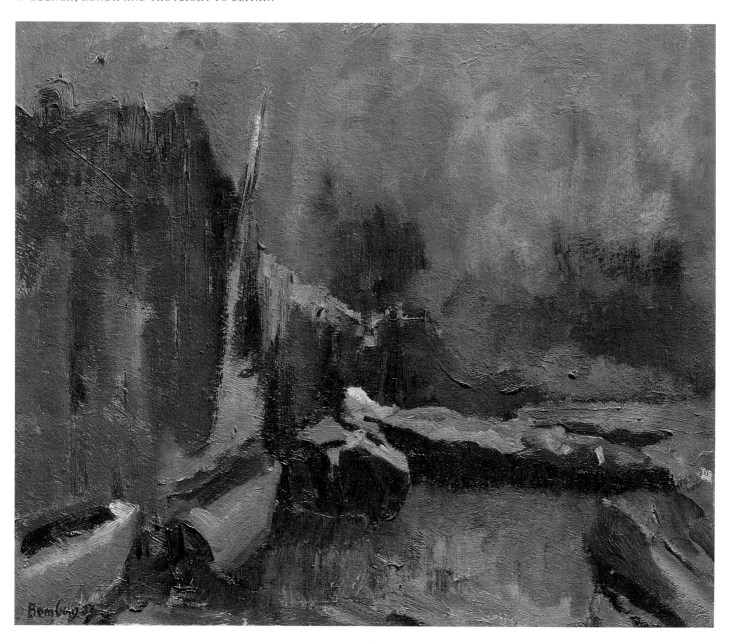

pl.42, cat.133 **Thames Barges** 1937

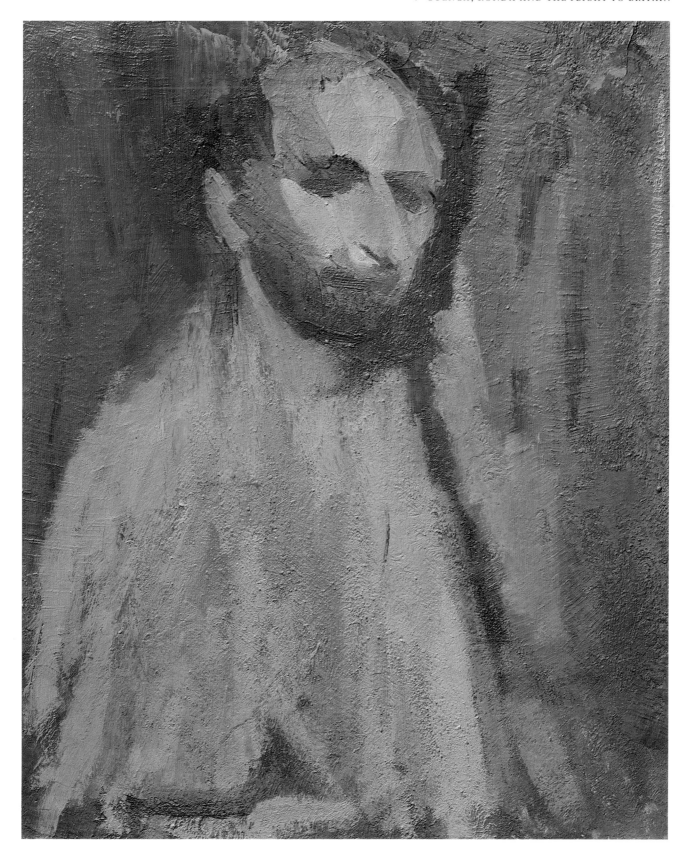

pl.43, cat.135 **Self-Portrait** 1937

VI Bomb Store and Blitz

When Bomberg heard on the radio about the formation of the War Artists' Advisory Committee, he sent in an application straightaway. The committee's brief seemed to coincide with his own views about the need for state patronage of artists, and he would have proved tireless in his efforts to produce powerful work for the scheme. But Kenneth Clark, the committee's chairman, had reservations about Bomberg's work; and besides, he explained in an article for *The Studio* that 'the War Artists collection cannot be completely representative of modern English art because it cannot include those pure painters who are interested solely in putting down their feelings about shapes and colours, and not in facts, drama, and human emotions generally.' If Clark thought of Bomberg as 'pure' in that sense, he was greatly mistaken. But Bomberg's application was twice refused, and only in February 1942 did the committee grant him a token invitation to paint the Burton-on-Trent bomb store.

Bomberg was so fascinated by the sight of the bombs stacked in the disused mines that he made painting after painting of the eerie scene (cats.144-50, pls.44,45). His meagre supply of canvas was soon exhausted, and so he turned to greaseproof paper in his determination to explore the full implications of his allotted subject. The images he produced there showed how conscious he was of the bombs' destructive purpose, and his work contrasts very favourably with the blandness of the bomb-store painting which Cuthbert Orde had executed for the committee a couple of years before. His mediocre work was viewed favourably and rewarded with further commissions, whereas Bomberg found himself treated with disdain. The committee did not even accept the painting he submitted, preferring to take three of his drawings instead (cats.142-3).

His frustration was intense, for the bomb store visit had succeeded in bringing his long period of creative barrenness to an end. The extended sequence of oil-on-paper images he executed, in preparation for a huge Memorial Panel which the committee never allowed him to produce (cats.151-2, pl.46), can be counted among the finest of his later works. He described the Panel as 'a memorial to the heroism of that kind of labour. There are some aspects scattered over various sections that could be brought together under one roof so that the painting became representative of the whole activity.' But his words were of no avail in persuading the committee's members to change their minds, and they did not even display Bomberg's three drawings in the regular exhibitions of war art staged at the National Gallery. He wrote to them about the omission in 1943, declaring that it gave him 'the impression that I am out of favour for any of the commissions that are being distributed often in duplicate, triplicate & quadruplicate etc., etc., & the rapidity with which they are publicly shown astounds me. I would much appreciate enlightenment on whether my work will be shown or not, whether I am in or out of favour & whether I may expect another commission – or whether I am considered by this committee as not a suitable artist for the encouragement of a commission.' He desperately needed clarification, but the reply he received was insultingly opaque. 'It is hoped that one or more of the drawings will shortly be on exhibition', wrote the committee's secretary, before adding that 'on the other points you

raised, as to your standing with the committee, and the likelihood of further commissions, the committee did not express an opinion.'

In an attempt to take his mind off the galling bomb store episode, Lilian decided to direct Bomberg's attention towards the possibility of flower painting. 'I was in the habit of passing a lady who sold flowers outside Gloucester Road tube station', she recalled. 'I thought that if I spent a little housekeeping money on a bunch that I picked, David might be induced to start painting them. I took a bunch home, arranged them in a vase on the living-room table and left them there. After two or three days I suggested to him that he paint them.' Bomberg demurred at first, but soon threw himself into the enterprise with relish. The sense of enjoyment is directly evident in the paintings he made, and Lilian described how after a while 'he always arranged them himself, in the same vase, against the same curtain. He wasn't interested in flower arrangement – he'd just put them in and paint them.' Bomberg eventually produced an extended series of impetuous canvases which celebrate the beauty and violence of the blooms bursting from vases scarcely able to withstand their burgeoning vigour (cats.153-4, pls.47,48). When he displayed two of them in a 1943 exhibition, a reviewer remarked that 'these are veritable *explosions* in oil colours; No.25 goes off with an almost audible bang'.

The atmosphere of war permeated all the work he produced around this time. A rare attempt to paint a nude woman lying on a bed resulted in a sensual yet disquieting image, body flung back so that her face is hidden from view (cat.157, pl.49). This anonymous figure, the very antithesis of a coquettish model aware of the male artist's appreciative gaze, assumes a pose strangely reminiscent of the naked body in Sickert's 1909 painting 'The Camden Town Affair'. Bomberg's attitude towards the woman, a farm-worker called Anne, may well have been affected by the destruction he witnessed all around him in a London beleaguered by the blitz. Around 1944 he began drawing the ravaged city, using his charcoal to convey the elegiac atmosphere of streets devastated almost beyond recognition by the German raids (cats.158, 160-2). St Paul's cathedral was virtually the sole edifice left intact in these brooding panoramas, many of which were drawn from the tower of a nearby church. It was the only building Bomberg obtained permission to enter, probably because firm rules prevented access to monuments vulnerable to enemy assault. 'There was always an element of danger', Lilian remembered, because 'we didn't know when the raids were taking place. David went out in spite of this.'

Wren's masterpiece presides over the only painting Bomberg produced of blitzed London (cat.159, pl.50). But the cathedral is surrounded by the glowing shells of buildings burned out by incendiary bombs, and he must have mourned the loss of a city he had regarded as his home since early childhood. Gradually, as he continued his drawings, the idea of an ambitious project took shape in his mind. He wrote to the Ministry of Works in October 1945, seeking 'permission to view from "Big Ben" the aspect of the City and the River. I am working on a series of drawings that will form when co-ordinated a panorama of London – to be reproduced and published in London.' Like so many of Bomberg's projects, the scheme never reached fruition: his style was too stark to attract publishers interested in topographical surveys of the city. But the drawings themselves remain, testifying to the compassion with which he surveyed the battered remains of a city whose skeletal structure lends itself well to Bomberg's defining line.

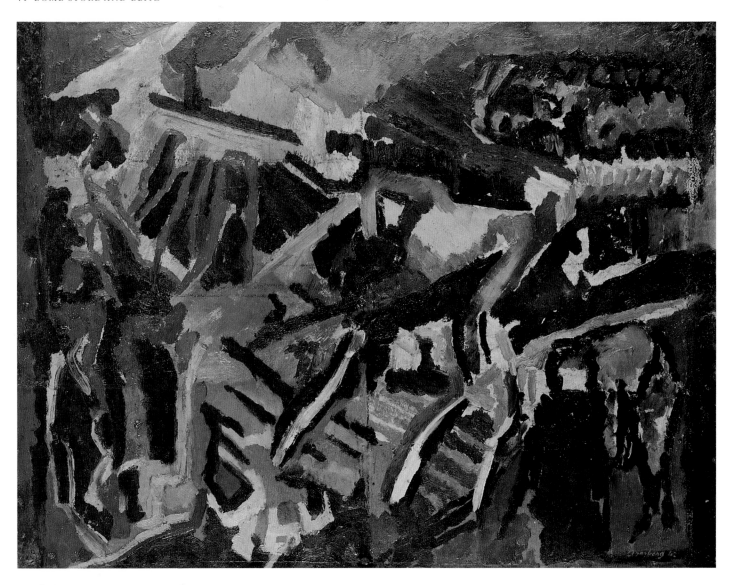

pl.44, cat.144 **Bomb Store** 1942

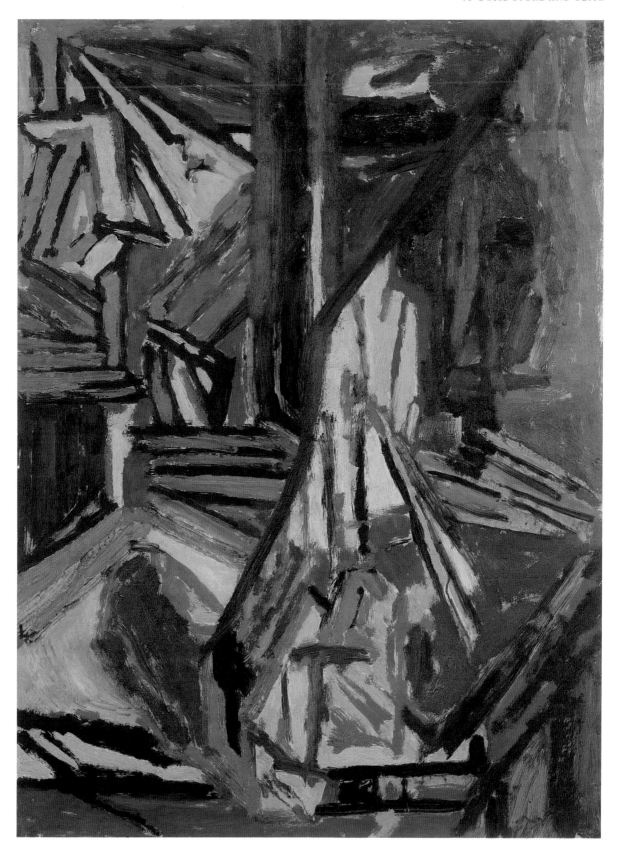

pl.45, cat.146 **Bomb Store** 1942

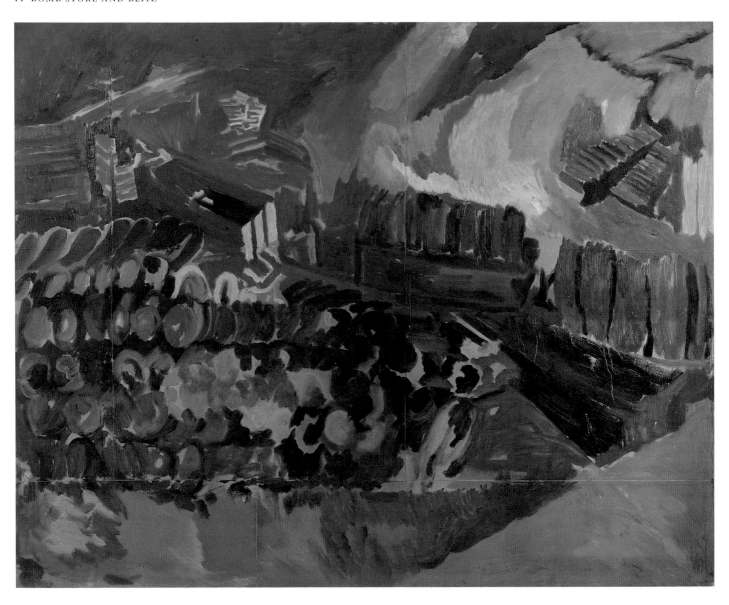

pl.46, cat.151 **Bomb Store:**
Study for Memorial Panel 1942

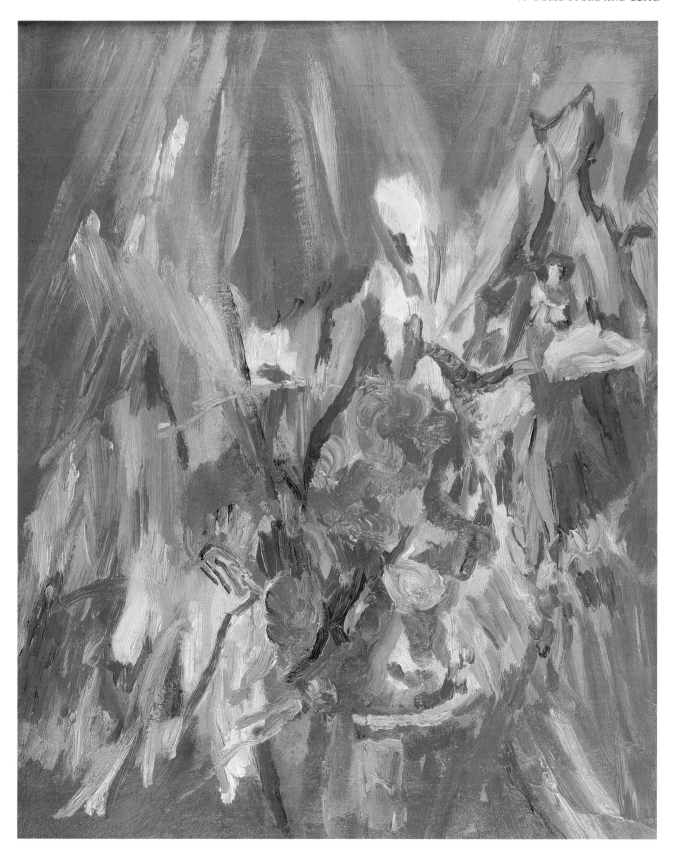

pl.47, cat.153 **Flowers** 1943

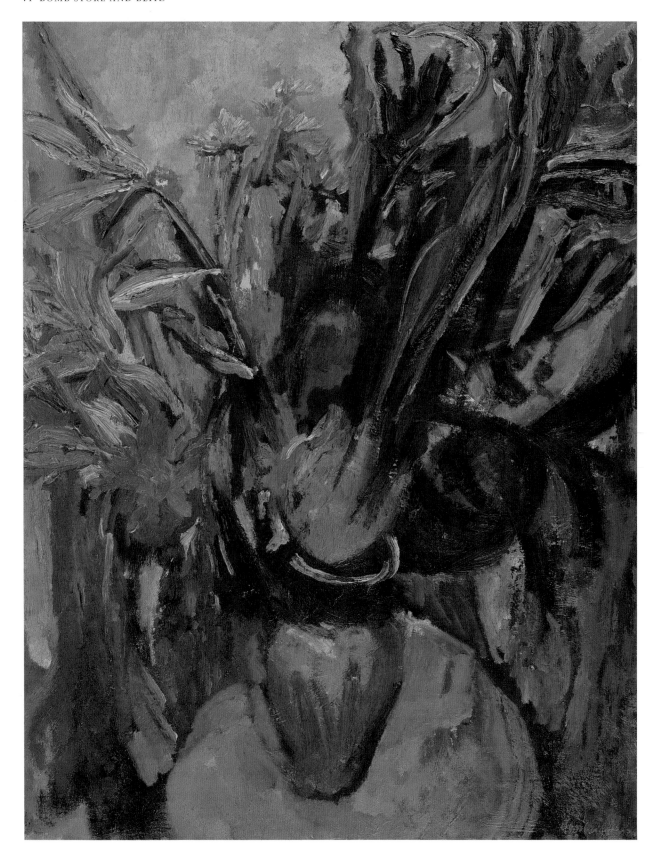

pl.48, cat.154 **Flowers** 1943

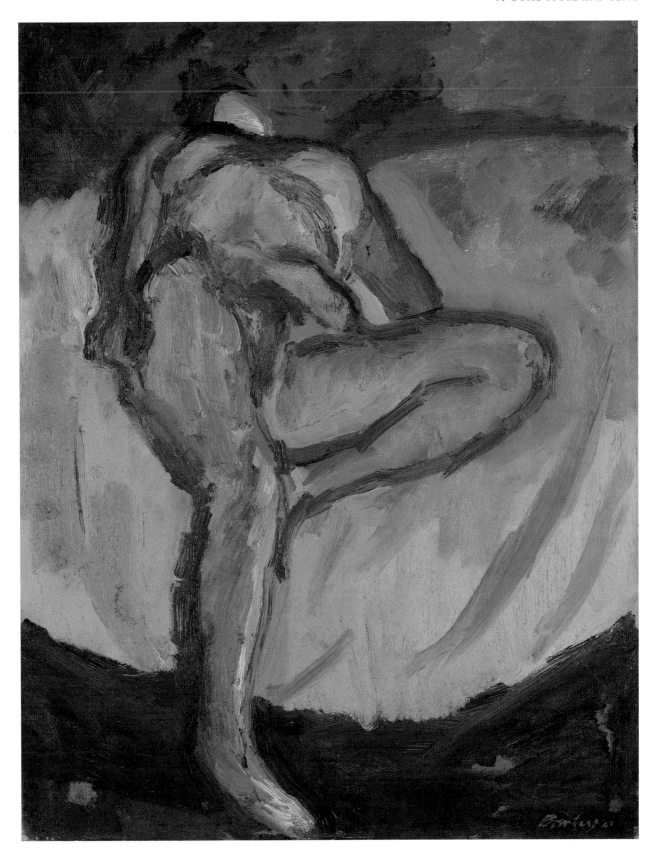

pl.49, cat.157 **Nude** 1943

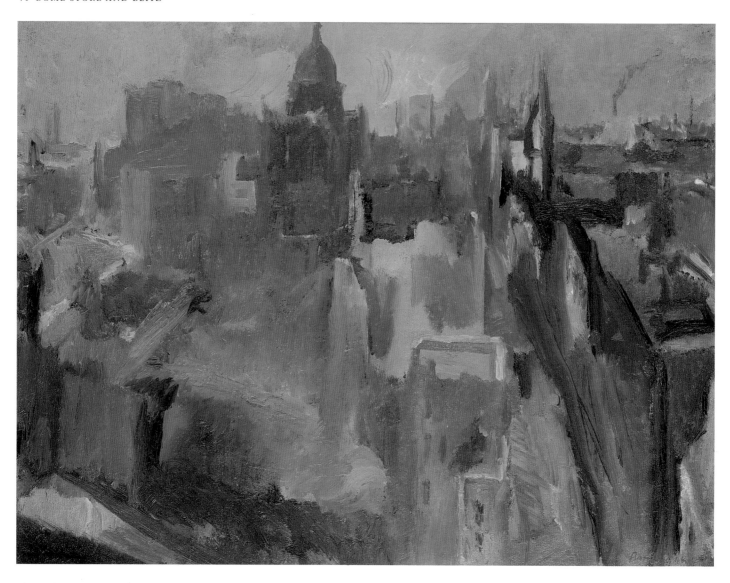

pl.50, cat.159 **Evening in the City of London** 1944

VII Devon, Cornwall and Cyprus

Lilian had always been reluctant to let Bomberg apply for teaching posts in art schools. 'I determinedly fought against him becoming a teacher,' she remembered, 'because I thought he would be lost as an artist and devote too much energy to it'. When he finally obtained a position in the Borough Polytechnic her fears were confirmed. Nurturing the students absorbed an enormous amount of his energy, so that only in the summer holidays did he manage to devote himself properly to his own work. His previous painting expeditions to the British countryside had been blighted by bad weather and an inability to find the inspiration he experienced in Spain. But severe financial constraints obliged him to set off in 1946 for North Devon, where Lilian had enjoyed a stay at Instow many years before. Although she found it much changed, Bomberg was fired by the extensive view from their tent above Bideford Bay. Several expansive canvases bear witness to the liberation it afforded, and the overcast weather prompted him to charge a painting like 'Sunset, Bideford Bay, North Devon' with a memorable amount of gestural vivacity (cat.165, pl.51). In the same year he also resumed his exploration of flowers, discovering a wider and less explosive range of moods even as he continued to stress the blooms' surging exuberance (cat.163-4).

The success of the Devon trip doubtless encouraged him to travel west again the following year. Leaving his extensive involvement with the Borough students behind him for a few weeks, he set off with his family for Cornwall. The landscape he found there, on a farm near Zennor, proved even more conducive than North Devon. It remains to this day one of the most primordial stretches of country in Britain, and Bomberg made the most of the opportunities it provided (cats.168-70, pls.52,53). His brushwork at once became broader and more insistent, paralleling in its frank declaration of mark-making the otherwise very different Abstract Expressionist handling developed by New York artists during the same period. Although he visited St Ives during the expedition and painted its harbour, Bomberg made no attempt to contact the group of artists who lived there. He had not seen Ben Nicholson since the unsatisfactory stay in Switzerland twenty-five years earlier, and Bomberg was now far too isolated as an artist to find anything in common with his former friend. He remained with his family, studying the Zennor coastline in a mood of sustained exaltation. Even when the weather broke, so that rain vied with sunshine for supremacy over Cornwall, he was able to let this turbulence enter his painting and animate it with a new dynamism (cat.171).

The Cornwall trip yielded the most outstanding British landscapes Bomberg ever executed. But he still longed for the heat and light of the Mediterranean, and his inability to continue after returning from Zennor demonstrated that London did not provide him with the right atmosphere for the development of his own work. Hence the alacrity with which he took up the suggestion of an architect friend to visit Cyprus in the summer of 1948. It was an ideal location, more fiery than Spain and burnished with colours which helped Bomberg to develop a more vehement palette. His Cyprus paintings are often inflammatory in their impact. They revel in a country that seems about to flare into outright conflagration, and the ruins of St. Hilarion gave him the chance to pursue the interaction between architecture and

landscape which he had explored so fruitfully at Ronda (cats.173-6, 178, pls.54,55,56).

By no means all the Cyprus canvases are as exclamatory in their response. Bomberg painted the Moorish Wall at St Hilarion in a far more subdued range of colours (cat.176), investigating a deeply shadowed hillside with the avidity he had earlier bestowed on the inferno of 'Trees and Sun' at Platres (cat.177). The Monastery of Ay Chrisostomos, where the family stayed later in the expedition, likewise led to a more restrained approach (cat.179,pl.57). But just as the remote Monastery of St George, Wadi Kelt, had impressed Bomberg sufficiently to produce some of his finest Palestine paintings (cats.92-3), so he now studied the terrain around the Cyprus monastery with great intensity. Although brush strokes and colours alike are less excitable than they had been in the festive 'Castle Ruins, St. Hilarion' (cat.173, pl.54), they remain equally eloquent. Andrew Forge was justified in maintaining that 'the great fiery landscapes of 1948' deserve 'to be compared with the best of his contemporaries in Europe.'

Very few of these remarkable canvases were exhibited during Bomberg's lifetime. When he displayed his work in the 1951 London Group show, John Berger was perceptive enough to declare in a review of the exhibition that 'perhaps the most outstanding painting is a ravine landscape by David Bomberg. Bomberg's apparently careless and passionate use of paint has weight and guts to it, one is thrilled by a brush mark as a juicy slash of paint and as a precise statement of the angle of declivity of a gully, seen through atmosphere.' But Berger's acute analysis of the complex role performed by Bomberg's brushwork, emphasizing the substance of pigment and gesture while it stayed faithful to the character of the terrain he scrutinised, was not shared by other critics. They forebore to comment, and in the same year Bomberg found that his classes at the Borough Polytechnic had been reduced to Wednesday and Friday evenings only. Although he always advised his students to 'keep the paint moving, even if it is only for six hours a week', he failed to heed his own advice. Bomberg did not paint for around three years after returning from Cyprus, reserving the practice of his art for occasional demonstrations in the Borough class. 'Once I watched him draw over a student's drawing', recalled Leon Kossoff. 'I saw the flow of form. I saw the likeness to the sitter appear. It seemed an encounter with what was already there and I'll never forget it.'

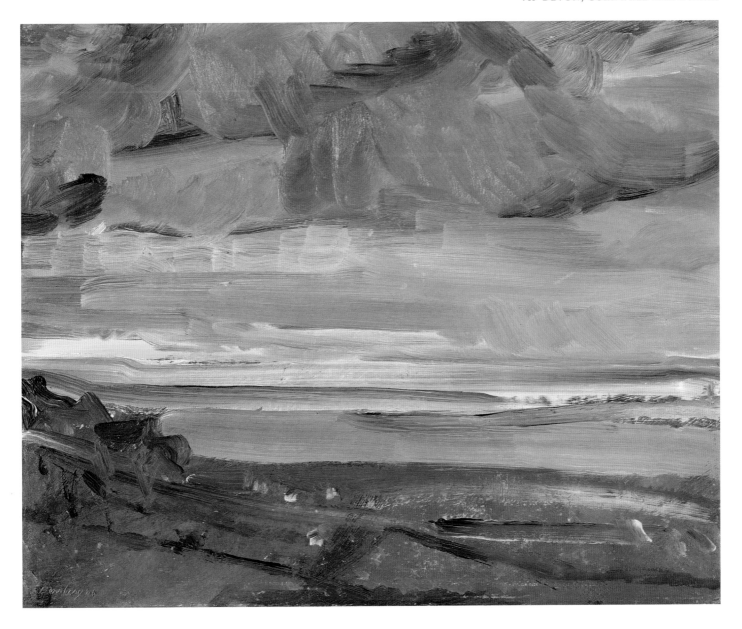

pl.51, cat.165 **Sunset, Bideford Bay, North Devon** 1946

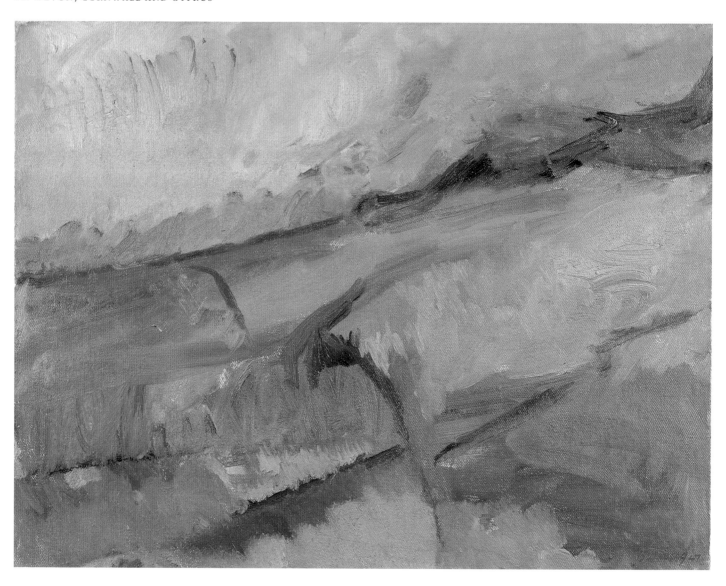

pl.52, cat.168 **Trendrine, Cornwall** 1947

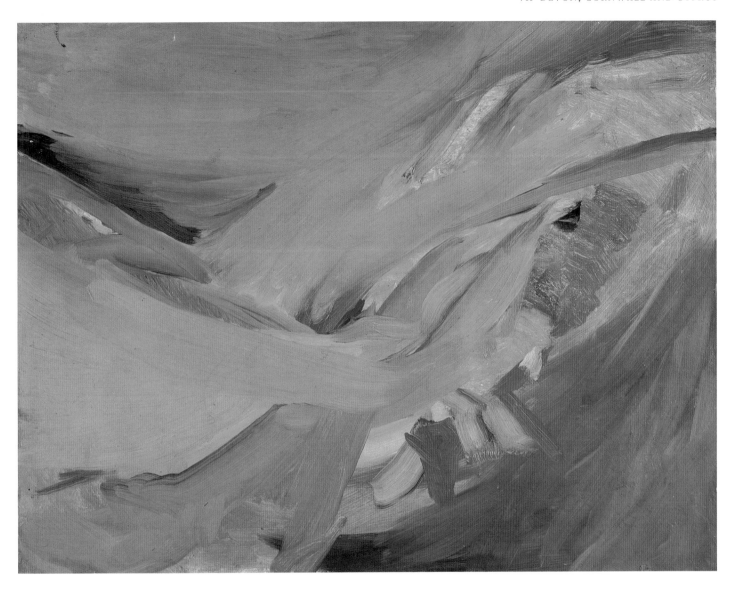

pl.53, cat.170 **Trendrine in Sun, Cornwall** 1947

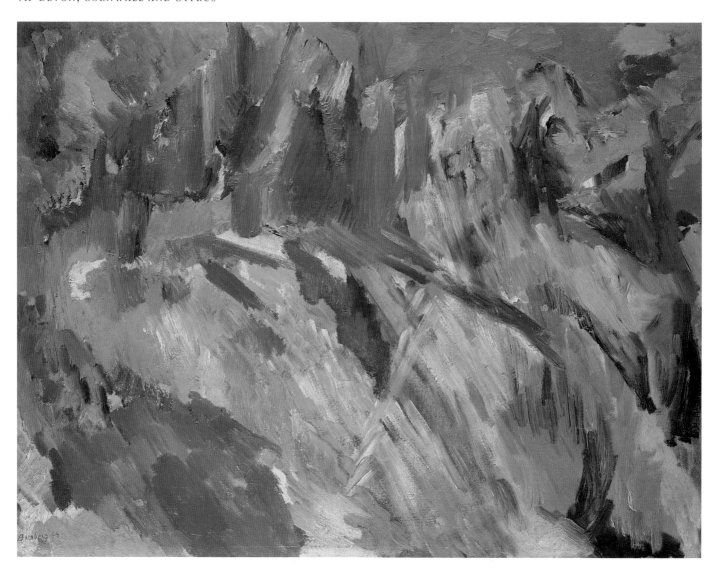

pl.54, cat.173 **Castle Ruins, St. Hilarion, Cyprus** 1948

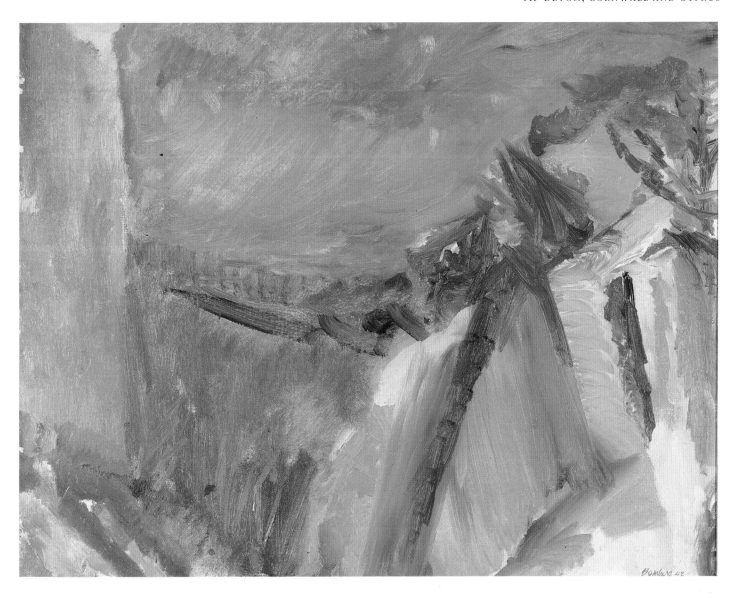

pl.55, cat.175 **Rock Fortress, Cyprus** 1948

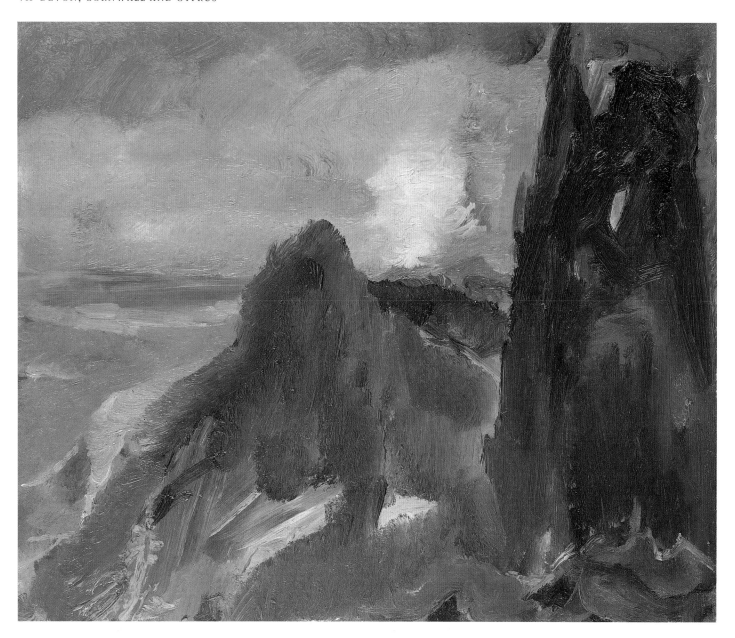

pl.56, cat.178 **Sunset, Mount Hilarion, Cyprus** 1948

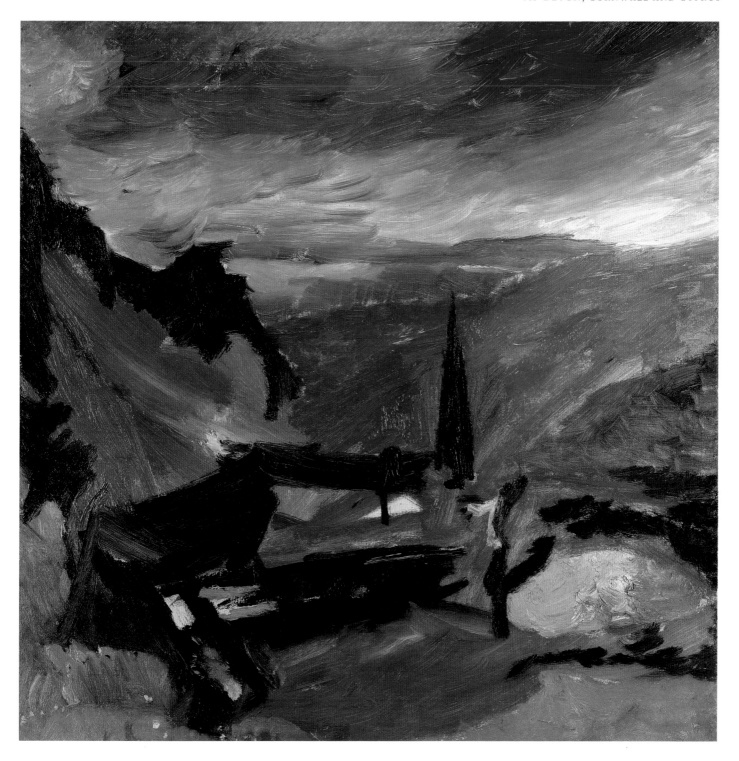

pl.57, cat.179 **Monastery of Ay Chrisostomos, Cyprus** 1948

VIII The Return to Ronda

The long period when Bomberg was unable to paint, between 1949 and 1952, finally came to an end when Dinora offered to sit for him. During the course of a single session lasting a few hours he executed three portraits, culminating in a sonorous half-length which proved that he had lost none of his ability to arrive at the essence of a sitter's personality (cat.180, pl.58). Soon afterwards, near the end of a difficult period with his students and Lilian alike, he produced a radically simplified painting called 'Mother of Venus' which acted as a metaphor of estrangement (cat.183). Like 'The Rokeby Venus', the woman in Bomberg's canvas is turned away from the viewer. But unlike Velázquez's painting, the mood remains un-relievedly sombre and no glimpse of her face is provided by a background mirror.

The breakdown of his relationship with Lilian was only a temporary affair, and with the help of a local Hampstead priest they became reconciled. But the introspective mood which had produced 'Mother of Venus' lingered on, affecting the self-portrait he painted a few months later. He called it 'Talmudist' (cat.182), as if to acknowledge the continuing influence of his Jewish heritage, and the broken handling of this shadowy face heralds the sense of dissolution which would play such a powerful part in the last portraits he produced.

They belong to the second Ronda period, which commenced in the spring of 1954 when Bomberg and Lilian revisited the Andalucian town where he had produced so many notable canvases nearly twenty years before. But to begin with, at least, he concentrated on painting and drawing the landscape – an aim commensurate with the intentions behind the short-lived school he established with Lilian at the Villa Paz. The brochure announced that it would provide 'a summer and winter course annually in Spain for students of all countries in painting, sculpture and architecture and others in the profession of the visual arts.' Uphold-ing the principles he had promulgated at the Borough, the brochure went on to promise that the Villa Paz school intended 'to free the Practice of Art, from the precepts and limitations involved in the academic inheritance from the seventeenth century onwards, and members of the course will be encouraged to comprehend and interpret their individual assessment of Mass in the representation of form, whether in Landscape, Architecture, or working from Life in the various aspects of Drawing and Painting.'

After the venture came to a swift end, Bomberg fulfilled its aims in his own work. He soon found his old passionate involvement with the Andalucian countryside returning in full force. 'Rising Wind, Ronda' defines a moment of dramatic unrest, when the motif he selected was about to be overtaken by turbulence (cat.187, pl.60). Bomberg's handling of the mountain is inescapably reminiscent of Cézanne's Mont Saint-Victoire, and goes a long way towards explaining why he had paid a particular tribute to the French master in his catalogue introduction to the Borough Bottega exhibition of 1953. He had admired Cézanne ever since encountering his work for the first time at Fry's *Manet and the Post-Impressionists* survey in 1910. 'Rising Wind, Ronda' confirms his veneration, while declaring a romantic sensibility and unfettered handling quite distinct from Cézanne's more disciplined rigour.

Bomberg did not always need storms to make him focus on the animism of nature. The drawings he executed at Ronda, many of which deserve to be ranked among the finest

manifestations of his draughtmanship, become increasingly attentive to the dynamism pervading the wild, rocky terrain around him (cats.184–5). During the expeditions to Devon, Cornwall and Cyprus, drawing had played no part in his response to the landscape he scrutinised. But now, encouraged perhaps by the charcoal studies he had made during a visit to the cathedrals of Notre Dame, Avalon, Vézelay and Chartres in 1953 (cat.181), his interest in drawing revived. Rubbing the charcoal with his fingers to enhance the tactility of his perceptions, he attained a more heightened relationship with the Spanish countryside. The dilapidated Casa de la Virgen de la Cabeza, where he and Lilian made their last home outside Ronda, affords magnificent views of both the town and the terrain surrounding it. Bomberg made full use of them, studying the epic bareness of the earth as well as the surging mass of rock with the houses perched so precipitously on its ridge (cats.194–202).

In view of his rapidly worsening health, and the depression caused by the Tate Gallery's misrepresentation of his work in its *Wyndham Lewis and Vorticism* exhibition, Bomberg's ability to produce these final images takes on a heroic dimension. An overriding sense of conviction drove on the infirm artist when his body threatened to fail him, and he produced in the unusually large drawing entitled 'Valley of the Tajo' a magnificent summation of his prolonged obsession with Ronda's vertiginous plateau (cat.189, pl.62). The will-power required to make such titanic images despite his physical weakness was formidable, as Bomberg's former student Peter Richmond realised when he settled in Ronda around this time. 'Bomberg had a profound belief in the integrity of the individual: that if the individual would be true to the vision he was given, he was an irresistible force in the world', Richmond recalled afterwards. 'Against the tyranny of systems, the tyranny of ideas, the tyranny of hopes and fears, he set his faith in the power of individual vision, realised through individual energy in individual work, to free man from tyranny without and within.'

Hence the emphasis on the solitary artist in the most powerful of Bomberg's late figure paintings, 'Hear O Israel' and the 'Last Self-Portrait' (cats.191–2, pls.64,65). Both images expose the painter in all his desolating loneliness and confess to despair with lacerating honesty. But the vibrant action of light also serves an affirmative purpose, asserting Bomberg's belief in 'the power of individual vision' as he confronts the inevitability of death. The more his corporeal strength ebbed, the closer he came to divining the elusive force immanent in nature. The last landscape Bomberg painted, 'Tajo and Rocks, Ronda', brings his involvement with the Andalucian country to a poignant conclusion by stressing its incipient dissolution (cat.193, pl.66). All the former solidity gives way, here, to a vision of nature divested of substance and almost melting in the light. The painting's chromatic richness enhances Bomberg's apprehension of flux, as land and sky merge in a fugitive haze of brushstrokes. His dreamlike canvas amounts to a moving final testament, painted by a man who has become reconciled to the transience permeating the apparent impregnability of Ronda. But even as it bids farewell to the landscape he cherished above all others, this valedictory painting penetrated to the heart of 'the spirit in the mass.'

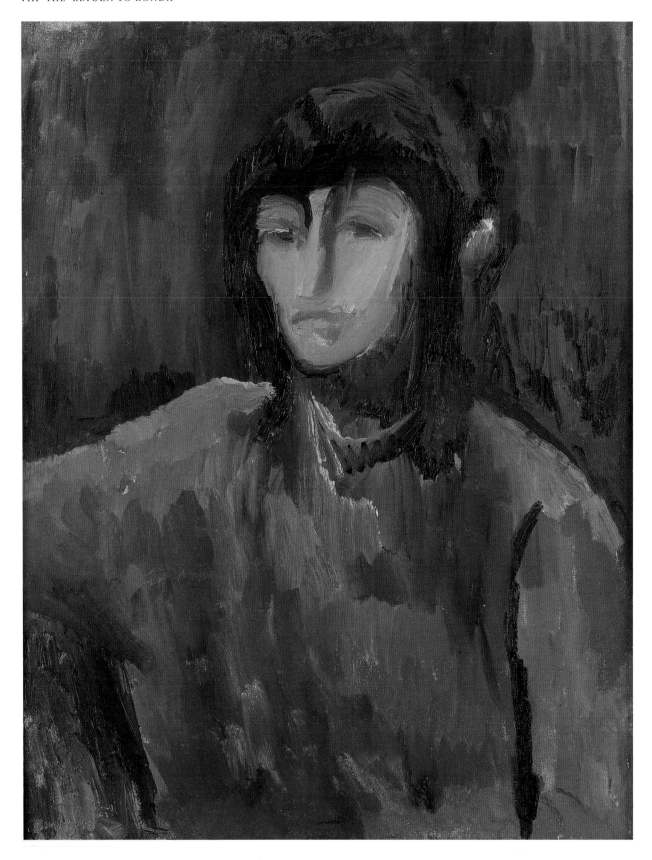

pl.58, cat.180 **Portrait of Dinora** 1952

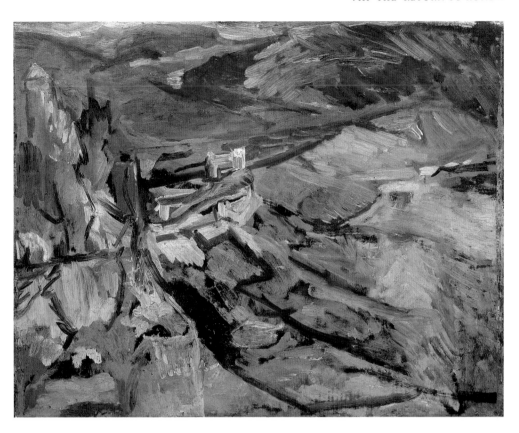

pl.59, cat.186 **Ronda, towards
El Barrio, San Francisco** 1954

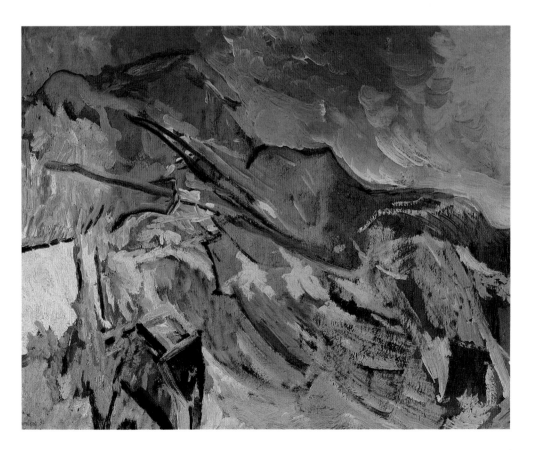

pl.60, cat.187
Rising Wind, Ronda 1954

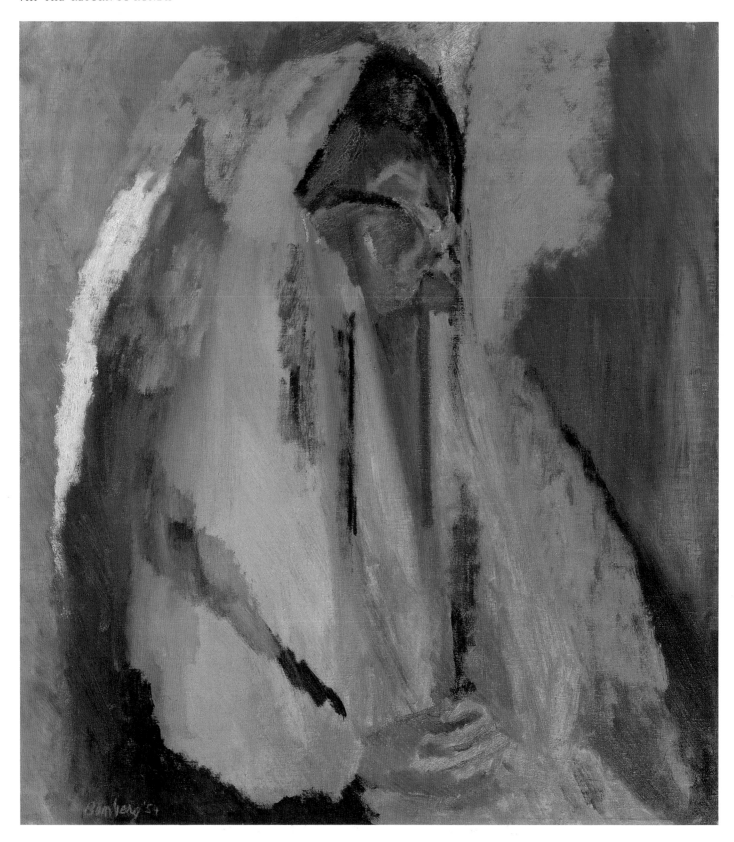

pl.61, cat.188 **Soliloquy, Noonday Sun, Ronda** 1954

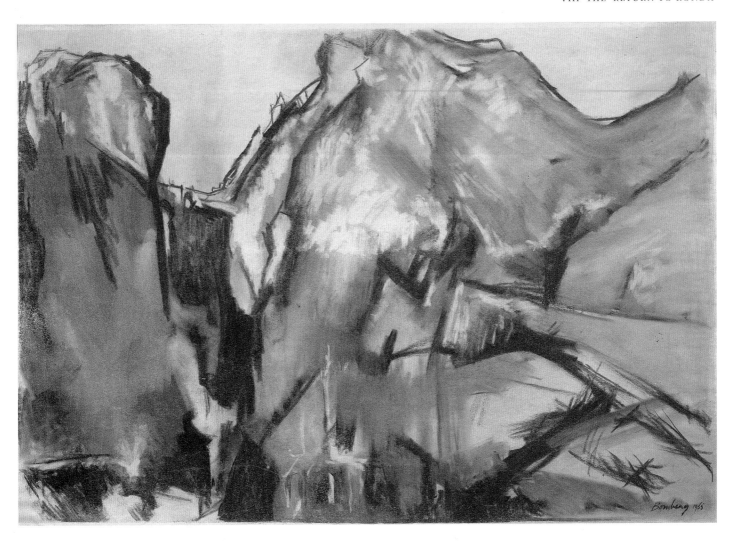

pl.62, cat.189 **Valley of the Tajo** 1955

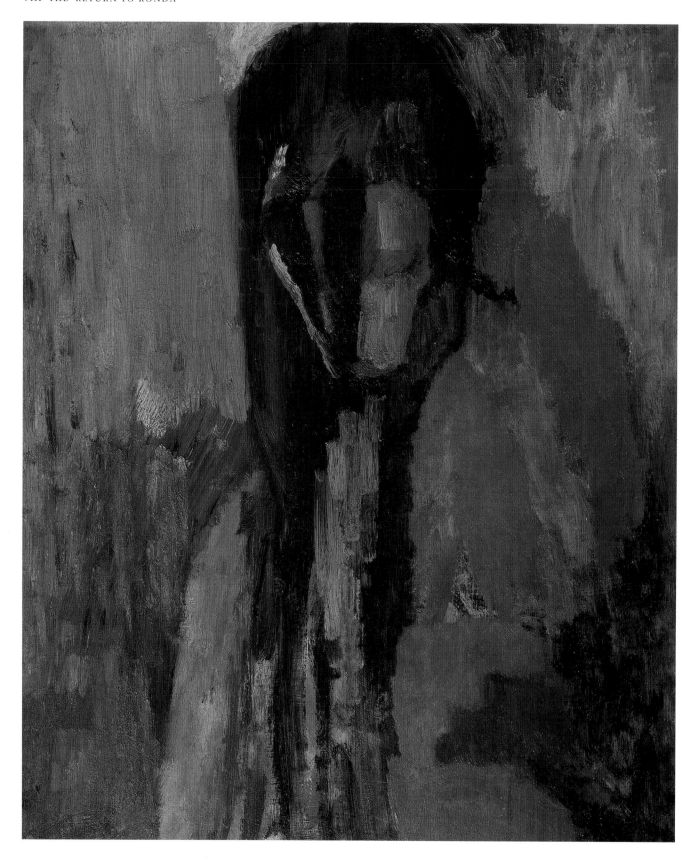

pl.63, cat.190 **Vigilante** 1955

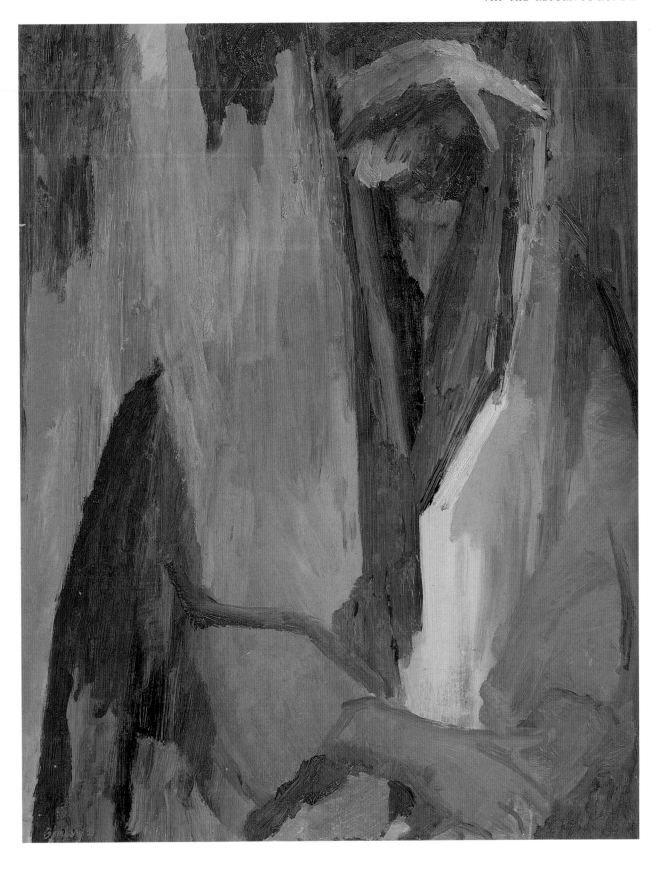

pl.64, cat.191 **'Hear O Israel'** 1955

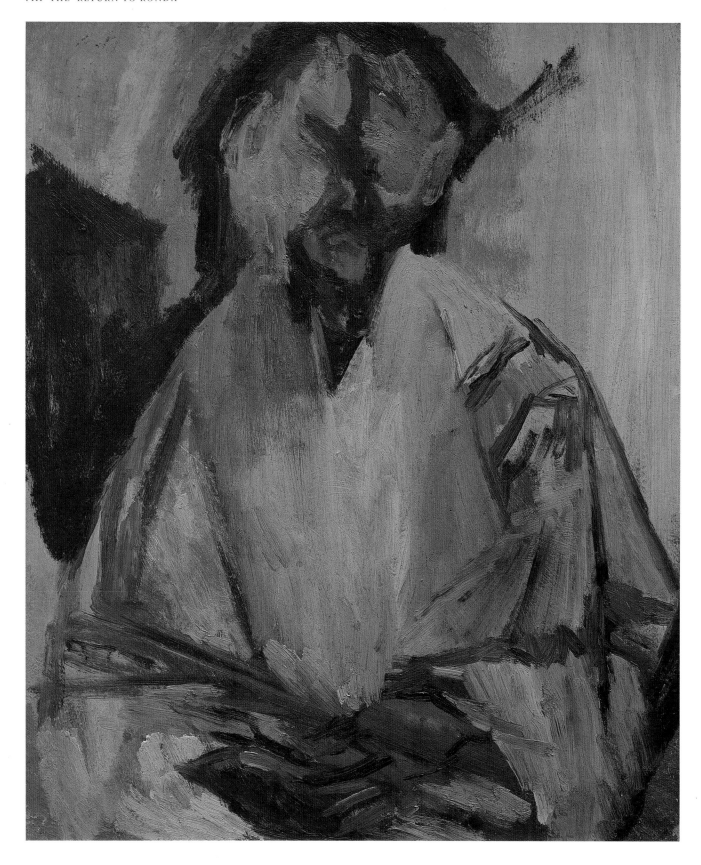

pl.65, cat.192 **Last Self-Portrait** 1956

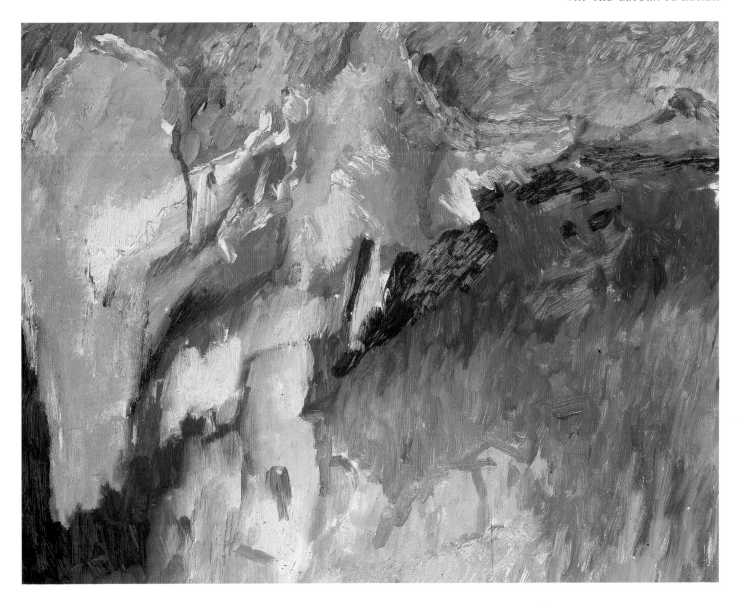

pl.66, cat.193 **Tajo and Rocks, Ronda** 1956

Dinora Davies-Rees. Photograph of David
and Lilian Bomberg at La Casa de la Virgen
de la Cabeza with Ronda beyond, 1956.
Artist's Family.

Catalogue List

Measurements are given in inches
followed by centimetres in brackets;
height precedes width.

I *The Early Years*

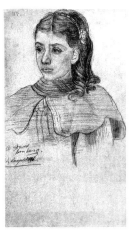

**1 Portrait of the artist's sister,
Rachel** 1905–6
Charcoal on paper $14 \times 11\frac{1}{2}$ (35 × 28.7)
Tate Gallery Archive

2 Self-Portrait 1909
Pencil on paper $6\frac{1}{4} \times 4\frac{3}{4}$ (16 × 12)
Artist's Family

**3 Classical Composition (Judgement
of Solomon?)** 1910
Crayon and charcoal on paper
$10\frac{3}{4} \times 14\frac{5}{8}$ (27.7 × 37.3)
Private Collection, New York

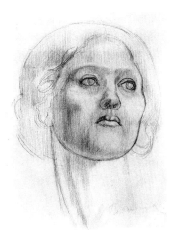

4 Head of a Girl *c.*1911
Pencil on paper $12\frac{3}{8} \times 9\frac{3}{8}$ (31.4 × 23.7)
Private Collection, Washington DC

5 Bedroom Picture *c.*1911–12
Oil on canvas $29\frac{1}{2} \times 28\frac{3}{8}$ (75 × 72)
Private Collection

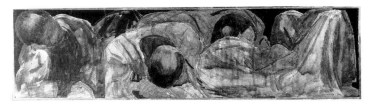

6 Sleeping Men 1911
Watercolour on paper
$8\frac{3}{4} \times 35\frac{1}{2}$ (22.2 × 90.2)
Tate Gallery

7 Studies of the Posed Model and other Compositions 1911–12
Pencil on paper 14¾ × 11 (37.7 × 28)
Artist's Family

8 Head of a Girl 1912
Pencil on paper 10⅝ × 8⅝ (27 × 22)
Anthony d'Offay Gallery, London

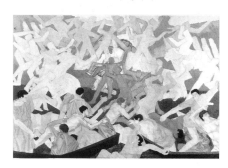

9 Island of Joy c.1912
Oil on canvas 54 × 80½ (137 × 204.5)
Private Collection
plate 1

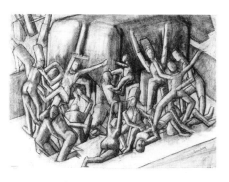

10 Struggling Figures: Study for Vision of Ezekiel c.1912
Charcoal on paper 19 × 22 (48 × 68)
Board of Trustees of the Victoria and Albert Museum

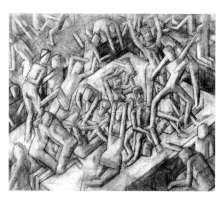

11 Study for Vision of Ezekiel c.1912
Charcoal and pencil on paper
22 × 26¾ (56 × 68)
Private Collection

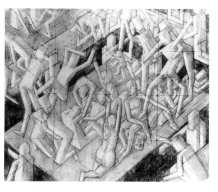

12 Study for Vision of Ezekiel c.1912
Chalk and pencil on paper
27 × 22 (56 × 68)
Tate Gallery

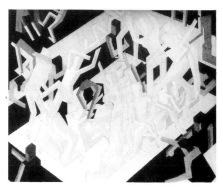

13 Vision of Ezekiel 1912
Oil on canvas 45 × 54 (114.5 × 137)
Tate Gallery
plate 2

14 Lyons Café 1912
Oil on panel 15¾ × 12¾ (39.9 × 32.6)
Private Collection

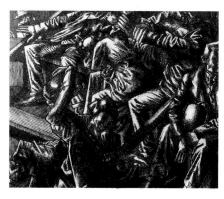

15 Jewish Theatre 1913
Chalk on paper 21⅝ × 23¾ (55 × 60.5)
Leeds City Art Galleries

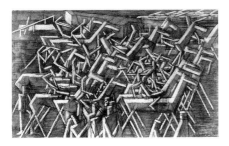

16 Racehorses 1912–13
Chalk and wash on paper
$16\frac{1}{2} \times 25\frac{1}{2}$ (42×65)
Warden and Fellows of Nuffield College,
Oxford

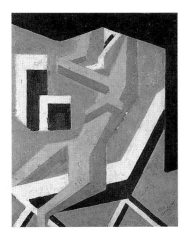

17 Figure Study *c.*1913
Oil on board $16 \times 12\frac{5}{8}$ (40.5×32)
Richard Salmon, London
plate 3

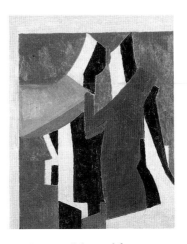

18 Composition with
Figures 1912–13
Oil on panel 16×13 (41×32.8)
Whitworth Art Gallery, University of
Manchester
plate 4

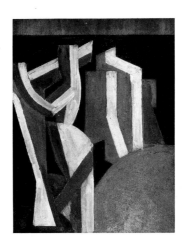

19 Figure Composition *c.*1913
Oil on board $14 \times 10\frac{1}{4}$ (35.5×26)
City of Bristol Museum and Art Gallery
plate 5

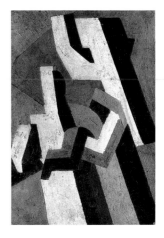

20 Figure Composition *c.*1913
Oil on board $13\frac{3}{4} \times 10\frac{1}{4}$ (35.1×25.8)
Manchester City Art Galleries

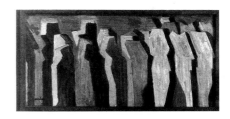

21 London Group *c.*1913
Oil on panel $12\frac{3}{4} \times 27$ (33×68)
Israel Museum, Jerusalem

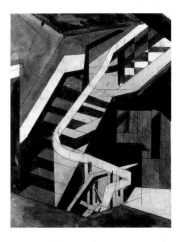

22 Interior *c.*1913
Watercolour and pencil on paper
15×11 (38×28)
Board of Trustees of the Victoria & Albert
Museum
plate 6

23 Cubist Composition *c.*1913
Ink on paper 11 × 10 (28 × 25.5)
Anthony d'Offay Gallery, London

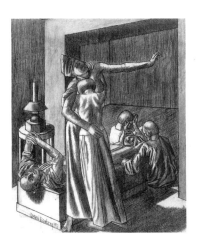

25 Family Bereavement 1913
Pencil and charcoal on paper
22 × 18½ (56 × 47)
Fischer Fine Art Ltd, London

27 Family Bereavement *c.*1913
Charcoal and conté on paper
21½ × 18¼ (54.5 × 46.2)
Mr and Mrs Geoffrey Chin

24 Cubist Composition *c.*1913
Pencil, watercolour and gouache on paper
10¾ × 10 (27.5 × 25.5)
Anthony d'Offay Gallery, London

26 Family Bereavement 1913
Watercolour on paper 22 × 19 (56 × 48.2)
Mr and Mrs Geoffrey Chin

II The Mud Bath Period

28 Study for Ju-Jitsu *c.*1913
Chalk on paper 21½ × 22 (54.5 × 56)
University of East Anglia
Collection of Abstract Art and Design

29 Ju-Jitsu *c.*1913
Oil on cardboard 24½ × 24½ (62 × 62)
Tate Gallery
plate 7

30 The Return of Ulysses *c.*1913
Black crayon on paper
12 × 18½ (30 × 46.5)
Museum of Modern Art, New York
(The Joan and Lester Avnet Collection)

31 Chinnereth *c.*1914
Chalk on paper 18 × 21 (45.5 × 53.5)
Warden and Fellows of Nuffield College,
Oxford

32 Acrobats 1913–14
Chalk on paper 18½ × 22½ (47 × 57)
Board of Trustees of the Victoria & Albert
Museum

33 Composition 1914
Crayons on paper 22 × 24 (55.5 × 59.5)
Ivor Braka Limited, London
plate 8

34 Study for In the Hold 1913
Crayon on paper 22¾ × 20 (58 × 51)
Private Collection

35 Study for In the Hold 1913–14
Chalk on paper 21¾ × 26 (55.5 × 66)
Tate Gallery

36 In the Hold 1913–14
Oil on canvas 78 × 101 (198 × 256.5)
Tate Gallery
plate 9

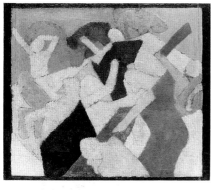

37 Bathing Scene 1912–13
Oil on drawing panel 22 × 27 (56 × 68.6)
Tate Gallery

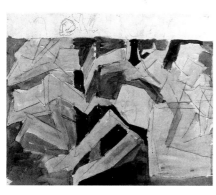

38 Study for The Mud Bath
(recto) *c.*1914
Pencil and watercolour on paper
$11\frac{1}{4} \times 13\frac{3}{4}$ (28.6 × 34.9)
Tate Gallery

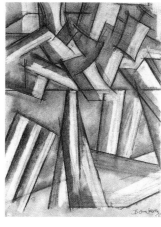

39 Study for The Mud Bath *c.*1914
Chalk and wash on paper
$27 \times 19\frac{3}{4}$ (68.5 × 50)
Mr & Mrs Fayez Sarofim
plate 10

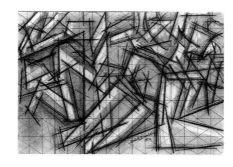

40 Study for The Mud Bath 1914
Black chalk and red crayon on paper
19 × 27 (48.5 × 68.5)
Israel Museum, Jerusalem
Gift of the Hanadiv Foundation, London 1971

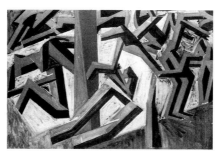

41 Gouache Study for The Mud Bath
II (recto) 1914
Gouache on paper 18 × 27 (45 × 68)
Ivor Braka Limited, London

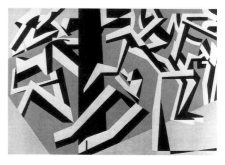

42 The Mud Bath 1914
Oil on canvas $60 \times 88\frac{1}{4}$ (152.5 × 224)
Tate Gallery
plate 11

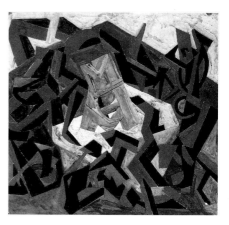

**43 Composition: Study for Reading
from Torah** (?) (recto) *c.*1914
Gouache on paper $21\frac{3}{4} \times 23\frac{3}{4}$ (52.5 × 59)
Private Collection

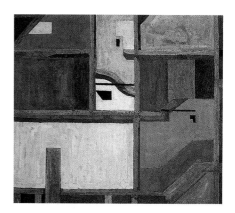

44 Composition (Green) *c.*1914
Gouache and varnish on paper
$11\frac{1}{4} \times 12\frac{1}{4}$ (28.3 × 31.4)
Anthony d'Offay Gallery, London
plate 12

CATALOGUE LIST

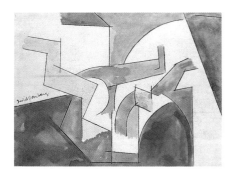

45 Abstract Composition *c.*1914
Pencil and watercolour on paper
$10\frac{3}{4} \times 14\frac{3}{8}$ (27.5 × 36.5)
Anthony d'Offay Gallery, London
plate 13

46 Drawing: Zin (?) *c.*1914
Chalk on paper 22 × 55 (56 × 63.5)
Private Collection

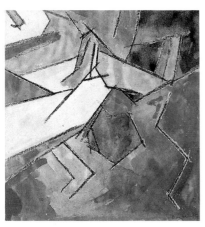

47 Abstract Design *c.*1914
Chalk and watercolour on paper
$10\frac{3}{4} \times 10\frac{1}{4}$ (27.3 × 26)
Collection of Mellon Bank
plate 14

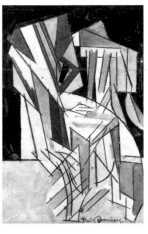

48 The Dancer 1913–14
Pencil, watercolour and gouache on paper
$10\frac{3}{4} \times 7\frac{1}{4}$ (27.5 × 18.5)
Anthony d'Offay Gallery, London

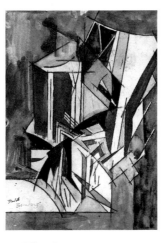

49 The Dancer 1913–14
Watercolour on paper 15 × 11 (38 × 28)
*Trustees of the Cecil Higgins Art Gallery,
Bedford*

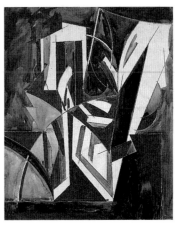

50 The Dancer 1913–14
Crayon, watercolour and gouache on
paper $26\frac{1}{2} \times 21\frac{3}{4}$ (67.5 × 55.5)
Anthony d'Offay Gallery, London
plate 15

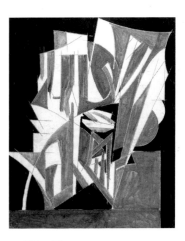

51 The Dancer 1913–14
Wax crayon and watercolour on paper
27 × 22 (68.5 × 56)
*Board of Trustees of the Victoria & Albert
Museum*
plate 16

[149]

52 The Dancer *c.*1914
Watercolour and chalk on paper
$14\frac{1}{4} \times 10\frac{1}{4}$ (36 × 26)
Ms Joan Rodker

III *War and Aftermath*

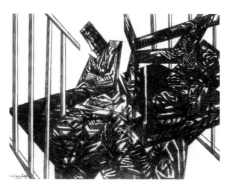

53 Billet 1915
Black ink on paper $15\frac{1}{2} \times 20$ (39.5 × 51)
Board of Trustees of the Victoria & Albert Museum

54 Figures Helping a Wounded Soldier *c.*1916–17
Ink on paper $4\frac{7}{8} \times 6\frac{3}{4}$ (12.5 × 17)
Private Collection

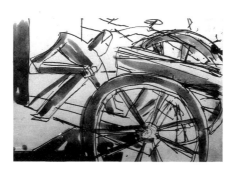

55 Gunner Loading Shell *c.*1918
Ink and wash on paper $4\frac{7}{8} \times 6\frac{3}{4}$ (12.5 × 17)
Artist's Family

56 Soldier Patrolling Tunnel *c.*1918
Ink and wash on paper $6\frac{3}{4} \times 4\frac{7}{8}$ (17 × 12.5)
Artist's Family

57 War Study *c.*1918
Ink and wash on paper $4\frac{7}{8} \times 6\frac{3}{4}$ (12.5 × 17)
Artist's Family

58 War Scene *c.*1918
Ink and wash on paper $6\frac{3}{4} \times 4\frac{7}{8}$ (17 × 12.5)
Artist's Family

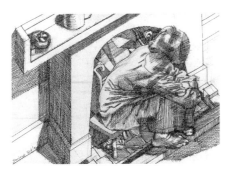

59 Fireside 1918
Ink and pencil on paper
$12\frac{1}{2} \times 18\frac{1}{4}$ (32 × 46.6)
Anthony d'Offay Gallery, London

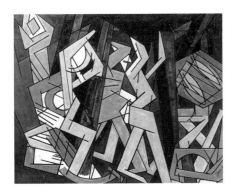

60 Study for 'Sappers at Work': A Canadian Tunnelling Company *c.*1918
Oil and watercolour on paper
$9\frac{1}{2} \times 12\frac{5}{8}$ (24 × 32)
Anthony d'Offay Gallery, London
plate 17

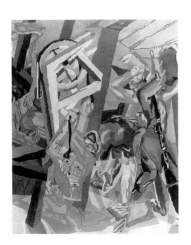

61 'Sappers at Work': A Canadian Tunnelling Company
(First Version) 1918–19
Oil on canvas $119\frac{3}{4} \times 96$ (304 × 244)
Tate Gallery

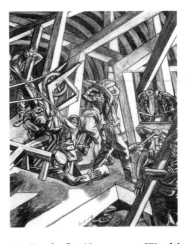

62 Study for 'Sappers at Work': A Canadian Tunnelling Company
(Second Version) 1918–19
Charcoal on paper $26\frac{1}{2} \times 22$ (67.3 × 55.9)
By courtesy of the Trustees of the Imperial War Museum

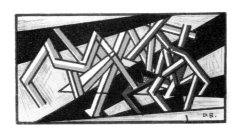

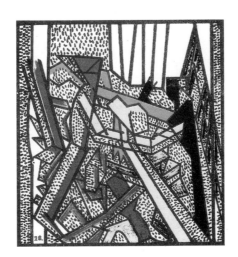

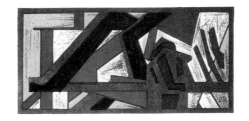

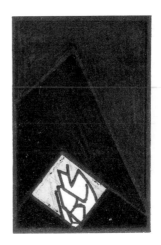

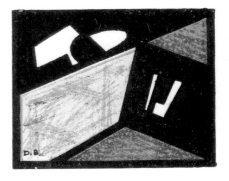

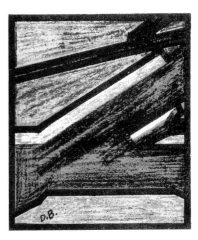

63 Russian Ballet lithographs 1914–19
Six colour lithographs, various sizes
Anthony d'Offay Gallery, London
plate 19

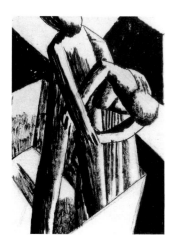

64 Men & Women 1919
Pen and ink wash on paper
10 × 8 (25.4 × 20.3)
Artist's Family

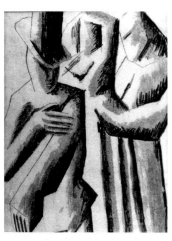

65 The Visitor 1919
Pen and ink wash on paper
10 × 8 (25.4 × 20.3)
Artist's Family

66 Lock-up 1919
Pen and ink wash on paper
10 × 8 (25.4 × 20.3)
Fischer Fine Art Ltd, London

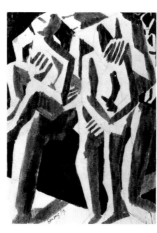

67 Family Group 1919
Pen and ink wash on paper
10 × 8 (25.4 × 20.3)
Private Collection, London

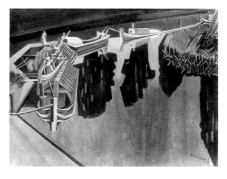

68 Barges 1919
Oil on canvas $23\frac{1}{2} \times 30\frac{1}{2}$ (59.7 × 77.5)
Tate Gallery
plate 20

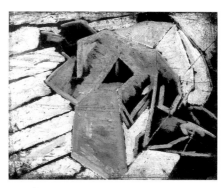

69 Bargees 1919–20
Watercolour on paper 24 × 30 (61 × 76.2)
Juliet Lamont

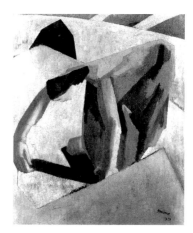

70 English Woman 1920
Oil on canvas 24 × 20 (61 × 51)
Ben Uri Art Society, London

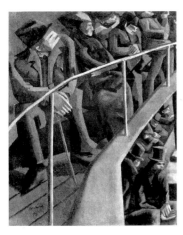

71 Ghetto Theatre 1920
Oil on canvas 30 × 25 (75.2 × 62.6)
Ben Uri Art Society, London
plate 21

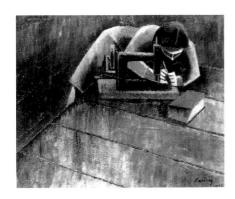

72 Woman and Machine 1920
Oil on canvas 24 × 30 (61 × 76.3)
Erich Sommer

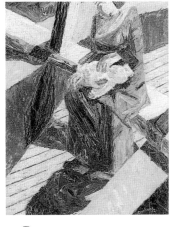

73 Bargee 1921
Oil on canvas 36 × 28 (91.5 × 71.1)
Thyssen-Bornemisza Collection
plate 22

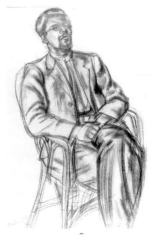

74 Portrait of Man *c.*1921
Black chalk 22 × 14½ (56 × 37)
Private Collection

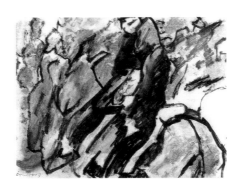

75 Vagrants 1920–22
Oil on paper 12⅝ × 16½ (32 × 42)
Artist's Family

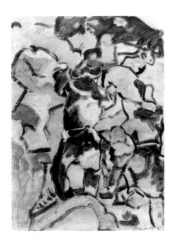

76 Players 1920–22
Oil on paper 16½ × 12⅝ (42 × 32)
Artist's Family

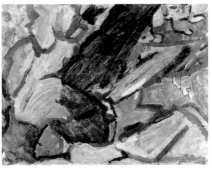

77 The Island: Land and Sea 1920–22
Oil on paper 12½ × 16 (31.3 × 40.2)
Joanna Drew

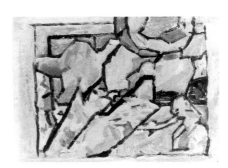

78 The Tent 1920–22
Oil on paper 13⅞ × 19¾ (35.2 × 50.2)
Tate Gallery
plate 23

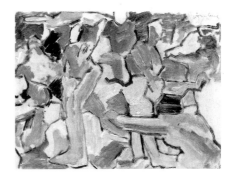

79 The Circus 1920–22
Oil on paper 12½ × 16 (31.7 × 40.5)
Collection of Cliff and Mandy Einstein

IV Palestine and Toledo

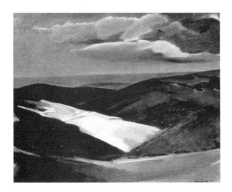

80 The Judaean Hills between Jerusalem and Jericho: Moonlight 1923
Oil on canvas $15\frac{3}{4} \times 19\frac{1}{2}$ (40 × 49.5)
Private Collection

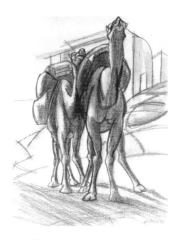

83 Camels 1923
Charcoal on paper $25\frac{3}{8} \times 20\frac{1}{2}$ (64.5 × 52)
Private Collection

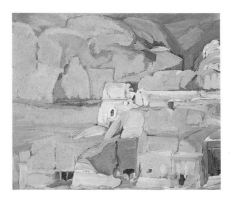

86 Steps to a 'High Place' on al Khubdha, Petra; early morning 1924
Oil on canvas $17\frac{3}{4} \times 21$ (44.5 × 53)
Private Collection

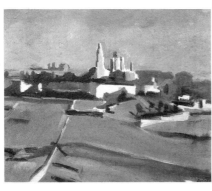

81 Mount Zion with the Church of the Dormition: Moonlight 1923
Oil on canvas 16×21 (40.6 × 51)
Ben Uri Art Society, London

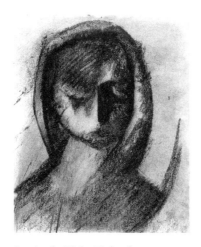

84 Arab Girl – Palestine 1923
Charcoal on paper $10\frac{1}{2} \times 9$ (58.4 × 43.2)
Private Collection

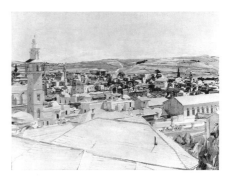

87 Jerusalem, looking to Mount Scopus 1925
Oil on canvas $22\frac{1}{8} \times 29\frac{3}{4}$ (56.2 × 75.5)
Tate Gallery
plate 25

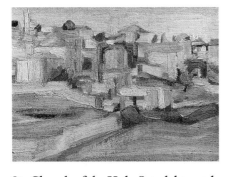

82 Church of the Holy Sepulchre and City, Jerusalem 1923
Oil on board $10\frac{1}{2} \times 14\frac{1}{2}$ (26.6 × 36.8)
Mrs Devora Barnett

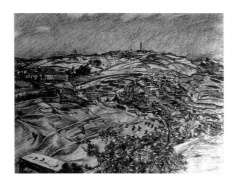

85 Mount of Olives 1923
Black chalk on paper $15 \times 19\frac{1}{8}$ (38 × 49)
Private Collection

88 Church of the Holy Sepulchre, Jerusalem 1925
Oil on canvas 24×20 (61 × 51)
Ivor Braka Limited, London

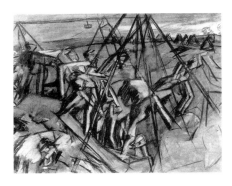

**89 Quarrying: Jewish Pioneer
Labour** *c*.1925
Black chalk on paper 20½ × 28½ (52 × 72.5)
R. Shovel

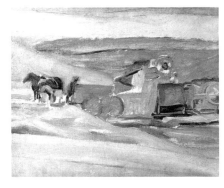

90 The Crushing Machine *c*.1925
Oil on board 12⅛ × 15¼ (30.9 × 39)
Private Collection, London

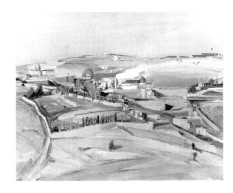

**91 The South East Corner,
Jerusalem** 1926
Oil on canvas 20 × 26 (51 × 66)
Private Collection

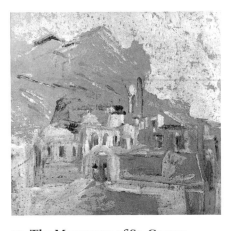

**92 The Monastery of St. George,
Wadi Kelt (?)** 1926
Oil on tissue paper 19 × 20 (48.5 × 51)
Fischer Fine Art Ltd, London

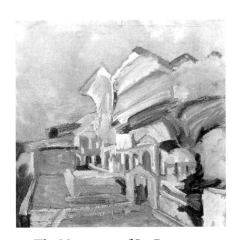

**93 The Monastery of St. George,
Wadi Kelt(?)** 1926
Oil on paper 20 × 20 (50.8 × 50.8)
Jewish Chronicle, London

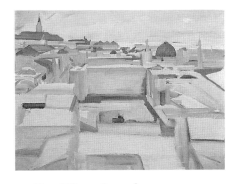

94 Roof Tops, Jerusalem 1927
Oil on canvas 26 × 33 (67.5 × 86)
Private Collection
plate 26

**95 The Ophthalmic Hospital of the
Order of St John** 1927
Oil on canvas 26 × 29¾ (67.3 × 76.2)
Museum of the Order of St. John

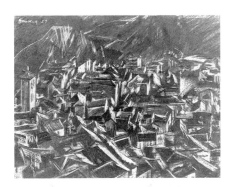

96 Toledo 1929
Charcoal and gouache on paper
28 × 32¼ (71 × 81.5)
Private Collection

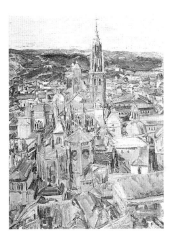

97 Cathedral, Toledo 1929
Oil on canvas 30½ × 23⅜ (77.5 × 59.5)
Private Collection
plate 27

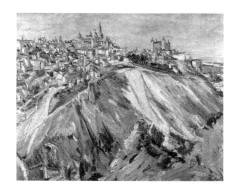

98 Toledo and River Tajo 1929
Oil on canvas 23 × 30 (58.4 × 76.2)
Oldham Art Gallery
plate 28

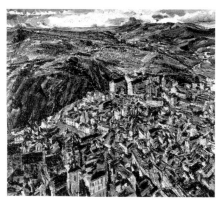

101 Toledo from the Alcazar 1929
Oil on canvas 26½ × 30 (67.3 × 76.2)
Mr Ota Adler CBE
plate 29

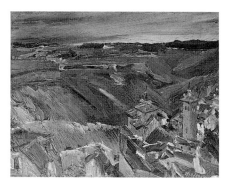

104 San Miguel, Toledo 1929
Oil on canvas 11¾ × 15 (31.5 × 40)
Private Collection

99 Sunset, Toledo 1929
Oil on canvas 22½ × 30 (58.4 × 76.2)
Private Collection

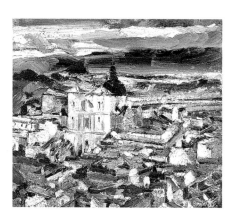

102 San Juan, Toledo: Evening 1929
Oil on canvas 15 × 16¾ (38.5 × 43.5)
Private Collection
plate 30

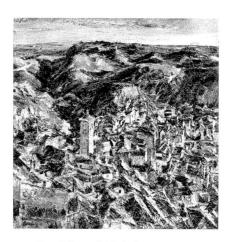

105 San Miguel, Toledo 1929
Oil on canvas 28 × 28 (71 × 71)
Ivor Braka Limited, London
plate 31

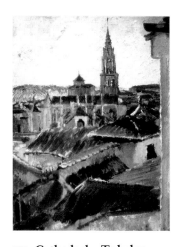

100 Cathedral, Toledo: Evening 1929
Oil on canvas 26 × 20 (66.1 × 50.8)
Private Collection

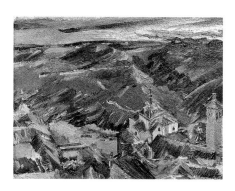

103 Convent and Tower, San Miguel, Toledo 1929
Oil on canvas 19¾ × 25¾ (50.2 × 65.5)
Keith Critchlow

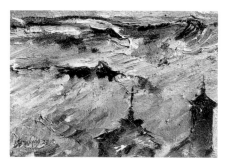

106 Hills in Mist, San Miguel, Toledo (The White Mist) 1929
Oil on canvas 9 × 13⅛ (22.8 × 33.1)
Juliet Lamont
plate 32

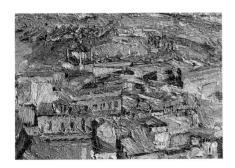

107 Outskirts of Toledo 1929
Oil on canvas $9 \times 13\frac{1}{8}$ (22.8 × 33.1)
Herman Collection

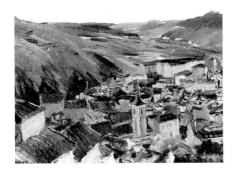

108 San Justo, Toledo 1929
Oil on canvas 20×26 (50.8 × 66)
Ferens Art Gallery, Hull City Museums and Art Galleries

V Cuenca, Ronda and the Flight to Britain

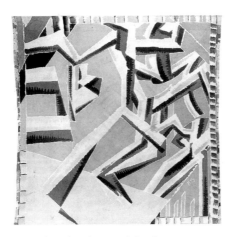

109 Shawl: The Mud Bath *c.*1929–30
Hand-painted silk 55×55 (139.8 × 139.8)
Board of Trustees of the Victoria & Albert Museum, London
plate 33

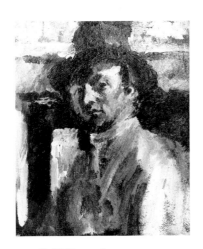

110 Self-Portrait 1931
Oil on board $23\frac{1}{2} \times 19\frac{1}{2}$ (59.8 × 49.5)
Private Collection
plate 34

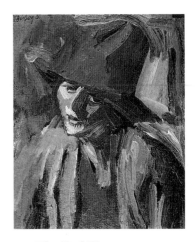

111 The Red Hat 1931
Oil on canvas $24\frac{1}{2} \times 20\frac{1}{4}$ (62 × 52)
Private Collection
plate 35

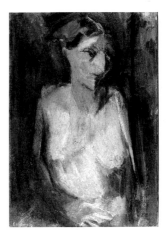

112 Lilian 1932
Oil on canvas 30×22 (76.2 × 55.9)
Tate Gallery

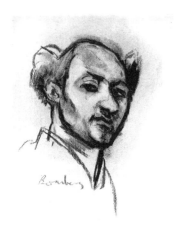

113 Self-Portrait *c.*1932
Charcoal on paper 19¾ × 15½ (50.3 × 39.5)
Private Collection

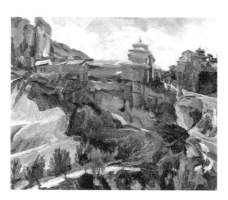

116 Hoz del Huecar and Convent of San Pueblo, Cuenca 1934
Oil on canvas 25 × 30 (63.5 × 76)
Private Collection
plate 36

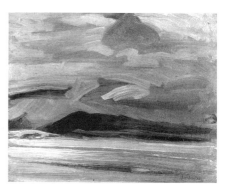

119 Mist: Mountains and Sea, Santander 1934
Oil on board 12½ × 16 (31.7 × 40.6)
Private Collection

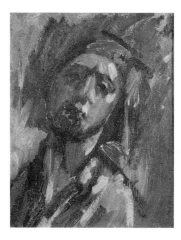

114 Portrait of the Artist 1932
Oil on canvas 20 × 16¼ (50.8 × 41.2)
Artist's Family

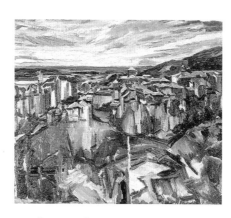

117 Sunset, Cuenca 1934
Oil on canvas 26¼ × 30½ (66.5 × 77.5)
Private Collection

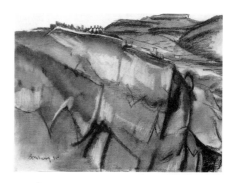

120 The Great Rock, Ronda 1935
Charcoal on paper 18¼ × 24½ (46.5 × 62.8)
J.D. and K.B.H.

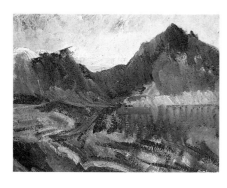

115 Brierloch – Glen Kinrich, Cairngorms 1932
Oil on canvas 19 × 26¼ (51 × 67.5)
Private Collection

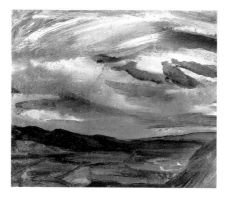

118 Storm Fury, Cuenca 1934
Oil on canvas 20¼ × 24¼ (51.5 × 61.7)
Private Collection, France

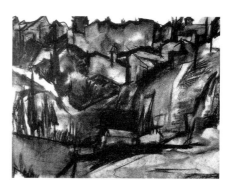

121 Ronda 1935
Charcoal on paper 18¼ × 24 (46.5 × 60)
Private Collection

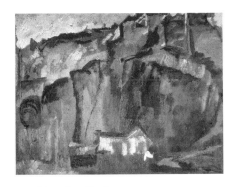

122 Ronda, Spain 1935
Oil on canvas $19\frac{1}{2} \times 25\frac{1}{2}$ (49.5×65)
Professor E. Boyland

125 Dark Street, Ronda 1935
Oil on canvas $30 \times 22\frac{3}{4}$ (77×59)
Private Collection

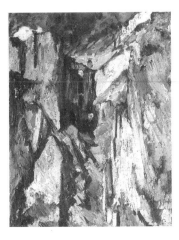

128 Ronda: In the Gorge of the Tajo 1935
Oil on canvas $36\frac{1}{2} \times 28\frac{1}{2}$ (92.7×72.3)
Private Collection
plate 38

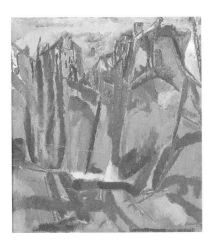

123 Moorish Ronda, Andalucia 1935
Oil on canvas $26\frac{1}{4} \times 24$ (66.7×61)
Ivor Braka Limited, London

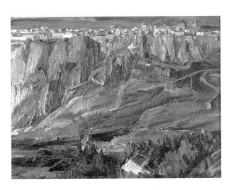

126 Ronda 1935
Oil on canvas 29×36 (73.7×91.5)
Private Collection

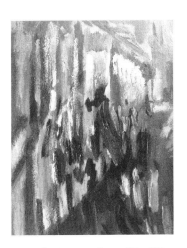

129 The Procession of La Virgen de la Paz 1935
Oil on canvas 24×20 (61×50.8)
Syndics of the Fitzwilliam Museum, Cambridge

124 The Moor's Bridge, Ronda 1935
Oil on canvas 30×26 (51×66)
Mr & Mrs Herbert L. Lucas

127 Sunset, Ronda, Andalucia 1935
Oil on canvas $26\frac{3}{4} \times 30$ (66.7×76.2)
Private Collector, New York
plate 37

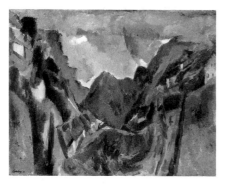

130 Storm over Peñarrubia 1935
Oil on canvas $28\frac{1}{2} \times 36\frac{3}{4}$ (76.2 × 96.6)
Private Collection
plate 39

133 Thames Barges 1937
Oil on canvas 20 × 24 (50.8 × 61)
Private Collection
plate 42

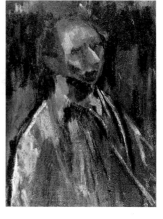

136 Self-Portrait 1937
Oil on canvas 30 × 28 (75.5 × 55)
*Scottish National Gallery of Modern Art,
Edinburgh*

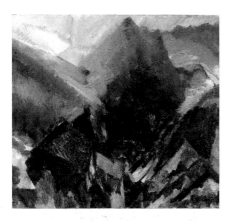

**131 Sunrise in the Mountains, Picos
de Asturias** 1935
Oil on canvas $23\frac{3}{4} \times 26\frac{3}{8}$ (59.3 × 67)
Private Collection
plate 40

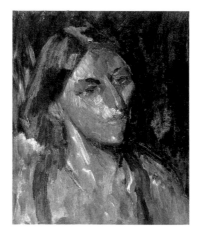

134 Portrait of Lilian 1937
Oil on canvas 24 × 20 (61 × 50.8)
Mr & Mrs Herbert L. Lucas

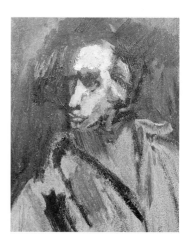

137 Self-Portrait 1937
Oil on board 24 × 20 (61 × 50.8)
Private Collection

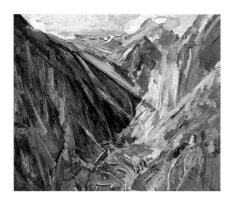

**132 Valley of La Hermida, Picos de
Europa, Asturias** 1935
Oil on canvas $35\frac{3}{4} \times 41\frac{1}{2}$ (91 × 107.1)
Sheffield City Art Galleries
plate 41

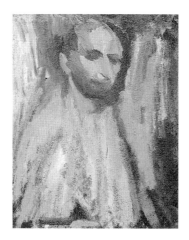

135 Self-Portrait 1937
Oil on canvas 24 × 20 (61 × 50.8)
Arts Council of Great Britain
plate 43

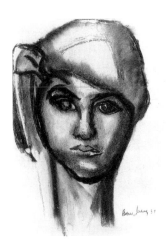

138 Dinora 1937
Charcoal on paper 17 × 13 (43.2 × 33.1)
Artist's Family

**140 Design for 'Belshazzar':
Babylonian Nobleman** 1937
Charcoal and watercolour on paper
20 × 16 (50.8 × 40.7)
Juliet Lamont

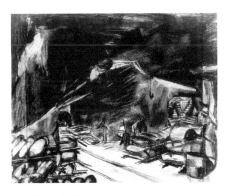

142 Bomb Store 1942
Charcoal on paper 21 × 26 (53.5 × 66)
*By courtesy of the Trustees of the Imperial
War Museum*

139 The Baby Diana 1937
Oil on canvas 29 × 38 (50.2 × 40.3)
Tate Gallery

**141 Design for 'Belshazzar':
Babylonian Woman** 1937
Watercolour on paper 18¾ × 22
(47.7 × 55.9)
Juliet Lamont

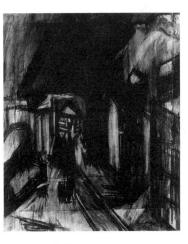

143 Bomb Store 1942
Charcoal and chalk on paper
31¼ × 27¼ (79.4 × 69.2)
Royal Air Force Museum, Hendon

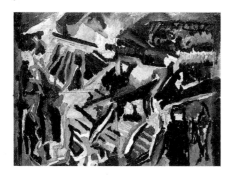

144 Bomb Store 1942
Oil on canvas 30 × 36 (76 × 91.5)
Private Collection
plate 44

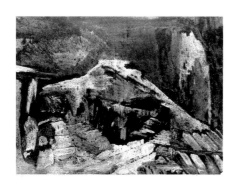

145 Underground Bomb Store 1942
Oil on paper 31¾ × 42½ (80.6 × 108)
Fischer Fine Art Ltd, London

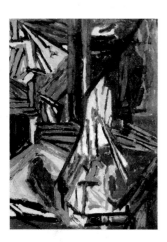

146 Bomb Store 1942
Oil on paper 30¼ × 22⅞ (76.5 × 57.8)
Private Collection
plate 45

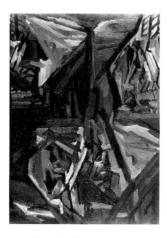

147 Bomb Store 1942
Oil on paper 30¼ × 22⅞ (76 × 57.5)
Private Collection

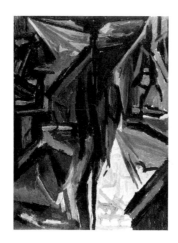

148 Bomb Store 1942
Oil on paper 30¼ × 22¾ (76.5 × 57.5)
Private Collection

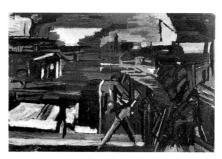

149 Bomb Store 1942
Oil on paper 25½ × 39⅜ (65 × 100)
Artist's Family

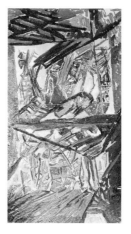

150 Bomb Store 1942
Oil on paper 53¾ × 30¼ (136.5 × 77)
Artist's Family

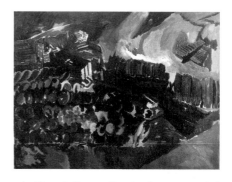

151 Bomb Store: Study for Memorial Panel 1942
Oil on paper 46 × 59½ (117 × 151.2)
Artist's Family
plate 46

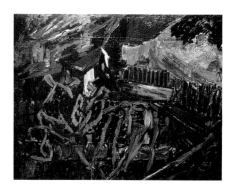

152 Bomb Store: Study for Memorial Panel 1942
Oil on paper 46½ × 59¾ (118 × 149)
Artist's Family

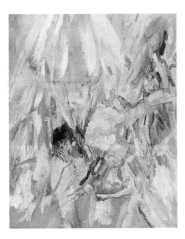

153 Flowers 1943
Oil on canvas 36 × 28 (91.5 × 71)
City of Bristol Museum and Art Gallery
plate 47

155 The Baby Juliet 1943
Oil on canvas 14¾ × 11 (38.2 × 29.3)
Artist's Family

157 Nude 1943
Oil on canvas 36 × 28 (91.4 × 71.1)
Tate Gallery
plate 49

154 Flowers 1943
Oil on canvas 36 × 28¼ (91.4 × 71.8)
Tate Gallery
plate 48

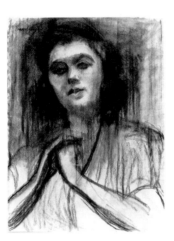

156 The Artist's Sister-in-law 1943
Charcoal on paper 24 × 18¼ (61 × 46.5)
Cecily Deirdre Bomberg

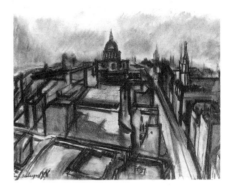

**158 Evening in the City of
London** 1944
Charcoal on paper 10¼ × 24¼ (46.4 × 59)
Visitors of the Ashmolean Museum, Oxford

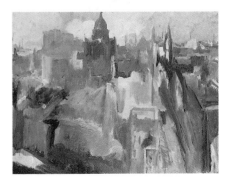

**159 Evening in the City of
London** 1944
Oil on canvas 27½ × 35¾ (69.8 × 90.8)
Museum of London
plate 50

VII Devon, Cornwall and Cyprus

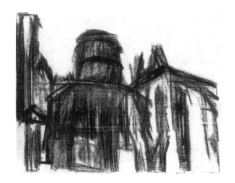

160 Round Church, Middle Temple 1944
Charcoal on paper 18¾ × 24½ (47.7 × 62.2)
Fischer Fine Art Ltd, London

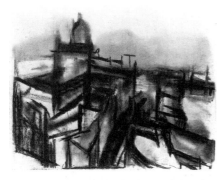

161 St. Paul's and River 1945
Charcoal on paper 20 × 25⅛ (50.8 × 63.8)
Tate Gallery

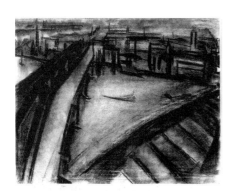

162 London River (Blackfriars Bridge) 1946
Charcoal on paper 19¼ × 24¾ (50.2 × 62.8)
Private Collection

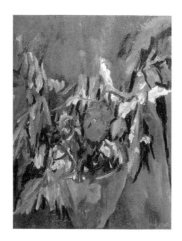

163 Flowers 1946
Oil on canvas 36½ × 28 (92.9 × 71.2)
Mr & Mrs Herbert L. Lucas

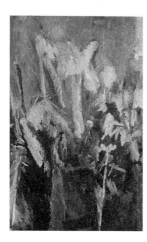

164 Flowers, early Summer 1946
Oil on canvas 36 × 24 (91.4 × 71.8)
Fischer Fine Art Ltd, London

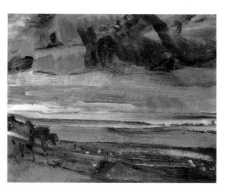

165 Sunset, Bideford Bay, North Devon 1946
Oil on canvas pasted on panel 24 × 30 (61.2 × 76.3)
Laing Art Gallery, Newcastle upon Tyne (Tyne and Wear Museums Service)
plate 51

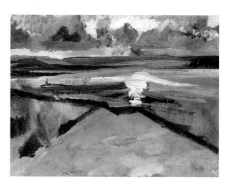

166 Bideford, Devon – the meeting of the Tor and the Tay 1946
Oil on canvas 23 × 30 (58.4 × 76.2)
National Gallery of Victoria, Felton Bequest 1973

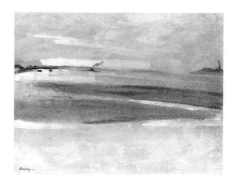

167 Barnstaple Bay, Devon 1947
Oil on canvas 20 × 26 (51 × 66)
Pamela Sylvester

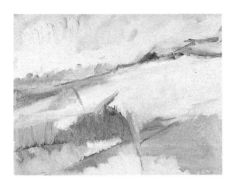

168 Trendrine, Cornwall 1947
Oil on canvas 32 × 42 (84 × 109)
Arts Council of Great Britain
plate 52

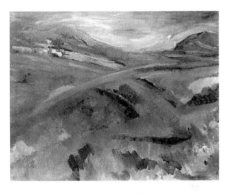

169 Tregor and Tregoff, Cornwall 1947
Oil on canvas $32\frac{1}{8} \times 39\frac{1}{2}$ (87 × 107.3)
Tate Gallery

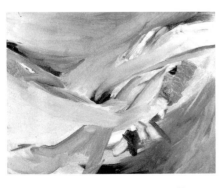

170 Trendrine in Sun, Cornwall 1947
Oil on canvas $23\frac{1}{4} \times 30\frac{1}{4}$ (59 × 77)
Manchester City Art Galleries
plate 53

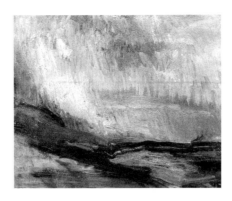

171 Sea, Sunshine and Rain 1947
Oil on canvas 25 × 30 (63.5 × 76.2)
Alfred Street

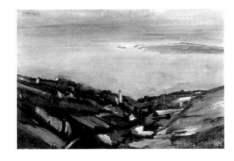

172 Evening, Cornwall 1947
Oil on canvas $27 \times 41\frac{3}{4}$ (68.7 × 106.1)
Herbert Art Gallery, Coventry

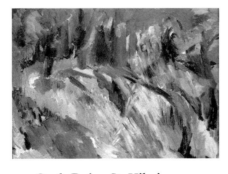

173 Castle Ruins, St. Hilarion, Cyprus 1948
Oil on canvas $36\frac{3}{4} \times 50\frac{1}{4}$ (93.5 × 127.6)
Trustees of the National Museum and Galleries on Merseyside (Walker Art Gallery, Liverpool)
plate 54

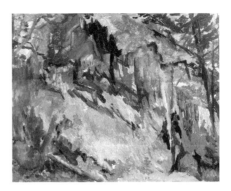

174 St. Hilarion and the Castle Ruins 1948
Oil on canvas 39 × 50 (99 × 127)
Private Collection

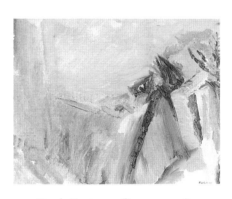

175 Rock Fortress, Cyprus 1948
Oil on canvas $28\frac{1}{2} \times 36\frac{3}{8}$ (72.5 × 92.5)
Edgar Astaire
plate 55

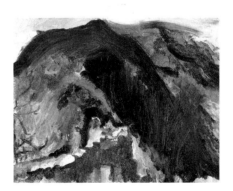

176 Moorish Wall, Cyprus 1948
Oil on canvas 28 × 36 (71 × 91.5)
Castle Museum, Nottingham

VIII The Return to Ronda

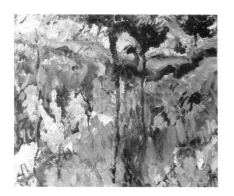

177 Trees and Sun, Cyprus 1948
Oil on canvas 25 × 30 (63.5 × 76)
Ivor Braka Limited, London

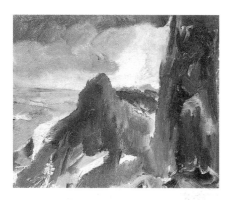

**178 Sunset, Mount Hilarion,
Cyprus** 1948
Oil on canvas 20¼ × 24¼ (51.5 × 61.5)
Private Collection
plate 56

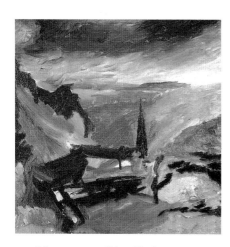

**179 Monastery of Ay Chrisostomos,
Cyprus** 1948
Oil on canvas 36 × 36 (91.5 × 91.5)
Private Collection
plate 57

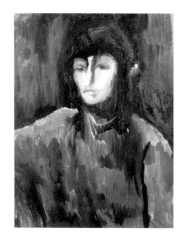

180 Portrait of Dinora 1952
Oil on canvas 36 × 28 (91.4 × 71.1)
Fischer Fine Art Ltd, London
plate 58

**181 Spires and Towers, Notre Dame
de Paris** 1953
Charcoal on paper 24¾ × 20 (63.5 × 52)
Artist's Family

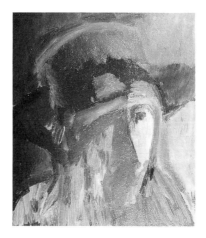

182 Talmudist 1953
Oil on canvas 30 × 25 (76.2 × 63.6)
Private Collection

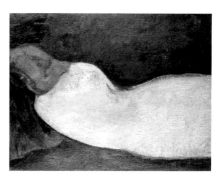

183 Mother of Venus 1953
Oil on canvas 28 × 36 (71.5 × 91.5)
Collection Matthew Marks, New York

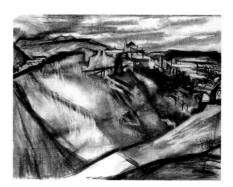

184 Ronda 1954
Charcoal on paper 18¾ × 24 (47.6 × 61)
*Trustees of the Cecil Higgins Art Gallery,
Bedford*

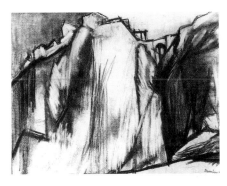

185 Ronda Bridge and Gorge 1954
Charcoal on paper 19 × 24½ (48.5 × 62.5)
Private Collection

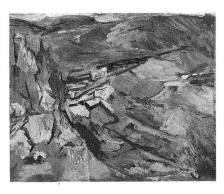

186 Ronda, towards El Barrio, San Francisco 1954
Oil on board 28 × 36 (71 × 91.5)
Leslie Marr
plate 59

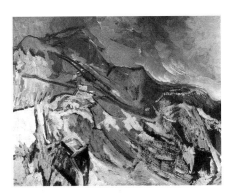

187 Rising Wind, Ronda 1954
Oil on canvas 27¼ × 34½ (69.3 × 87.7)
Private Collection
plate 60

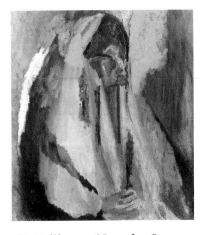

188 Soliloquy, Noonday Sun, Ronda 1954
Oil on canvas 35 × 31 (89 × 79)
Private Collection
plate 61

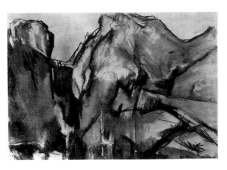

189 Valley of the Tajo 1955
Charcoal on paper 27 × 39 (68.5 × 99)
Private Collection
plate 62

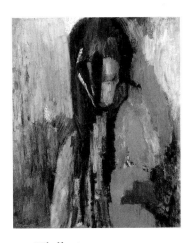

190 Vigilante 1955
Oil on canvas 28¼ × 23½ (72 × 60)
Tate Gallery
plate 63

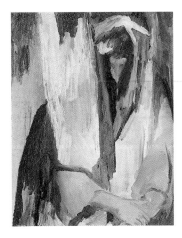

191 'Hear O Israel' 1955
Oil on canvas 36 × 28 (91.5 × 71)
Cecily Deirdre Bomberg
plate 64

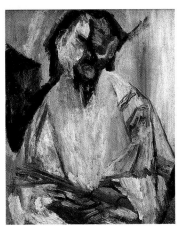

192 Last Self-Portrait 1956
Oil on canvas 30 × 25 (76 × 63.5)
Private Collection
plate 65

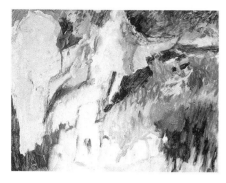

193 Tajo and Rocks, Ronda 1956
Oil on canvas 28 × 36 (71 × 91.5)
Private Collection
plate 66

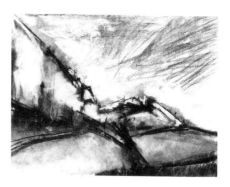

196 Ronda, Evening 1956
Charcoal on paper 17¾ × 23⅝ (45.1 × 60.1)
*Scottish National Gallery of Modern Art,
Edinburgh*

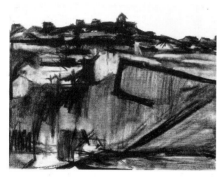

194 Ronda *c.*1956
Charcoal on paper 19 × 25 (48.5 × 63.5)
Private Collection

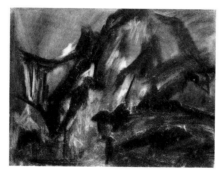

197 Ronda 1956
Charcoal on paper 18 × 24 (42 × 59.5)
Private Collection

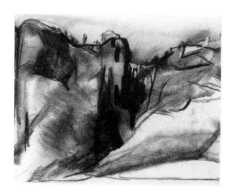

195 Ronda Bridge, the Tajo *c.*1956
Charcoal on paper 19 × 24 (48.5 × 62.5)
Mr and Mrs John Kay

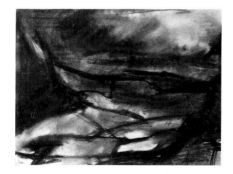

**198 The Valley, Ronda:
Moonlight** 1956–7
Charcoal on paper 17¾ × 23½ (45 × 59.5)
Artist's Family

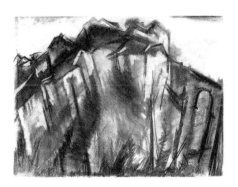

**199 Ronda, Houses and
Bridge** *c.1956*
Charcoal on paper 18⅛ × 23¾ (45.7 × 61)
Private Collection

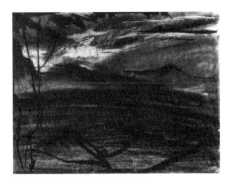

**202 Evening from La Casa de la
Virgen de la Cabeza** 1956–7
Charcoal on paper 18 × 24 (45.7 × 60.3)
Trustees of the British Museum

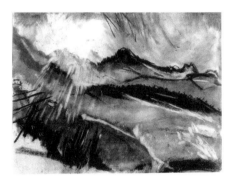

200 Evening Light, Ronda 1956
Charcoal on paper 18 × 24 (45.8 × 61)
Artist's Family

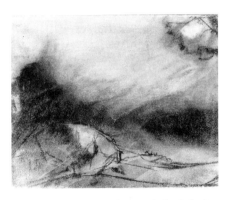

**203 La Casa de la Virgen de la Cabeza:
Night** 1956–7
Charcoal on paper 19⅜ × 24 (49.1 × 61)
Juliet Lamont

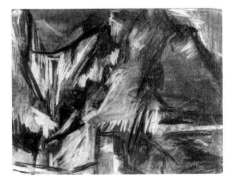

201 The Tajo, Ronda 1956–7
Charcoal on paper 17¾ × 23½ (45 × 59.5)
David Sylvester

Select Bibliography

Only a selection of those books, magazines, catalogues and pamphlets most closely concerned with Bomberg's work is included here. Unpublished material is grouped in a separate section at the end, and newspaper reviews are not listed. For a complete bibliography, the reader is referred to *David Bomberg* by Richard Cork, published by Yale University Press, New Haven and London, in 1987.

Alley, Ronald. 'David Bomberg's "In the Hold", 1913–14', *The Burlington Magazine*, vol.cx (1968).

Auerbach, Frank. Interview with Catherine Lampert in the catalogue of *Frank Auerbach*, an exhibition held at the Hayward Gallery, London, May–July 1978.

Berger, John. 'David Bomberg' in *Permanent Red. Essays in Seeing* (London 1960).

Bomberg, David. Interview with the *Jewish Chronicle* (8 May 1914).

Bomberg, David. Foreword to the catalogue of *Works by David Bomberg*, an exhibition held at the Chenil Gallery, London, July 1914.

Bomberg, David. *Russian Ballet*. Text and six colour lithographs (London, The Bomb Shop, 1919).

Bomberg, David. 'Approach to Painting', introduction to the catalogue of *First Borough Group Exhibition*, held at the Archer Gallery, London, June 1947.

Bomberg, David. Letter to the Editor, *The New Statesman*, 10 July 1948.

Bomberg, David. Interview with Oswell Blakeston, *Art and Artists*, 16 July 1948.

Bomberg, David. Preface to the catalogue of the *Third Annual Exhibition of the Borough Group*, held at the Arcade Gallery, March 1949.

Bomberg, David. Foreword to the catalogue of *Exhibition of Drawings and Paintings by the Borough Bottega and L. Marr and D. Scott*, held at the Berkeley Galleries, London, November–December 1953.

Bomberg, David. 'The Bomberg Papers', ed. D. Wright and P. Swift, *X, A Quarterly Review* (June 1960).

Bomberg, David 'and Members and Council of the Borough Bottega'. *Villa Paz Brochure* (Ronda 1954).

Causey, Andrew. 'The Two Worlds of David Bomberg', *Illustrated London News*, 18 March 1967.

Cork, Richard. Introduction and notes for the catalogue of *Vorticism and its Allies*, an exhibition held at the Hayward Gallery, London, March–June 1974.

Cork, Richard. *Vorticism and Abstract Art in the First Machine Age*, Volume 1, *Origins and Development* (London 1975).

Cork, Richard. *Vorticism and Abstract Art in the First Machine Age*, Volume 2, *Synthesis and Decline* (London 1976).

Cork, Richard. 'Bomberg in Palestine: The Years of Transition', essay in the catalogue of *David Bomberg in Palestine 1923–27*, an exhibition held at the Israel Museum, Jerusalem, autumn 1983.

Cork, Richard. 'A Tribute to Lilian Bomberg', in the catalogue of *David Bomberg: A Tribute to Lilian Bomberg*, an exhibition held at Fischer Fine Art Ltd, London, March–April 1985. With other tributes by Joanna Drew, Cavan O'Brien, Nicholas Serota and David Sylvester.

Cork, Richard. 'Bomberg and the Bomb Store', *The Burlington Magazine* (July 1986).

Cork, Richard. 'Machine Age, Apocalypse and Pastoral', 'Vorticism, Bomberg and the First World War' and 'Late Bomberg', essays in the catalogue of

British Art in the Twentieth Century, an exhibition held at the Royal Academy, London, January–April 1987.

Cork, Richard. *David Bomberg* (New Haven and London 1987).

d'Offay, Anthony. Introduction to the catalogue of *Abstract Art in England 1913–15*, an exhibition held at the d'Offay Couper Gallery, London, November–December 1969.

d'Offay, Anthony. 'David and Lilian Bomberg', introduction to the catalogue of *David Bomberg 1890–1957. Works from the collection of Lilian Bomberg*, an exhibition held at the Anthony d'Offay Gallery, London, February–April 1981.

Drew, Joanna. Catalogue of *David Bomberg 1890–1957*, an exhibition held at the Tate Gallery, London, March–April 1967.

Forge, Andrew. Introduction to the catalogue of *David Bomberg 1890–1957, An Exhibition of Paintings and Drawings*, held at the Arts Council Gallery, London, autumn 1958.

Forge, Andrew. 'Bomberg's "The Mud Bath" ', *The Listener*, 11 November 1965. Partially reprinted in the catalogue of *David Bomberg 1890–1957*, an exhibition held at the Tate Gallery, London, March–April 1967.

Fry, Roger. 'Two Views of the London Group', *The Nation*, 14 March 1914.

Fuller, Peter. 'David Bomberg' in *Beyond the Crisis in Art* (London 1980).

Fuller, Peter. 'David Bomberg: Pre-Raphaelitism and Beyond', *Art Monthly*, June 1987.

Gross, John. 'The Bomberg Approach', *Sunday Times Colour Magazine*, 22 March 1964.

Holden, Cliff. 'David Bomberg: an artist as teacher', *Studio International*, March 1967.

Holt, Lilian. Interview with Sue Arrowsmith, *Art Monthly*, March 1981.

Hulme, T. E. 'Modern Art. IV. – Mr David Bomberg's Show', *The New Age*, 9 July 1914.

Hulme, T. E. *Speculations. Essays on Humanism and the Philosophy of Art*, edited by Herbert Read (London 1924).

Kaines Smith, S. C. Foreword to the catalogue of *An Exhibition of Paintings and Drawings of Palestine and Petra by David Bomberg*, held at the Ruskin Gallery, Birmingham, February 1929.

Lewis, Wyndham. 'Room III (The Cubist Room)', preface to the catalogue of the *Exhibition by the Camden Town Group and Others*, Brighton Public Art Galleries, December 1913–January 1914.

Lewis, Wyndham. Note in the catalogue of *The First Exhibition of the Vorticist Group, opening 10th June 1915 at the Doré Galleries, London*.

Lewis, Wyndham. 'Round the London Galleries', *The Listener*, 10 March 1949.

Lipke, William C. *David Bomberg. A Critical Study of His Life and Work*, with an appendix devoted to a selection of Bomberg's writings (London 1967).

Lipke, William C. 'Structure in textures of colour', essay in the catalogue of *David Bomberg 1890-1957. Paintings and Drawings*, an exhibition held at the Tate Gallery, London, March-April 1967.

Michelmore, Richard. Introduction to *David Bomberg – The Teacher*, the catalogue of an exhibition held at the 15 Bury Walk Gallery, October 1986.

Neve, Christopher. 'The Divided View. David Bomberg in Ronda, Andalucia', *Country Life*, 23 May 1985.

Newmark, J. 'The Rose-red City of Petra', *The Studio*, August 1932.

Oxlade, Roy. *David Bomberg 1890-1957*, RCA Papers No.3 (London 1977). (See also Unpublished Material).

Oxlade, Roy. 'A Rejection of "Bomberg Comes Home" ', *Art Monthly*, December 1979 (See Spencer, Charles).

Rachum, Stephanie. 'David Bomberg: Views from the Jewish–Zionist Side', essay in the catalogue of *David Bomberg in Palestine 1923-1927*, an exhibition held at the Israel Museum, Jerusalem, autumn 1983.

Read, Herbert. 'Bomberg', *Arts Gazette*, 13 September 1919.

Roberts, William. *The Vortex Pamphlets 1956-1958* (London 1958).

Roberts, William. *Early Years* (London 1982).

Robertson, Bryan. 'David Bomberg', *The Studio*, January 1946.

Rodker, John. 'The New Movement in Art', *Dial Monthly*, May 1914.

Rodker, John. *Poems* (privately printed, London 1914).

Rothenstein, John. Chapter on Bomberg in *Modern English Painters. Volume Two. Nash to Bawden* (London 1984).

Russell, John. 'London', *Art News*, May 1967.

Spencer, Charles. 'David Bomberg 1890-1957', *The Studio*, October 1958.

Spencer, Charles. 'Bomberg Comes Home', *Art Monthly*, November 1979 (see Oxlade, Roy).

Spencer, Charles. 'Anglo-Jewish Artists: The Migrant Generations', essay in the catalogue of *The Immigrant Generations: Jewish Artists in Britain 1900-1945*, an exhibition held at the Jewish Museum, New York, 1983.

Spurling, John. Introduction to the catalogue of *David Bomberg. The Later Years*, an exhibition held at the Whitechapel Art Gallery, London, September-October 1979.

Storrs, Sir Ronald. 'David Bomberg', preface to the catalogue of *Paintings of Palestine and Petra by David Bomberg*, an exhibition held at the Leicester Galleries, London, February 1928.

Storrs, Sir Ronald. *Orientations* (London 1937).

Sylvester, David. 'Round the London Art Galleries', *The Listener,* 18 September 1958.

Sylvester, David. 'Bomberg and Whistler', *The New Statesman,* 17 September 1960.

Sylvester, David. Introduction to the catalogue of *David Bomberg 1890-1957,* an exhibition held at Marlborough Fine Art, London, March 1964.

Sylvester, David. 'The Discovering of a Structure', essay in the catalogue of *David Bomberg 1890-1957,* an exhibition held at the Tate Gallery, London, March-April 1967.

Sylvester, David. 'Selected Criticism', essay in the catalogue of *Bomberg. Paintings, Drawings, Watercolours and Lithographs,* an exhibition held at Fischer Fine Art, London, March-April 1973.

Wees, William C. *Vorticism and the English Avant-Garde* (Toronto and Manchester 1972).

UNPUBLISHED MATERIAL

Auerbach, Frank. Interview with Richard Cork for Leonie Cohn, 1983, tape owned by Leonie Cohn, London.

Auerbach, Frank. Interview with Richard Cork for BBC Radio 3, transmitted 18 November 1985 (produced by Judith Bumpus).

Bomberg, Alice. Letters to David Bomberg and Diary of the Petra expedition, collection of the Tate Gallery Archive.

Bomberg, David. Letters, poems, theoretical writings, lists of work and memoirs, collection of the Tate Gallery Archive.

Bomberg, Lilian. Letters to David Bomberg, collection of the Tate Gallery Archive.

Creffield, Dennis. Letter to Richard Cork, collection of the author.

Kisch, Frederick. Diary, collection of Central Zionist Archives, Jerusalem.

Kossoff, Leon. Letter to Richard Cork, collection of the author.

Leftwich, Joseph. Diary, collection of Tower Hamlets Library, London.

Lipke, William C. 'A History and Analysis of Vorticism', doctoral thesis for the University of Wisconsin, 1966.

Marr, Leslie. Letters to Richard Cork, collection of the author.

Mayes, Alice. 'The Young Bomberg, 1914-1925', memoir dated 1972, collection of the Tate Gallery Archive.

Mayes, Alice. Letters to Lilian Bomberg, collection of the Tate Gallery Archive.

Mayes, Alice. Letters to Richard Cork, collection of the author.

Mead, Dorothy. 'The Borough Group', memoir, n.d., collection of the Tate Gallery Archive.

Minutes of the Borough Bottega Group, collection of Richard Michelmore, London.

Newmark, Kitty. Letters to Richard Cork, collection of the author.

Oxlade, Roy. 'Bomberg and The Borough: An Approach to Drawing', MA thesis for the Royal College of Art, London, 1976.

Richmond, Peter. 'David Bomberg', memoir dated October 1979, private collection.

Lenders

The Friends of the Tate Gallery

The Friends of the Tate Gallery is a society which aims to help buy works of art that will enrich the collections of the Tate Gallery. It also aims to stimulate interest in all aspects of art.

Although the Tate has an annual purchase grant from the Treasury, this is far short of what is required, so subscriptions and donations from Friends of the Tate are urgently needed to enable the Gallery to improve the National Collection of British painting and keep the Twentieth-Century Collection of painting and sculpture up to date. Since 1958 the Society has raised over £1 million towards the purchase of an impressive list of works of art, and has also received a number of important works from individual donors for presentation to the Gallery.

In 1982 the Patrons of New Art were set up within the Friends' organisation. This group, limited to 200 members, assists the acquisition of works by younger artists for the Tate's Twentieth-Century Collection. A similar group – Patrons of British Art – was formed in late 1986 to assist the acquisition of works for the Collection of British painting of the period up to 1914.

The Friends are governed by a council – an independent body – although the Director of the Gallery is automatically a member. The Society is incorporated as a company limited by guarantee and recognised as a charity.

Advantages of Membership include:

Special entry to the Gallery at times the public are not admitted. Free entry to, and invitations to private views of paying exhibitions at the Gallery. Opportunities to attend lectures, private views at other galleries, films, parties, and of making visits in the United Kingdom and abroad organised by the Society. A 10% discount on all stock in the Tate Gallery shop, apart from books and catalogues, and a 10% discount on current special exhibition catalogues. Use of the Members' Room in the Gallery.

MEMBERSHIP RATES

Any Membership can include husband and wife

Benefactor Life Member £5,000 (single donation)
Patron of New Art £475 annually or £350 if a Deed of Covenant is signed
Patron of British Art £475 annually or £350 if a Deed of Covenant is signed
Corporate £250 annually or £200 if a Deed of Covenant is signed
Associate £65 annually or £50 if a Deed of Covenant is signed
Life Member £1,500 (single donation)
Member £18 annually or £15 if a Deed of Covenant is signed
Educational & Museum £15 annually or £12 if a Deed of Covenant is signed
Young Friends £12 annually.

for further information apply to:

The Friends of the Tate Gallery,
Tate Gallery, Millbank, London SW1P 4RG
Telephone 01–821 1313 or 01–834 2742.

Subscribing Corporate Bodies as at December 1987

* Agnew & Sons Ltd, Thomas
Alex, Reid & Lefevre Ltd
Allied Irish Banks Plc
American Express Europe Ltd
Art Promotions Services Ltd
† Associated Television Ltd
Bain Clarkson Ltd
Balding + Mansell UK Ltd
† Bankers Trust Company
Barclays Bank International Plc
Baring Foundation, The
Beaufort Hotel
* Benson & Partners Ltd, F.R.
Bowring & Co. Ltd, C.T.
British Council, The
British Petroleum Co. Plc
Brocklehursts
Bryant Insurance Brokers Ltd, Derek
CCA Stationery Ltd
Cazenove & Co.
Charles Barker Group
* Chartered Consolidated Plc
* Christie, Manson & Woods Ltd
* Christopher Hull Gallery
Citicorp Investment Bank Ltd
Colnaghi & Co. Ltd, P & D
Commercial Union Assurance Plc
Coutts & Company
Crowley Ltd, S.J.
De La Rue Company Plc
Delta Group Plc
Deutsche Bank AG
* Editions Alecto Ltd
Electricity Council, The
Equity & Law Charitable Trust
Esso Petroleum Co. Plc
Farquharson Ltd, Judy

Fine Art Society Ltd
Fischer Fine Art Ltd
Fishburn Boxer & Co.
Fitton Trust, The
* Gimpel Fils Ltd
Greig Fester Ltd
Guinness Peat Group
Hill Samuel Group
IBM United Kingdom Ltd
* Imperial Chemical Industries Plc
Johnson & Higgins
Kiln & Co. Ltd
Kleinwort Benson Ltd
Knoedler Kasmin Ltd
* Leger Galleries Ltd
Lewis & Co. Plc, John
* Lumley Cazalet Ltd
Madame Tussauds Ltd
† Manor Charitable Trustees
* Marks & Spencer Plc
Marlborough Fine Art Ltd
* Mayor Gallery, The
Minet & Co. Ltd, J.H.
Morgan Bank
Morgan, Grenfell & Co. Ltd
National Westminster Bank Plc
Norddeutsche Landesbank
Ocean Transport & Trading Plc
* Ove Arup Partnership
Pateman Underwriting Agencies Ltd
Patrick Underwriting Agencies
Pearson Plc
Peter Moores Foundation
* Phillips Son & Neale
Piccadilly Gallery
Plessey Company Plc, The
Rayne Foundation, The

Redfern Gallery
† Rediffusion Television Ltd
Richard Green Gallery
Roberts & Hiscox Ltd
Roland Browse & Delbanco
Rothschild & Sons Ltd, N.M.
Royal Bank of Scotland Plc
RTZ Services Ltd
Schroder Wagg & Co. Ltd, J. Henry
Schupf, Woltman & Co. Inc
Scott Mathieson Daines Ltd
Seascope Insurance Holdings
* Secretan & Co. Ltd, F.L.P.
Sedgwick Group Plc
* Sinclair Montrose Trust
Smith & Son Ltd, W.H.
Somerville & Simpson Ltd
Sotheby Parke Bernet & Co.
Spink & Son Ltd
Star Assurance Society
Stephenson Harwood
Stewart Wrightson Ltd
Sun Alliance & London Insurance Group
Swan Hellenic Art Treasure Tours
Swire & Sons Ltd, John
* Tate & Lyle Ltd
Thames & Hudson Ltd
† Tramman Trust
* Ultramar Plc
Vickers Ltd
* Waddington Galleries Ltd
Willis Faber Plc
Winsor & Newton Ltd

* By Deed of Covenant
† Life Member